Buying and Selling
Multimedia Services

Buying and Selling Multimedia Services

Gerry Souter

FOCAL PRESS

Boston, Oxford, Johannesburg, Melbourne, New Delhi, Singapore

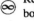
Recognizing the importance of preserving what has been written, Butterworth–Heinemann prints its books on acid-free paper whenever possible.

 Butterworth–Heinemann supports the efforts of American Forests and the Global ReLeaf program in its campaign for the betterment of trees, forests, and our environment.

Library of Congress Cataloging-in-Publication Data
Souter, Gerry.
 Buying and selling multimedia services / Gerry Souter.
 p. cm.
 Includes index.
 ISBN 0-240-80272-1 (alk. paper)
 1. Multimedia systems. I. Title.
 QA76.575.S595 1997
 651.7—dc21 96-49425
 CIP

British Library Cataloguing-in-Publication Data
A catalogue record for this book is available from the British Library.

The publisher offers special discounts on bulk orders of this book.
For information, please contact:
Manager of Special Sales
Butterworth–Heinemann
313 Washington Street
Newton, MA 02158–1626
Tel: 617-928-2500
Fax: 617-928-2620

For information on all Focal Press publications available, contact our World Wide Web home page at:
http://www.bh.com/fp/

10 9 8 7 6 5 4 3 2 1

Printed in the United States of America

For Janet, My Wife and Partner

With Love

Contents

Acknowledgments

The research for this book grew in volume well beyond my own project diaries, my accumulated experience in multimedia for the past 25 years, and the volunteered wisdom of my colleagues. People whom I met strictly as a voice on the telephone went out of their way to help and offer leads to new directions I had not considered. To these professionals, I offer my gratitude and thanks. The readers will benefit from their conscientious efforts.

Special thanks go to Robert Dronski, a designer, programmer, and multimedia innovator who provided pages of leads and insights on digital media and the evolving Internet. Very special thanks are due Tammy Harvey, associate acquisitions editor at Focal Press, for her constant encouragement and courtesy throughout this long project.

Additional thanks for patience, courtesy, and support are extended to the following contributors:

Carl Renalls, 3M
Carol Engdahl, 3M
Christina Walker, The Hoffman Agency for Hewlett Packard
Daniel L. Baca, Yamaha Systems Technology, Inc.
Joyce Lekas, The Lekas Group for Yamaha Systems Technology, Inc.
Greg Barr, PCMCIA
John Taylor and Ken Ramoutar, Zenith Electronics Corp.
Greg Marcey and Alissa Friedman, Ahrens Interactive Group
Mike Foster and Clay Bodine, Lighthouse Productions
Karen Allen, Lupe Hirt, and Kelly Odle, The Benjamin Group for Toshiba
 American Information Systems, Inc.

Gerry Souter
Arlington Heights, IL

Introduction

- Does the word *multimedia* sound intimidating and expensive?
- Do you believe people who are "into" multimedia belong to some special club complete with a secret handshake?
- Do you want to join the club?

This book will help you become a full-fledged member of the multimedia club and not empty your corporate coffers in the process. It offers ground rules for preparing to launch a project, finding and hiring creative people to build it, understanding what these people are talking about, selecting media that matches your market and audience, and maintaining control over the process as it happens. These disciplines are based on my 30 years of experience, starting as a photojournalist creating slides for education filmstrips and moving on to filmmaker, video producer/director, scriptwriter, and, finally, project designer and manager.

I've been a client buying from multimedia vendors as well as a "creative" on the other side of the conference table, selling multimedia. I've learned that "value for dollars" is the ruling guideline when planning a project, selecting an appropriate vendor, and ultimately creating a winning program. Knowing how to spend and how to save those dollars is an important key to a successful multimedia project. Another critical element—probably the most critical element—is your mental attitude as you approach the complexities of multimedia design and implementation.

Embarking on a project that constitutes a major investment in people, time, and dollars to achieve certain established goals requires a basic and thoughtful understanding of asset management. One of the great asset managers of modern times was George C. Marshall, overall military commander of the U.S. Armed Forces in World War II and a

designer of the Marshall Plan for postwar Europe. Following World War I, the army dwindled and was in danger of becoming an impotent force. Marshall was a colonel at the Fort Benning Infantry School in 1934 and was painfully aware of this decline when he wrote *Infantry in Battle.* In that article he wrote:

> . . . *In our schools we generally assume that organizations are well-trained and at full strength, that subordinates are competent, that supply arrangements function, that communications work, that orders are carried out. In war, many or all of these conditions may be absent. The veteran knows this is normal and his mental processes are not paralyzed by it.*[1]

This military axiom has application in civilian life situations, concerns, reactions, and negotiations that take place every day in the multimedia marketplace. They are insights gathered from veterans.

[1] George C. Marshall, "Infantry in Battle," U.S. Army Infantry School, *Infantry Journal,* Washington, DC, 1934; quoted from Michael D. Doubler, *Closing With the Enemy,* University Press of Kansas, 1994, p. 9.

Part One

Part One

1

What Is Multimedia?

First, let's define what we mean by *multimedia*. Most companies have been using the elements of multimedia for years. The term *multimedia* was coined by author Joseph Klapper in his 1960 book, *The Effects of Mass Communication*. It meant the use of separate media in a single presentation. It started out as an adjective, graduated to a noun, became hyphenated (multi-media) and was swept into business communications as part of "AV" (audiovisual) presentations back in the 1970s. At that time, when computers were basically slow, clunky affairs compared to today's home computers, there was only cine film, 35mm slides (single-advanced or programmed), overhead projection transparencies, and emerging videotape. A "computer" ran the slide show using paper punch-tape or beeps on 1/4-inch audio tape. To Steve Jobs and his sidekick Steve Wozniac, an apple was still a juicy red fruit.

AV coupled with computers had humble origins. A Commodore computer could run laser light shows. The Amiga was dying until someone stuffed a "graphics" chip inside, went searching for a niche market and, eventually, the graphic video effects offered by the "Toaster™" were available to producers and directors. Finally, Apple and IBM software writers became aware of the "presentation" industry, which went on to become the "computer graphics" industry.

Today, computers are ubiquitous. They unlock your car door, perk your coffee, and you can't take notes at a meeting without opening up your Wizard, Psion, or other multifunction personal digital assistant. Parents once worried about their kids developing spatulate fingers from

beating on computer keyboards all day. Today, you have three different carpal stress syndromes and those spatulate adults from the pre-mouse era are trying to find the keys on these teensy pocket computers or write on a screen with a "pen" that is only as thick as a cocktail stirrer.

With the successful introduction into the home of the computer-as-workstation, the ability to send faxes from the car seat via cellular phone, the explosion of 3-D graphics in high-power video games, the super-trendy Internet, and the merging of computers with high-speed fiber-optic lines, a huge new market has opened. Electronic entrepreneurs redesigned themselves as *multimedia* drumbeaters by kidnapping the term, abandoning its hyphen, and grafting it onto any computer-created presentation product.

Actually, multimedia embraces everything from virtual reality computer environments and CD-ROM extravaganzas, through traditional audiovisual uses, to multiscreen video walls, interactive training programs, satellite teleconferencing broadcasts, and Web sites on the beckoning Internet. The truth is that most of today's computer-based "multimedia" is largely a digital *presentation* animal. How we *get to* the information has changed more than the makeup of its parts. Regardless of the sophistication of the user interface, the programs are created using still images, screen text, video clips, recorded audio, animation, and graphic design. All of these elements are cobbled into computer-readable bit/byte clusters waiting to be called on stage by the next line of program code launched from a hard drive, disk, card, or computer chip.

Good graphic design, cleanly recorded audio, well-directed quality video, and intelligent writing are combined through use of the wonderful new computer toolboxes now available. But a box of shiny new tools does not make a good mechanic. Creating any project from today's lengthy menu of media possibilities is a team effort — a team of talented specialists. Finding the best creative interpreters for a given set of requirements is the challenge. Rarely do they live, or thrive, in the typical corporate atmosphere. When company downsizing comes, these bewildered folk are usually the first to hit the streets. It is virtually impossible for a company to justify having a staff large enough to cover all the variations of today's corporate communications. Even the largest multimedia production houses can't do that. The corporate project managers must sally forth to meet with, select, and work alongside creative specialists who can bring a program idea to life.

The problems facing companies who want to expand their marketing and training into the "new" digital multimedia age have not

Figure 1-1. A multimedia service company had an opportunity to move into the industry-rich environment of Taiwan. Important government contacts had been made, heavy insurance dollars committed, necessary permits filed, and a gala grand opening cocktail party thrown for all the important bigwigs. An office was opened in Taipei, stationery printed, and the search for clients begun. With a promise of a bright future before it, the plan had two fatal flaws: long-distance management and management rooted in a ". . . if it ain't broke . . ." philosophy. First, a close examination of the sales effort would have revealed that the Taipei manager had no particular love for non-whites, in particular the Taiwanese. Also, like the company's stateside sales reps, he knew very little about the technical side of multimedia communications. Second, all services sold in Taiwan had to be processed using the company's facilities in the United States. Management rationalized that those expensive facilities had to be kept busy. Numerous similar facilities were available in Taipei at considerably less cost and did not have to pass through the nightmare of Taiwan customs. Eventually, fixation on what worked in the States, the inability to merge into Taiwan's business culture, and management by fax doomed the project. A change in the company's management style was perceived as "risky." In a creative business, the company failed to recognize that the basis for creativity is the seeking of alternatives.

changed—the scope has merely widened. Where once the menu was table d'hôte, it is now a la carte; and if that were not all, the company must also think of the project in terms of what the new media combinations deliver. Over the years, our knowledge of what is "possible" tends to focus our perceptions such that we prefer to reject what is beyond our past experience. We cling to what we know. There is a comfort factor in the current way of approaching communications strategies and tactics: If what we are doing isn't the best way, it would have been replaced. The bugs are out of the way we do it now. It is time tested. It was selected from other possibilities and has evolved into an acceptable procedure. We are already committed to the expectations of our loyal customer base. "If it ain't broke, don't fix it."

Many of today's corporate marketing people peering out across the multimedia landscape also have the urge to equate something that is new with risk. Yet, understanding that today's "new" is simply an alternative packaging of familiar forms of media into *new formats for presentation* takes some of the scary edge off risk.

The company must also consider a changing audience for its project. Media literacy has increased through exposure. Television, movies, video games, the Internet, home computers, cellular phones, fax machines—people are accepting the information exchange explosion in exponentially greater numbers. They are becoming techno-hip. This hipness is due largely to the fact that access to this information exchange has been made easier. An intimate knowledge of techno-speak is no longer required for membership—though a soupçon of the fundamentals helps as we'll discuss later. A growing number of techno-seers have had a revelation. The easier it is to join the club, the more dues you collect. Commerce and creativity are no longer mutually exclusive realities. It is not a "dumbing down" of creative effort, it is a raising of everyone's collective appreciation because we—companies and production houses—can both finally get our arms around the product.

Now, we have the shiny tools and we have our hip audience. How do we use the former to communicate with the latter? One key to creating any successful project outside of the company's in-house operation is to understand that the tool wielders beyond the company gate are also companies. They may have an employee roster of one, or a hundred, but they are out to make a profit, grow their businesses, put a little away in the fruit jar buried under the porch, and send their kids to college. They are exchanging their expertise for

money and most of them want to produce a product they can be proud of while preparing the ground for a long-term relationship with their clients. There is no secret handshake or mystic incantations. They're just folks.

But one thing above all others I've mentioned is the absolute truth — the vendors approached to bid on and execute your multimedia project *are on the clock* from the first meeting to discuss the proposal to the last wrap-up day when the final billing goes out. There is no "cost of doing business" once a project is won. The hours spent in meetings with your team, on storyboards, on the phone, on internal meetings between members of the vendor's team to discuss your project, and so on, are all considered to be billable hours in one way or another when the bottom-line budget is totaled up. The clearer the path from client concept to project wrap-up, the more money will be saved. This point will be constantly reemphasized throughout the narrative.

2

Prelaunch Thoughts

The normal route for bringing multimedia artisans to the corporate front door is to send out a missal announcing the company's stated needs accompanied by a request for proposal (RFP).

I spent 8 years with a Fortune 500 company learning how to write an RFP to *buy* multimedia. For 11 years after that, I tried to decipher prospective client proposal requests so we could *sell* multimedia. During both internships, the good, the bad, and the ugly passed through my hands. Worst of all, during those last years, I fielded far too many prospective client telephone requests for a "ballpark" budget.

Even if — by some stroke of whimsy — we won the job, costly hours on the clock would be spent trying to untangle the client's best intentions to create a project that would accomplish the job. Of course, the "ballpark" number roughly arrived at will, very likely, have become engraved on the client's frontal lobe and when the whole of the project comes to light, the actual cost may exceed that first groping guesstimate. Then, a great shout and clamor goes up and accusations of "bait and switch" can arise during the fingerpointing. The time taken to prepare a well-thought-out RFP in most cases could have saved hundreds and sometimes thousands of dollars.

Some clients have gone to the well with a hole in their bucket a few times and had a bad experience. Their RFPs are masters of self-defense: pages long, they resemble tech manuals and specify elements down to the tiniest detail. Unfortunately, the well keeps getting deeper as new technology comes along. They are often so entrenched in their narrow perception of the media marketplace and armored with their minutely

Figure 2-1. ". . . We're gonna make a video about a new service—can't tell you what it is because it's confidential. Usually, Leo in marketing shoots our video films for training. He's got his own camera. We figure no longer than 30 minutes. Mr. Smartfingerfulcher, our founder, will introduce it and we'll shoot around the plant for a day. Our tech writer will do the script and you can polish it. Probably want some graphics too and can you fax me your numbers by tomorrow afternoon? . . . Do we have a budget in mind? Well, that's your job isn't it? Tell us what you think it will cost . . . just a ballpark number."

delineated specs that they stubbornly rule out very creative and cost-effective possibilities.

The multimedia buyer must think through the pending project with regards to the people who will be reading the RFP. Even without a clear knowledge of all the multimedia tools available, certain basic premises can be outlined. These will guide the project team toward a choice of media and the vendor who can supply it.

- What is the project's objective? To motivate sales? Introduce a product or service? Draw crowds to a trade show booth? Add dynamic elements to a meeting? Train personnel in a new procedure or product features? Present the company's story and image? Improve internal communications?

- Who is your audience? What will they be looking for? What have they seen before? Is their point-of-view represented in your project team?

- What is the venue for the presentation of the project (a meeting, trade show, point-of-purchase location, small group in a conference room, individual workstation, a site on the Internet, television or satellite broadcast, etcetera.)?

- What's your real budget? What is the total amount available to spend on the project? Do the participating departmental money providers demand sign-off on the elements of the project before committing the cash? Are they represented in your project team? (Turf wars are to be avoided at all costs once a project is awarded at a given budget.)

- How much of that budget do you want to *actually* spend? Should there be a cushion to allow for the unknown, *unforeseen* changes that can occur in a project? (We'll talk about "unforeseen" changes later.)

- What kind of media will best do the job?

Part Two of this book discusses in reasonable detail various specific media available to deliver the product to the audience, but first one or two words about the reasons behind choices are appropriate here.

Driven by the latest buzzwords sputtering out of the press, sometimes a client will choose a medium because it's "hot!" At other times, other mediums are chosen, because the client has a "comfort level" with the medium they have used before.

There are so many technologies available to clients that to try to wedge a need into a trendy format is as bad as sticking to a format because that's "what's always been used." *The target audience and the result expected from the experience should be a major factor in choosing the medium and presentation format.*

Figure 2-2. A client with very deep pockets decided to use a CD-ROM as a point-of-purchase deliv-
ery system. Their product had numerous fine details that set it apart from the competition. Craftsmanship
equaled value. The script called for many close-ups of the product on a very large video screen and the
client was adamant that the colors and details be rendered accurately. They had used a LaserDisc™ pro-
duced years ago in the program to be replaced. When my team recommended a LaserDisc for the new
product, the client backed away. They wanted the "new" technology. It wasn't until data-compressed
full-screen video images of the product rendered on CD-ROM were compared to the sharper color-rich
images of the LaserDisc that the client relented. New isn't always better.

Figure 2-3. A computer manufacturer wanted to produce a video to show users how to operate a new model. They had used video to train techs and had seen videos that described how to use software. When we suggested a computer-based training program, the client was hesitant. They were not aware of the graphic and interactive capabilities now possible to help lead a novice through the learning experience. When a computer-based program produced for another client was shown to the manufacturer, they bought off on the idea—producing a product that would run on their machines where the training was supposed to take place. The computer didn't have to sit next to a VCR and TV screen in order for the user to be trained.

- Does the chosen medium match the chosen venue? Think ahead about distribution.

- The target audience should be able to extract the necessary information from the chosen medium. Before considering the available delivery systems to carry the message, *a complete understanding of the information receiving capabilities of the audience is essential.*

Selecting the hippest, hottest, "wired" medium to carry the word can be a very expensive ego trip if the folks on the other end of the pipeline have no means to download the wisdom. This problem has been with us since the dawn of multimedia when the "company-wide meeting" was king.

Large meetings were once the cash cows of large production houses, because that was one way for corporations with deep pockets to take the word to the sales force in one long three- to five-day dose. Slides, film/video, live talent, elaborate sets, pyrotechnics, corporate "game shows," the call to arms from the CEO—the whole bag of motivational tricks—was loosed on the expectant audience, which was shackled to their seats by executive order. By the end of the meeting, a near religious revival meeting atmosphere had everyone on their feet praising Sweet Corporate Wisdom.

The catch was, of course, that valuable salespeople and managers had to be transported from their territories and offices to this affair, housed, fed, and sent home again brimming with a usually short-lived Pattonesque desire to kill the competition. The cost of these extravaganzas gradually has begun to outweigh the results. Rarely does the production house ever hear of steeply rocketing sales numbers that could be directly attributed to the meeting. The meetings have become traditional events that are expected rather than critical information milestones in the companies' growth. Big prizes are offered for exceptional sales performance. They are the ego feathers in the headdress of the Sales Division.

The need to control costs and focus the message has begun to change the face-to-face delivery medium to smaller groups centered around "meetings-in-a-box" created with videotapes, print pieces, meeting guidebooks, and ice-breaker games. Finally, phone and video teleconferencing and pass-around VHS videotapes have become the mediums of choice for the stressed budgets of corporate communications. Every office has to have a speakerphone and a videocassette player. Today's multimedia and Internet information blitz is demanding as much of the receiver of information as it is of the distributor.

Figure 2-4. A huge multimillion dollar corporation was faced with a need for training its thousands of employees at all levels of management in hundreds of offices across the United States. Proper paper handling procedures were not being followed. All of the company's transactions were still being handled on paper. Every office was responsible for maintaining paper files on transactions in their local area and if the proper file names were not typed in or the wrong color tabs used, the literal paper trail was aborted. They asked for a videotape to train the people. When the gospel of good training was explained, showing that video does not train, but helps reinforce good training programs, they relented and accepted a proposal for a computer-based training program for each workstation using the video as a motivator and supplement.

At this point, the truth was told by the company representative. Most of the offices had some kind of VCR and TV set, but many relied on the worker to take the tape home to view it. Secondly, many of the computers that were in the offices ran off old 286 microprocessors. There were no Macs, no Windows programs, and the computers were mainly used to write letters and type up labels for the files.

Before anything could be created to train these people, the company would have to provide ways and means to use the material effectively.

The choice of multimedia to get the word out in the 1990s and beyond requires a careful assessment of the targeted recipients. More companies are upgrading their offices by taking advantage of the plummeting prices of hardware and software. They are also keenly watching the Internet and intranet distribution wars that are jumping on the back of the 1996 Telecommunications Act allowing wider competition between cable and telecommunications companies.

Salespersons today are likely to be carrying a laptop computer complete with fax and direct modem to the factory. As demand continues and prices drop accordingly, the CD-ROM is becoming ubiquitous, storing inventories, providing training, and demonstrating products. Wireless telecommunications provide direct links to the 1000-page price and availability-maintained catalog on the Web with orders sent directly to the factory via an e-mail link. Never has a thorough knowledge of the audience been as important than in this evolutionary communications age.

The equivalent on the selling side, the trade show, has kept afloat numerous display companies and production houses. Acres of high-glitz booths, pretty girls, mellow-voiced hosts, acrobats, mimes, huge video walls, participation games and tests of skill, blinking computer monitors, and battalions of salespersons with ready order books and sweaty palms have populated vast exhibition halls across the United States.

These "trade only" shows focus on buyers — the persons who are *not* carrying huge plastic bags filled with every free brochure and plastic giveaway. Despite rapidly escalating costs and severe drain of personnel and time, they remain a mainstay of the targeted customer assault while providing high profile, "old boy" competition for industry leaders. Unfortunately, these trade shows also reveal the sharp demarcation between the big spenders at the top of the pile and the bottom feeders who may have a wonderful product, but can't afford the square footage, or the dancing bear.

Multimedia and the Internet level that playing field for the less-than-lavishly capitalized company and can still reach a finely targeted customer demographic. A clever, compelling design and structure for a well-thought-out multimedia program or Web site can offset a whole chorus line of dancing bears.

The multimedia experience has a wide range of applications. An audience of a hundred should have a different experience than a single user. One experience is shared, the other is intimate. When a person at a trade show sees that his or her manipulation of an interactive multimedia kiosk is repeated on a 12-foot screen above the booth, that per-

Figure 2-5. A video producer was asked to document a speaker for a series of programs to be sent to selected universities. The budget was very small and the speaker showed up with hand-drawn charts, a blackboard, and said ". . . um" after every three or four words. Because of a time crunch, the video was shot and edited in five hours. The producer went away dejected over the product that would be distributed under his name. A couple of months later while at a convention, the producer was approached by a university professor who asked if it was he who produced the video sent to their institution. Sheepishly, the producer admitted the deed. The professor shook his hand and thanked him profusely for the program. "We had been trying to get that information for months and your really professional tape told us everything we wanted to know." It turned out that previous tapes had never even been *edited* before.

son may back off if he or she is uncomfortable with computer interfaces. A one-on-one approach is just that—an intimate exchange producing a satisfying interaction.

The exception to this is the "game" kiosk where a group can have fun taking turns with their peers at building a score or overcoming eye/hand coordination exercises. If the target audience is "into" this kind of competition, they go for it.

Mature mediums such as film and video can span any venue from a video wall to a single monitor. A general audience will normally compare any projected or screen-presented live-action program with their most familiar point of reference—movies and TV. The quality of the presentation hardware should extract the maximum quality possible from the medium. Video used in computer multimedia can now be presented in "real time"—the normal 30 frames per second—thanks to new standards in video data compression. In early multimedia designs and some of today's very content-dense programs on CD-ROM, a half speed or 15 to 20 frames per second is used to save data space. Most people don't find that objectionable. They are willing to overlook the somewhat jumpy image.

Even the best video projected on a huge screen will reveal the image scan lines and suffer in visual quality if viewed too close. Even electronically enhanced projection (such as scan line doublers and doubled-up projectors) will not equate the video image with a movie film image. Why use video for a large audience then? Most video on large screens is shown in meetings made up of people with a common reference and presents images made up of products, locations, or people familiar to the audience, or contains information they need so they also overlook the technically inferior image—the "home movie" syndrome: "She's purple and out of focus, but that sure is great old Aunt Clara."

The moral of Figure 2.5 is that content is more important than flashy production values—especially if you can't afford flashy production values. By knowing what an audience is used to seeing, raising the quality even a little bit will greatly enhance their experience. In some cases, the greatest creativity involves finding a way to produce the project at all for the available dollars.

A trap exists here, however. A client who ignores the heartfelt warnings of the vendor can achieve magnificently bad results.

Figure 2-6. A household utensils manufacturer was producing its first video wall. The client's point person was in charge of everything in the booth including the wall and the furnished video and photographic components that would make up the message. The wall was composed of nine 40-inch screens to form a virtually seamless projection surface. Unfortunately, the stacks of photographs required were product outtakes to be retouched for print use. The video was largely composed of VHS "screen grabs" taken from live cooking program clips showing the kitchen utensils in action. The final straw was the placement of the wall facing an aisle only 10 feet wide.

The budget was low. The pressure was high and numerous warnings by the producer went for naught. When the wall premiered, it was a success only because of its useful content, but viewers had to disregard the giant fuzzy video and lots of bad product shots to get at the message.

3

Organizing for Project Launch

It's important to review your own organization before you invite the multimedia folk into your tent. A few questions are worth asking.

Is your project team headed by a visionary?

Visionaries are wonderful, creative people who should be cherished and nurtured. Often, they are the company's creative outriders — always up ahead searching the horizon for new and dazzling discoveries. They are often given free rein to lunge fearlessly into the creation of the request for proposal (RFP) and to be the contact or point person for all the bidders. Given the responsibility of laying the ground rules for the project, they seek to put their own creative stamp on the project — to make it their own. The bidders are encouraged to dig deeply into their bags of tricks. The review committee following in the visionary's wake should expect to see a brilliant presentation by the bidder. The proposed project should contain panache and verve and state-of-the-art production values. "The budget? Just knock us dead and be very creative!" says the visionary.

In the visionary's heart of hearts, he or she prays that "creativity" will include ways to "knock us dead" within the confines of a stingy budget that must come from contributions of several departments — all of whom must buy off on the project before they release their precious funds. If he or she is a new visionary, there is naive certainty that the smiling bidders will be forthcoming with terrific projects for peanuts. If he or she is an old visionary, there is the desperate gamble that *this* time the greedy wizards

will come up with dazzling cheap ideas that can be sold to the empty suits on the fourth floor. There are no *very* old visionaries except those in outpatient clinics or cleaning car windows at busy intersections.

The truly valuable visionary is one who indulges the muse *and* keeps both feet firmly fixed in reality by informing the bidders that, while a maximum effort will be appreciated, creativity also encompasses the ability to offer the whole package for a price that would make a Scotsman smile. Do not discourage the visionary, but keep the choke chain handy for everyone's sanity.

How closely should the company staff be involved with the production?

Many times, an advantage results from creating a project team that combines the vendor's production staff and the company's staff. This speeds the absorption of the company's culture among the vendor's people and brings the company personnel into closer contact with the production process. This blending can serve to speed decisions involving elements of the project—but it can also cause conflicting orders when departmental politics and "turf" concerns creep into decision making. The vendor's producer and other members of the team are not being paid to help salve bruised egos, or to help one company manager bulldoze his segment over the top of less aggressive souls.

How important is the point person to the project's successful completion?

The ideal bridge between the company and the production vendor's team is the *point person* (project manager, contact person, lead person, or liaison) and *at least* one backup point person.

The ideal point person is high enough up the company flowchart to be able to make decisions, or to directly contact those lofty decision makers. The point person should fully understand the project's background, its ranking in the hierarchy of other projects that may be ongoing, and the project's ultimate desired result. The point person should be involved in the proposal process and should have the confidence of everyone on the company side of the table. From the vendor's point of view, the point person is a minor deity—the ultimate sign-off, the El Supremo. It helps if the point person is easy to get along with, open to ideas, positive in judgment calls, and—most important—*available.* Few things are more frustrating than a point person who can never be reached. But the very credentials that make a good point person also make an excellent executive—someone always in demand. The only obvious solution is to designate an excellent backup point person.

When a project has the luxury of two good point people, it is rich indeed. Interlaced with voice mail, paging, fax, e-mail, cell phones, and the Internet, the day of the "unreachable" point person is nearing an end.

What steps can you take at the beginning to avoid costly changes later in the project?

Changes — significant changes — late in the project can wreck a budget and endanger the project's deadline. If the elements to be changed have already been approved, the company must eat the redo dollars. (See C.R.E.E.P. in the Chapter entitled "Managing a Multimedia Project" later in this book.) Vendors worthy of the name offer *change notices* to clients. These notices spell out the impact in dollars and time on the project resulting from the requested change. A signature is required before the change is implemented by the vendor. Quite a number of changes deemed "important" by clients are shelved when the impact becomes known. Another effect of late-in-the-project changes is on the vendor's morale — especially in the ranks of those who must redo their work. Some clients thrive in a crisis mode, bounding from catastrophe to catastrophe, living on the adrenaline rush from dwelling near the brink. This is fine if their pockets are deep and their vendor's production team enjoys Maalox by the quart.

Some changes are unavoidable: the prototype product that becomes "unavailable" because it exploded during the final test; the executive who develops a wheezing cold just before the on-camera taping; the revolution that breaks out before the new banana republic sales office can be visited (don't laugh, it happened).

The project point person is the conduit through whom all good and bad news flows. Self-preservation for this person must include constant updating of all people involved in project input — whether that input is information, visuals, or their own bodies on tape. Keeping communication open with the personnel who are helping these inputs happen is critical. At the other end of the pipeline is the vendor, always eager and usually a bit anxious to be kept in the flow.

Statistics are one bane of everyone's existence. Statistics change. Everyone knows statistics change at the last minute. Parts of the project requiring the latest statistics should be built in such a way that they may be updated electronically right up to the last possible second. Planning helps eliminate, or at least cope with, those elements of the project that are subject to change — or scheduled alteration.

Minimizing changes is also the job of the vendor. A good vendor will constantly update its client concerning work accomplished.

Figure 3-1. There was a possibility that the CEO of a corporation might have to be in Taiwan to kick off a product introduction at the Taipei World Trade Center on the day he was scheduled to deliver an on-camera introduction to an important—and overdue—corporate image tape. Knowing this, the point person worked with the vendor to contact the Trade Center, which has an in-house taping crew on call. The script was faxed to Taiwan and when the CEO showed up, the TelePrompTer™ was ready. In 15 minutes the introduction was complete and on its way to the States, courtesy of the Taiwan Government at a cost of $US250.

Obtaining complete approvals throughout the life of the project is critical. Delineate that approval process in your RFP at the outset.

Has time been allowed for unforeseen delays?

Unforeseen, contingency— these are words that chill the blood of a potential client and yet, they are words used in most proposals. They are cover words that producers use to make clients aware that bogeymen do live under beds and can jump out at any moment. Usually they refer to bad weather delays, materials lost in delivery, illness of key personnel, a cattle stampede, or any act by a deity or the post office that could delay script approvals, chief executive officers' on-camera appearances, product availability for photography, sales statistics, photography of a specific manufacturing process, and so on. About 10 percent of the total budget is usually set aside to deal with these ambushes.

Unfortunately, many of the unforeseens are created by the client. There are many elements to keep track of as they are fed to the vendor to turn into a multimedia project. Scheduling events is the biggest bear trap. Senior officers are tough to pin down for on-camera taping or voice recording. But, as mentioned earlier in Figure 3.1 with the Taiwan taping incident, you learn to lead these busy people like you would shoot a skeet target with a shotgun — or set aside a war chest of dollars to cover misses.

Scheduling interactions between vendor specialists and key company personnel must also be meticulous. For example, training designers must meet with the people who will be trained as well as the people who are requesting the training in order to develop an analysis that reflects the real needs and a path to provide those needs. This process is time consuming but critical in any interactive project. Miscues in scheduling are very costly to deadlines in these complex projects where each element builds off another. The domino effect has derailed many a carefully crafted budget.

Another unforeseen is the prototype-to-be revealed that suddenly becomes unavailable. If possible, consider alternatives: designer renderings, mock-ups, CAD drawings — anything that can substitute at the last minute.

Dealing with the company advertising agency or internal computer graphics department can also lead to mind-numbing unforeseens. Graphic art that exists, such as logos, elements from advertisements, and statistical graphs, can be incorporated into multimedia programs, saving the cost of having the vendor's artists re-create them. The unforeseen that arises is the method of transfer to the digital or video environment used by the vendor. Clients have made assumptions that since a piece of artwork exists as a computer file, it can be translated straight across into a computer-based project. Alas, there are a number of software tools

Figure 3-2. A client notified its advertising agency that it would need to make available a photograph for video animation that had been conveniently built up in layers using Photoshop software by Adobe. The agency accomplished the job and asked no further questions. When the photograph showed up on a floppy disk, it was duly fed into a vendor's graphics department computer. No layers. Animation would now be very costly because of the process of separating each element and isolating it. A phone call to the agency netted the puzzling insistence that the correct layered file had been sent. Just before hanging up, the agency rep queried "You are using Photoshop version 3.0 aren't you?" Alas, no. The vendor's versions stopped at 2.5. The freelance designer assigned to the project earned several hundred dollars extra, because he happened to have the updated version of Photoshop on his computer at home.

available to create and transfer artwork and computer graphics. Before any assumption is made, if the vendor is alerted to the graphic element's format they will be able to budget for its inclusion in the project and plan for executing that transfer. Is the artwork a flat art rendering, photostat, 35mm slide, transparency, or computer file? If it is a file, then what software was used to create it — and what *version* of that software? This "version" business can be critical if the features used in one version do not translate into a later, or earlier, version.

To ease this particular unforeseen, put the vendor or would-be vendor in contact with the people in graphics or at the ad agency and allow them to exchange tech-talk. If you are uncomfortable with that approach, then have the graphics people and agency people write out the specs of the artwork and have these specs available as a fax for bidders or, better yet, include it in the RFP. Bids will then accurately reflect the cost of the process.

- *Unforeseen statistical changes:* Depending on what department provides them and what department interprets them, statistics, as previously mentioned, are in a constant state of flux. The saving grace is the ability to set aside a flexible part of the media to allow for statistical changes right up to the absolute last second.

- *Unforeseen proprietary complications:* Special proprietary manufacturing processes that have been written into the script usually require a number of sign-offs and supervision at the time of taping or photography so as not to reveal too much to the competition. Having the sign-offs in hand and the needed supervising technicians on hand when the cameras start grinding will eliminate that particular unforeseen.

- *Preparation for dealing with deadlines:* This may seem a condescendingly simple issue for grown adults who came up through any school system, but something happens to most people after they leave college, or when they join the workforce. Time becomes a plastic, amorphous thing to be shaped to the needs of the moment rather than the precisely ticking measurement used to mark the beginning and end of events. In a basketball game, the clock is critical down to the second. People scramble to get their taxes in the mail by midnight, April 15. The start of the New Year is a countdown.

But our daily reckoning of time more often becomes "See you at two-ish, okay?" The daily planner and those personal digital assistants have gone a long way toward helping us manage our business lives, but still, deadlines for certain events to be accomplished somehow fall through the cracks. Every project is usually accompanied by a production

Figure 3-3. An interactive trade show program had been prepared for a client and all was running smoothly until the time came to load the program into the client's show computers and test the systems. Unfortunately, the computers were still in a truck parked at the last trade show. The person responsible for the computers had no backup assistant and was living in a world of pure stress during this nationwide cycle of shows. Without a chance for a preshow system test, a programmer hired by the vendor was flown to the site of the last convention, put aboard the truck with the computers, and during the long, cross-country drive managed to load the program software into each computer. The system test was carried out at the show venue and to everyone's great relief, everything worked. Additional cost to the project worked out to $3000 including airfare and hotel accommodations for the vendor's programmer.

Figure 3-4. The company was a manufacturer of speaker grilles for radios. Three days of videotaping had been scheduled two weeks in advance. The day before the shooting was to begin, the company point person suddenly realized the manufacturing area looked like the Black Hole of Calcutta. This shortcoming had been tactfully explained by the producer and director during the site survey a week earlier, but the dawning was slow to come.

To his undying credit, the point person was resourceful. He organized two teams. One team painted, the other handled smocks. The video crew started in the R&D lab, which looked pretty good. By that time, the Painting Team had stroked and splashed new paint over the walls that would be in the shot. The Smock Team dressed the workers in blue smocks. As the video crew taped that shot, the Painter Team moved to the next area, slathering away with brush and roller. As the video crew left the first area, the Smock Team moved in, snatched the smocks off the backs of the now videotaped workers and pounded down to the next area to dress the awaiting staff who were now standing in front of bright wet walls. By the end of the shoot, the teams were in a state of collapse, the factory looked like a crazy quilt and the smocks were rags, but it all looked great on tape.

schedule charted out by the vendor. This schedule lists all the events and their place on the time line from project beginning to project end. For a proposal that has received minimum guidelines, the schedule should at least show the elements, who is responsible for each, and the date they are due. A schedule is usually arrived at with the help of the client point person and is that person's bible for the project's duration. This document should be shared with and copied to every member of the client project team.

Missed deadlines are as bad as unforeseen problems in causing the domino effect as missed dates are reshuffled and time to complete dependent events becomes compressed. If the project's wrap-up date is literally carved in stone, then the crush caused by missed deadlines squeezes available hours to complete tasks into the dreaded time-and-a-half and double-time regions where no man treads without a wide-open checkbook.

Has everyone who will be involved in the production been notified in advance?

Sometimes in the opening stages of a planned project when the blood is high and anticipation great, it is not difficult to overlook certain nitty-gritty details such as letting the supervisor of the fourth shift at Plant 2 in Scranton, Pennsylvania, know a video crew will arrive at start of shift to shoot the Smartfingerfulcher Flimet Grinders. Anyone who has had to feed a video crew for an extra day in a strange city while the Amazing, New Flimet Grinders are located/repaired/painted green/whatever has an idea of accelerating budget costs.

This holds true for anyone who will be directly involved in elements of the project that require providing such essentials as graphics, products or people to videotape, locations, transportation, translation into English, or passes waiting at the security gate. For want of a nail many a project has suddenly found itself in real danger.

4

And, Finally, Help for the Jargon-Challenged

Traveling in Egypt a few years ago, I watched tourists bargaining with peddlers under striped awnings that flanked the narrow street of a Cairo bazaar. The noise level in the densely crowded space was very high. Everyone seemed to be shouting at each other. The non-Muslim tourists seemed to think that shouting English slowly would create understanding. All it created was the need for the poor vendor to have to shout back unintelligibly in order to be heard. Actually, a sale could be conducted in absolute silence using gestures, a bit of mime, and good humor. You just needed to know the code.

Dealing with the unrepentant techno-hip is often like speaking Urdu to a Georgia drag racer. Worse than not understanding, however, is convincing yourself that you do. And worse than that is leaving an impression with the Urdu speaker that you have grasped his heady concept.

Jargon is the code of the self-anointed novitiates who have steeped themselves in any pursuit to the point where they can carry out deep philosophical and technical conversations that, to the uninitiated, make pseudo-sense. The words and terms used are not unfamiliar. The spin put on the words and terms by the cognoscenti, however, can be 180 degrees away from common usage.

A simple example is the word *platform*. This is a common word, usually meaning a raised level surface on which to stand, or place something. To a politician, it means a listing of the party's adopted political tenets. To a multimedia designer, it means the computer system that

will use the created program: "The program can be used cross-platform on a PC, a Mac, or on UNIX."

Dealing with jargon at this early part in the book may seem out of place when most unfamiliar or technical terminology is usually relegated to a glossary at the end of the book amidst the wrap-up small print. Since this is a relatively short list, I think it serves the reader better to place it upfront. To attempt to explain *all* of the jargon used in multimedia-speak would defeat the purpose of this book. It would be mind-numbing. But there are a number of terms that are common coin to most multimedia projects. Just a few are offered that can be written on a shirt cuff as needed. They are in order of alphabet, not in order of importance.

AD/DA This is an analog-to-digital/digital-to-analog converter. This "black box" bit of hardware converts video signals so they can be used in either analog (videotape, LaserDisc) or digital (computer processed video clips for multimedia, still frames, and graphics) formats. Example of usage: "We'll need an AD/DA converter for this transfer and it will cost $250 a day to rent."

Audio video interleave (AVI) This is basically a storage file format that arranges video and audio files on your disk in a space-saving structure. The files are "interleaved" as follows: Video for frame number 1 is followed by audio for frame number 1, then follows video for frame 2, followed by audio for frame 2. Before the .AVI file structure, audio and video files had to dwell in separate locations on the disk. The .AVI format frees the programming from jumping from place to place all over the disk in search of audio and video files, hence making access faster.

Authorware While "Authorware" is the name of a software program used to develop multimedia applications (*Authorware Professional* for Authorware, Inc.™), it is also a generic term referring to any software used to create multimedia applications such as interactive kiosks, training programs, sales presentations, animation, and software demonstrations. Another type of authorware is *presentation,* or *run-time,* software. These programs are a miniature of the development authorware with just enough instructions to allow the multimedia result of the authoring process to run on any computer even if the original authoring ware is not resident in that computer. Some presentation software allows presenters to reorganize the authored program depending on the target audience.

Bandwidth The range of frequencies available over which sound or video may be transmitted. The narrower the bandwidth, the more limited the number of frequencies that can be sent or received, and the lower the quality of reproduction.

BMP format This is a graphics bitmap format that saves images according to their bit pattern. The images are composed of pixels containing a color component that can be one bit (black) or 24 bits (true color) wide. Microsoft Windows makes the greatest use of bitmap images.

Buttons Programming slang for any icons or words designed into the multimedia user page that, when clicked on with a mouse, perform some function.

Clip art Any artwork selected from a catalog of predrawn images to fulfill a graphic design need. The right to use these images is purchased along with the catalog. Clip art is an inexpensive alternative to custom-drawn graphics.

Cross-platform Software developed to work in a number of computer operating system environments, or "platforms," such as Apple, PC, or Unix.

Data monitor Most multimedia is designed to run on a computer data monitor that allows high resolution. CD-i and LaserDisc programs are the exception, both being originally created to operate off standard television screens. When considering monitors for the delivery of multimedia material there are a few factors that will be bandied about.

We'll take a break from the glossary list here to discuss monitor characteristics.

Resolution is the ability of the screen to reproduce detail measured by the number of scan lines it wipes across a full screen surface. VGA is a level of monitor screen resolution corresponding to 640×480 lines. This is the lowest standard resolution for most data programs. Super VGA is more suitable, allowing 800×600 — the minimum video mode for running Windows, or 1024×768. The refresh rate of the screen determines how often the scanned lines of color dots are replaced by the next set of lines. A computer image is literally "painted" on the screen one horizontal line at a time. A noninterlaced screen paints from top to bottom so quickly the eye cannot detect the process. The image appears rock steady, but the process takes a while (in computer time, it seems, anything that takes more than a billionth of a second to complete is total tedium). An interlaced scan system speeds the process by scanning the odd lines on one pass, even lines on the next. The downside to this increased speed is a noticeable flicker to the image, especially after a couple of hours peering at it.

Next comes *dot pitch*. The scanning process that paints the lines of color dots across the screen passes through a black mask riddled with tiny holes. These holes determine the size of each color dot and its sharpness. The lower the pitch number, the higher the resolution of the

dots; that is, a .28 dot pitch screen is sharper than a .40 dot pitch screen. Although a .40 dot pitch screen would be cheaper, using it for any length of time would be grim business for the eyes.

Monitor screen size is the final consideration. Most home computers offer a 14-inch screen with about 12 inches of actual viewing area. For multimedia, especially in training situations, a screen size minimum of 15 inches is recommended with 17 inches being optimum. Many multimedia programs are created in very high resolution environments, providing rich detail and much screen information to digest. The larger the screen, the less eyestrain over hours of use. It would be a shame to create a visually rich and creative multimedia project, then squeeze it down into a matchbox viewer.

Summing up, a 17-inch Super-VGA, noninterlaced, .28 dot pitch monitor screen would be an excellent choice for most applications. On the other hand, a cheaper 14-inch, VGA, interlaced, .40 dot pitch monitor would make employees eligible for workmen's comp.

Similar considerations hold true for laptop computers, but the common display type is the LCD (liquid crystal display) screen in which each picture element, or *pixel,* is already physically present on the screen and is separately addressed by a transistor in the computer's display chip as to brightness and color rather than having a "gun" scan the picture on the screen.

The LCD screen is being further developed as a desktop display monitor featuring a very thin, flat screen. Until now, the clunky CRT (cathode ray tube) has dominated computing, dating back to those text-only black-and-green monitors of the early 1980s. By the time this book is published, manufacturers such as Sony, Mitsubishi, Sharp, and Tektronix will probably have raised the bar considerably in the race for thin, big screens as well as the long-sought-after personal multimedia player that CD-i developers and Apple have been pursuing. LCDs, which use liquid crystal elements pressed between two sheets of glass and gas plasma, make use of neon gas and phosphors and are the main media for this flat screen technology. Gas plasma has the edge since its screen more closely resembles the familiar CRT monitor. Both Sharp Electronics and Mitsubishi predict 20-inch LCD flat panel displays and 40-inch gas plasma television screens will be available for users with deep pockets.

Another possibility is a hybrid gas plasma-addressed liquid crystal called the "Plasmatron" being built by Tektronix and licensed to Sony. This system uses single transistors for each scan line rather than each pixel. A lower part count means cheaper production and a higher man-

Figure 4-1. This monitor business brings back the memory of a friend who started out with computers back in 1982 with a simple, 12-inch green-text-on-black monitor. By 1984, he was ultracool peering at an amber screen, the height of chic. When the first color monitors came out—14-inch Amdek .60 dot pitch—he had to have one of those. In a year, he had upped his eyeglass prescription twice. Then came Microsoft Windows and everyone was into color screens. He moved up to the best Zenith flat multisynch screen that was the ultimate in monitors. A second computer sported the sharpest NEC multisynch monitor made. He purchased a 32-inch Sony Trinitron for his television viewing. When last seen, he was perched in front of a 24-inch picture window of a data monitor. Unfortunately, he found he had to sit about four feet away from it because the radiation blasting through the glass was beginning to crisp his shirtfronts and cause his eyebrows to fall out. Can you imagine having to put on a No. 15 SPF sunblock just to work with your computer?

ufacturing yield. Sony has been parading this concept around trade shows since the summer of 1995 and expects to test the consumer market with a 40-inch television screen in the very near future.[1]

Multimedia developers are keeping a keen eye on these screen developments because display environment and portability are major factors today. In a few short years, content on the Internet and that delivered from CD-based media will have taken an exponential leap forward, allowing lighter and cheaper delivery systems to display much greater depth in sound and images.

Delivery system This term refers to the media, both software and hardware, used to present a multimedia program to a user. Examples of delivery systems include computer, videocassette player, video wall, and the Internet.

Digital video interactive (DVI) Digital video at one time could only be accomplished using a special circuit board after the original analog video had been sent out to be digitally processed using a proprietary processing and compressing system created by DVI. Today, standard video processing formats such as MPEG and MPEG-2 digital video processing and compression is available through video "capture" boards in your computer without having to send your videotapes to a factory.

File compression/decompression Multimedia programs with their graphics, still photographs, video clips, animation, text, and audio — both voice and music — are often memory intensive. They take up a lot of space on a hard drive and can fill the 650-megabyte capacity of a CD-ROM. To make the best use of storage real estate, large files can be compressed using special algorithms and then decompressed for use as they are needed.

Frame grabber The ability to grab a single frame of analog video, digitize it, and hold it in a buffer for use in creating a multimedia screen. Consecutive images, such as live-action video, cannot be grabbed.

GIF format The Graphics Interchange Format (GIF) is another common graphics file format. While it is compatible with many types of systems and platforms, it can only handle up to 256 colors. GIF files are frequently used on the Web because they can be launched on any Web page with a minimum of programming.

Graphic file names Probably the biggest hassles occur over graphic file names. Sometimes, a number of different graphics-generating programs are

[1] Martin Levine, "Flat Feats," Technology Watch Column, *Multimedia Producer Magazine,* Knowledge Industry Publications, White Plains, NY, April 1996, pp. 79–80. (NOTE: This magazine is now called *Video and Multimedia Producer Magazine.*)

used in the creation of a multimedia project. Part of a chapter is devoted to this problem later in the book. They can be recognized by their file name suffixes: .GIF, .TIF, .BMP, .PM6, .EPS, .PCX, .TBK, and others. Inclusion of these file name suffixes is critical in any conversation or on any memos pertaining to graphics data. Some files can be easily converted from one file type to another. Some file types can be used for print as well as video. Others definitely cannot. Subtleties must also be observed. For example, there is a .TIF format for a Macintosh and a .TIF format for the PC when you save a file in the Adobe Photoshop program.

"Hyper" anything Hypertext, hyperlinks — adding "hyper" to a word means accessing data in various locations by means of clicking on a "hot" word or icon. For example, if you are reading text that reviews a recipe and the ingredient "garbanzo beans" is a hyperlink, then clicking on it transports you to a complete description of the humble legume.

Internet provider This is a company that maintains computer servers that host Internet Web sites, or information that can be explored by other Internet "surfers" via modem. The provider sells you space on a hard drive for your information (Web site) and also bills you for any maintenance such as graphic or data changes, or any downloading of data from inquiries addressed to the site. Internet providers also sell access to the Internet and the tools needed to explore its contents (Web browsers) for a monthly fee.

MIDI files MIDI files (file extension .MID) are digital audio files that, unlike .WAV files, which store actual sound data, can store instructions on how to reproduce a sound. A MIDI audio circuit board card that fits in a computer has stored on it many synthesized sounds. Playing back a MIDI file is like operating an old player piano where the holes in the piano roll instruct which key to hit a string. The main difference is that the same digital instructions can work with a piano, a guitar, or a saxophone, all sounds included on the card. MIDI files are used primarily for music.

Morphing Short for *metamorphosing,* and also called *polymorphic tweening* (Animator by Autodesk, Inc.), the process provides graphic programming horsepower to change an image from one subject into another in a smooth on-screen transition: a hummingbird into a grizzly bear, Soupy Sales into Richard Nixon, etcetera.

MPEG This acronym stands for Motion Picture Experts Group and refers to a standard adopted by the industry for digital compression and decompression of video. Digital video takes up an enormous amount of real estate on a hard drive. Without compression, one two-hour movie would require all the space on 2000 100-megabyte hard drives, roughly 180 gigabytes (193,273,528,320 bytes of data). The MPEG and MPEG-2 standard allows

digital video data to be squeezed into a much smaller space by using data in one frame of video to calculate what will be in succeeding frames without storing every frame. This process is called *predictive calculation.*[2]

Navigation A term used to describe moving about in an interactive computer program. You can navigate by using a mouse interface, by clicking on successive screen icons, or by using keyboard arrows to move up and down menus to proceed from where you are to where you want to be. Complex programs that use "nested" menus usually offer navigation aids along the way in the form of buttons that allow you to retrace your steps and not get lost.

Quicktime video These are Macintosh video files that are unique to the Apple platform. MPEG files are used on the PC platform.

Real estate This is another way of saying available memory for storing data. Because most digital data are saved on a hard drive, or disc such as a CD-ROM, the surface area is considered to be real estate. An example of the use of this term would be "That program takes up a lot of real estate."

Sampling When a digital audio .WAV file is recorded, the quality of the final product is determined by how often the music or sound source is sampled by the digital recording system. A tone that is sampled 1000 times will be reproduced more faithfully than a tone sampled 100 times. Low sample rates sometimes offer adequate quality for the audio requirement—a telephone quality voice, or AM radio quality music—and they take up less real estate in the memory. High sampling rates produce FM quality sound and require more storage memory for that fidelity.

Server The name implies its function. The server is a slave computer that serves a number of remote computers as a communications center, software repository, and memory bank. On the Internet, a server stores client Web page data for modem access and can be a feedback collection site. Fees are paid to the owner of the server for storage space on a hard drive, connect time to the Internet, and for other maintenance services related to the user's Internet Web site. In a local-area network (LAN), the server acts as a storage unit for applications software and files that are generated by the users. It can also provide modem communications for remote input and output by network users. Educational facilities use a form of server to send CD-ROM and CD-i programs to classrooms via a closed network.

Sound card Every multimedia computer has a sound card installed in order to reproduce audio files accessed on CD-ROM, CD-i, or other media with audio capability. Some cards have MIDI files installed to create music; others make use of .WAV files for reproducing a wide range of sounds. The

[2] Ron Wodaski, *Multimedia Madness,* Sams Publishing, Indianapolis, IN, p. 658.

sound card usually has accompanying software that allows editing and recording of audio material. Cards are rated by their audio resolution capability with the cheaper cards working at 8 bits, whereas faster cards with higher quality reproduction run at 16 bits of resolution at 44.1 kHz, the same rate at which CDs are recorded. Higher resolution and a kilohertz range do not always denote superior sound if the original recording quality was poor or if the card itself is "noisy," or was manufactured with loose tolerances.[3]

User interface This is computerese for "how you get at the program's information." Most CDs and interactive computer programs use a mouse or a touch-screen to make things happen. Others use some form of keyboard input to conform to menus, while entertainment-oriented software is often manipulated by a joystick or trackball. Today, virtual reality systems use sensor-packed helmet viewers, gloves, and whole-body suits to come alive in a personal cyberworld.

Employment of a particular type of user interface depends on the environment in which the program is to be used — and this environment is constantly changing. A very few years ago, any training or sales support project written for a laptop would have specified a keyboard interface. Today, virtually all laptops have a built-in or attachable pointing device similar to a mouse. In most cases, the interface used in a commercial environment will be the first thing that breaks. Joysticks have a high mortality rate due to abuse in uncontrolled locales such as malls. Trackballs work in a controlled environment where adult interaction is expected, but are subject to dirt and liquid penetration. For years, the touch screen has been the darling of the interactive set. The problem here is both mental (How many times did you have to be told by your parents not to touch the TV screen?) and physical since fingers that have been heaven-knows-where have been touching the screen all day, which results in a grubby-looking display.

As display and delivery units become smaller, the interface will become more challenging. Remember when personal digital assistants first came out with their itty-bitty keys? They provided a thoughtful stylus to poke at the keyboard. What was the first thing everyone lost? Manufacturing training programs sometimes use actual pieces of the process as input devices making the simulation very real and the result very satisfying. Back in the mid-1980s, interactive pioneer David Hon created a welding program that placed the video screen in a horizontal position and allowed the student to actually "weld" a bead on its surface. Knobs "controlled" the simulated blend of acetylene and air and a light pen was the torch tip.[4]

[3] *Ibid.*, p. 295.
[4] Gerry Souter, *The DisConnection*, Focal Press, Boston, MA 1988, p. 66.

Figure 4-2. When Disney World opened in Florida, a number of touch-screen kiosks were spotted around the park displaying maps and other pertinent information. To keep the displays clean, at intervals throughout the day an image of Goofy would pop up on the screen and his inimitable voice would say something like "Hey there, mind givin' my screen a little clean-up? Hyuk, hyuk, hyuk. . . ." Sad to say, some park goers thought a good way to clean a computer touch screen was to chuck a cup of ginger ale at it. After ungluing the guts of a few kiosks, Goofy was dropped for the elbow grease of a few park attendants carrying spray bottles and tissues.

Virtual reality This is a much-abused term in software marketing circles. Real virtual reality pertains to a 3-D environment through which the user's senses of sight, sound, and physical presence seem to move and interact with digitally created objects. To some marketing folk, any software program that allows user interaction with 3-D elements on a computer screen is "virtual reality." Other programs that incorporate a mechanically moving platform, seat, or vehicle that operates in synch with the screen elements also claim "virtual reality" kinship.

.WAV file This is a digital audio file composed of the data used to construct the waveform that reproduces any given sound. All sound is constructed of waves in the air: long and short, high and low. Once the sequence of waves that comprise a given sound is recorded, the end result is the *waveform*. Regardless of what kind of equipment the composite waveform is played back on, the reproduced sound will always be the same. Waveforms are digitally "sampled" when they are recorded. The greater the frequency of the sampling rate, the more data bits that are packed into the recorded waveform representation and the more accurate the reproduction. Windows-based programs can only read .WAV files.

WYSIWYG Pronounced "wizzy-wig," this term is an acronym for "what you see is what you get." It pertains to outputting any data that appears on your screen to, say, a printer. The printed matter will look exactly like the display screen. This comes from the days when word processors used codes to tell the printer to underline, or bold, or add any formatting embellishments to text. For instance, using the venerable CP/M Word Star word processor, you would hold down the *Ctrl* key and type *S* at the beginning and end of a word to show the printer that it should be ^underlined.^ WYSIWYG screen formatting changed all that.

5

Building the Request for Proposal

With jargon firmly implanted in the frontal lobe, or at least penciled on the sleeve cuff, one final knowledge check should be made to see if all your assumptions are valid before shipping out the request for proposal (RFP) document. We could touch on an infinite number of production specifics, but an overall view of the more obvious preconceived pitfalls can serve to illuminate shaky assumptions.

VIDEO PRODUCTION ASSUMPTIONS

Many corporate project planners believe they understand the video needs of their project since it is such a familiar medium. Common sense would seem to dictate several truths about production requirements. Having spent many years untangling these assumptions about video needs, I have chosen them as an appropriate example of some of the pitfalls that you might encounter during the RFP process.

Do you believe that on-location production would be cheaper than studio production?

When a corporate team is put in charge of getting their arms around a particular bit of media—videotape for example—erroneous preconceptions can cost dollars if not reversed by a knowledgeable vendor. One of these preconceptions involves taping a program on location as

opposed to in a studio. For an on-location shoot, all you need is the camera crew, camera, and a few lights—it all seems so simple. Why spend money to rent a sound stage when you can use real life? Location shooting provides immediate visual reference for the audience. While a company office "is" an office, a set in a studio must "suggest" an office through elaborate (read "expensive") artifice. No contest, right?

Au contraire. Location shooting is a thief of time and time equals dollars. Objects and people in their proper environment must be translated into the somewhat restricted *video* environment. Here, things cannot be too dark or too bright. They are not always in focus and sometimes don't all fit in the same frame. In video, we are viewing the world through a very selective knothole. Reality must be stuffed through this knothole in order to produce what is acceptable to viewers. To accomplish this, we need, among other things, carefully balanced lighting and a carefully selected frame that eliminates elements that are irrelevant to the needed image. Control of the surrounding environment to eliminate intrusions on the shot is vital.

Location video or film is shot with either synchronized sound, or silent (called *MOS,* which stands for "mit out sound" and comes from a German director who worked in the transition era between sound and silent films: "Ve vill shoot dis one mit out sound!"). This silent taping is also called *B-roll* and is the easiest form of location shooting. "Mit sound," however, is another matter. Taping a dialog scene near the airport's busy traffic pattern has been known to drive high-strung directors to distraction. While local sound intrusions can be controlled ("Quiet please!"), intermittent distant sounds are usually uncontrollable.

So what if a car goes by? Cars go by in real life. This is true, but if a line of dialog spoken by an actor is spoken while a car is going by and the script calls for another angle to be shot of the same line, then that car going by had better be there a second time as well. It is a distraction, a puzzling time lapse to the viewer. It is similar to the shots in a film where the camera cuts back and forth between two people at a table and between them are two drinks. Someone sipped from one of the glasses between takes and now as the camera cuts back and forth, the level of one glass magically goes up and down.

In feature films a whole industry has grown up around replacing dialog, adding effects, and removing unwanted sounds digitally. These processes cost vast sums of money, but then movies today cost millions of dollars.

To repeat, location reality and video reality take time to balance and equate. Shooting in a studio allows video reality to be created made-to-order with totally flexible lighting, art direction, and audio within the

Figure 5-1. We were shooting a video for an outdoor grill manufacturer. Everything was progressing well when an elderly neighbor three backyards away started up his lawn mower. The sound man rolled his eyes and shook his head. We waited a few minutes, resetting the shot and the mower coughed to silence. A big sigh of relief went up. The shots resumed and then the mower came to piercing life once more. With the sun arcing toward late day, we shot expensive talent barbecuing between sputtering fits of screaming lawn mower. Finally, the apoplectic director dispatched an assistant to see if the elderly gentleman could be "helped." It seems the mower's throttle linkage had broken and the resourceful senior had been using a pipe cleaner for repair, but it would work loose and have to be replaced. The assistant and two grips spent the better part of an hour repairing the linkage with odds and ends from the equipment van. With the necessary shots completed and the light fading into dusk, the crew waited patiently—at time and a half—while a grip finished mowing the old man's yard as part of the deal that had been struck.

set's soundproof confines. This is not to say that studio shooting is better than location shooting or cheaper to produce. The implied warning is to keep an open mind and be guided by the video production vendor's experience. Even in Hollywood films when outdoor conditions become intolerable, a backup set is often available to shoot interior scenes until outdoor conditions improve.

Do you believe that company "talent" can be substituted for "professional" talent to save money?

Hey, Bob in Financial could introduce this program. He's great. You should have heard the story he told at the Elks Club last night. . . .

Company "talent" is the first stop on the list of cost controls. After all, the company people know about the product/service/corporate goal/job skill, so they should be able to talk about it. Sometimes there are surprises and a shy accountant suddenly blossoms in front of the camera. But what usually happens is the opposite. A consultative vendor, having lost the battle over using company talent for long dialog scenes, tries to help. There is the TelePrompTer™, which fits over the camera lens and allows the talent to read the scrolling script reflected in a tilted glass while appearing to look at the camera. This takes some getting used to. Directors spend time between bad takes saying ". . . next time try to blink once in a while" to the glazed android peering myopically at the camera.

Another aid is the off-camera flip chart with key memory joggers written on it in big black pen. This chart inadvertently becomes a lifeline to someone who actually knows all the points backwards and forwards. As they speak, their eyes dart over to the chart, then back to the audience. This sidelong sneak-peeking makes them look shifty-eyed and untrustworthy. Finally, the last bastion for the director taping interviews is the *60 Minutes* style. Here, the interviewee looks off camera at cue cards or a scrolling monitor screen and speaks to an unseen interviewer rather than to the audience. This is a familiar technique and acceptable to most audiences.

Everyone remembers the scene in the film *Broadcast News* when the journalist finally gets his crack at the news anchor job. He sweats rivers. Nothing is less sincere on camera than a sweating, stammering company representative trying to do the job of a professional. On-camera professional talent costs dollars, but after take 15 when the company person still hasn't got it right, those dollars seem worth every penny.

Company talent is another thief of time and, as stated earlier, time equals dollars. Where professional talent can be used, substituting company personnel almost always results in lost time and budget overruns.

Figure 5-2. A computer company was announcing a new industry standard in computer construction that they had helped pioneer. The company president was accustomed to speaking in front of cameras and delivered his overview with the suave aplomb of a seasoned pro. He then introduced the project's chief engineer to "... fill in the details. ..."

Heavily dabbed with powder and panchro makeup to hide the beading sweat, the engineer was seated behind a prop desk to work from his little pile of index card notes. The sound man suddenly made the sign of "cut" by passing his finger across his throat. Baffled, the director, who thought the shot had been going well, took the headset from the sound man and listened to the replay. Under the words of the engineer was a rhythmic drumming sound: "... boom, boom, boom, boom ..." on the audio track. Puzzled, the director started the shot again and, this time, he could hear it himself—a faint and muffled "... boom, boom, boom, boom. ..." He called "cut" and asked the engineer to begin again, but this time did not roll the camera. In a moment spent prowling the set, he located the drumming sound. The engineer, in his nervousness, had been unconsciously thumping his knee against the inside of the hidden desk leg in a palsied spasm that began when the director called "action." Moving the desk six inches allowed the engineer to continue his little seated dance in silence.

Figure 5-3. The scene was a simple one. In a major tire manufacturer's store, the photo-model extra had to ask a tire salesman, "How much is *this* tire?" pointing to a specific, no-name cheap tire. How many different ways can a person ask "How much is *this* tire?"

Seventeen takes later after a third rerun of "*How* much is this tire?," which came before the fourth rerun of "How much *is* this tire?," the director called for a break. The exhausted extra looked at the small stack of tires with glazed eyes, bent down, and with genuine curiosity peered at the second tire from the bottom and asked the salesman, "How much is *this* tire?" We all want to believe the camera was left running so let's just say that's what happened.

One last point: Hiring bargain-basement talent can also backfire. Professional photo models in the Sears catalog level of performance are always cheaper than actors. Sometimes they are paid as extras to fill a scene with beautiful demographic people of every known race, creed, color, and shoe size — but giving them lines can be a disaster.

Do you believe in the cost per minute or per second (CPM/S) estimate?

Once upon a time, when the world was a simpler place and a film was a film, or a slide was a slide, and to produce each required certain fixed steps and costs, you could roughly estimate projects by *cost per minute.* Then, things changed. A 30-second broadcast commercial can cost $100,000 ($3333 per second) and a 20-minute training video can cost $20,000 (or less!). Today's incredible palette of tools and approaches to any given project is so broad that no real standard is possible. The CPM/S method of *estimating* what a project should cost is as arcane as the casting of runes.

The CPM/S method does have validity when *comparing* bids that offer the same approach. If bids A and B both suggest using MacroMedia Director™ software to produce a multimedia new product display and the materials they will receive from the company are identical as is the screen time of the presentation, then a cost per minute (or second if it is short) comparison can raise some valid questions.

CPM/S is also used by the vendor as a presubmission logic check anticipating the client's question, "What does that work out to in cost per minute?" Asking this question at a proposal review has as much validity as kicking the tires of a new car. Later, with all proposals in hand, CPM/S can be used as a quick math exercise to divide the proposals roughly into low, medium, and high costs (budget/minutes or seconds = CPM/S). Then they are examined closely to see what you get for those dollars.

Animation of any type is usually proposed at a cost per second. It is so expensive, it is normally used sparingly in business multimedia projects.

COMPUTER PRODUCTION ASSUMPTIONS

Assumptions made in the computer production venue are performed in less familiar ground than video because of the vast number of variables in computer programming and construction. Much of what happens with

Figure 5-4. A programmer was hired to encode a client-driven design for a computer-based training program to be distributed to dealers around the country. The program would be reissued via floppy disks each time a new product was introduced. Despite warnings from the vendor producer, the programmer assumed the client's design could be simplified and constructed the bid accordingly. The client, however, was adamant that the design be followed to the letter at least for the first edition. The programmer plunged ahead and, suffering from severe coffee-nerves, delivered the program. Later, when a new product required a new edition, it was discovered that the programmer, to save time, had simply "hard-wired" instruction sets that should have used reassignable variable names. This inflexible but expedient method required prodigious recoding. Another programmer stepped in and redesigned the entire program (at the vendor's unbillable cost), which delayed the release of the second edition to the client's chagrin. Eventually, the project ran to nine successful editions and the early teething horrors shrank to only a small nightmare in everyone's memories.

the computer production part of a multimedia project happens behind closed doors — and not just because many computer specialists lack certain social skills to be allowed near a client. Computer work takes concentration and a degree of isolation to accomplish. A missed mouse click or incorrect keystroke can scuttle hours of work. Certain truths, however, if known and appreciated, can lead to fewer surprises down the line.

Computer programming time/cost estimates require equal portions of optimism and reality. Combining all the elements into a cohesive whole that will perform exactly as expected by the user at the computer interface is the job of the programmer. At the first meetings of the vendor's team, the client's RFP, the vendor's creative solution, and the project deadline are discussed with the programmer who is not simply a receptacle for information, but a creative partner in the process. The methods by which the information is coded, retrieved, and displayed is worked out between the project designer and the programmer as a team. Often, the designer *is* the programmer working with a copy of the production *shell* software such as MacroMedia Director™, which does not require a knowledge of a true programming language such as C++.

Programmers deal in lines of code and by nature and by training are very precise when they are working. They cannot and should not be rushed. Good programmers build the project in modules that are connected to form the final program. These modules can be modified individually as changes are required. Often, the programmer has libraries of small modules that can be fitted into place as *stock* routines, preventing much code rewriting and debugging. These specialists are usually very inventive. To repeat, they cannot and should not be rushed.

Major concept changes, or assumptions concerning the availability of elements for inclusion, or assumptions concerning compatibility with company computer operating systems — production questions that have fallen into deep cracks — can explode into horrendous cost overruns at the programming stage. Programmers tend to be cautious when they offer up an estimate of time required. Good ones allow a fudge factor and state it as such. Others bid low hours and assume they can compensate for any changes with all-night crash sessions to explain the additional dollars in the bill. Delay of release, however, can be a greater problem than the cost of coping with change.

COMBINING VIDEO AND COMPUTER IMAGES

Having outlined some production truths in earlier sections, it is comforting to know that these two divergent elements — video production and computer design — are becoming increasingly compatible since

real-time (30 frames per second) full-screen video has become commonly available in digital media. When video was the weak stepchild, jerking along at 15 to 24 frames in little screen windows, because of the real estate it required on the disk, computer designers always felt the need to apologize for it. Now, because effective compression techniques have become available such that video is no longer a dominating real estate hog, video producers for multimedia are in big demand — especially those who understand the restrictions that are imposed.

Employing video in a program today does require some planning. A knowledge of the technical process of putting video clips into a computer-driven program is not necessary for the client, but an awareness of special considerations required for video insertion helps the client understand future discussions as the project is under way and provides guidelines to production assumptions.

Two visual cautions arise when contemplating the use of video clips. One is image size and the other is palette, or color range. The ability to use full-frame video in a multimedia program requires the video production staff to approach the shoot with the highest quality image acquisition they can provide. Full-frame digitally compressed video does not look as good as straight video right off the tape source. It can't, because the computer can only process so many pixels of resolution data. Clients who must display highly detailed renderings of products as part of their sales plan or customer image are best served using the analog LaserDisc as their cinema or video media source rather than any digital representation.

Confusion enters here when clients hear about Digital Beta SP™ tape and *tapeless digital editing* where all video footage is digitized into files and stored for editing in a system such as the Avid™. Yes, this technology is the editing procedure of preference for production houses who can afford the hardware. It will probably replace tape editing completely in the near future. One requirement to achieve this high-resolution tapeless editing is a very fast microprocessor and at least 9 to 10 gigabytes of storage capacity. Since a CD-ROM holds about 650 megabytes of data, it is easy to see that digitizing all of the information in video signals into computer pixels requires a huge amount of data space.

With a smaller video image designed into a screen *window,* the digitally processed video file using fewer pixels looks better, but another size consideration requires collaboration between the computer-oriented multimedia designer and the video production people. Now we are looking at the size of the subject matter. Here, we have a split mind-set between filmmakers and videographers. Filmmakers have always been

accustomed to the silky sharpness of their images when projected on a large screen. Audiences love sweeping vistas—especially in large-format film such as IMAX™, 65mm, and Super 35mm. The close-up in these formats is jarring in its crisp detail on a 60-foot screen. Videographers, on the other hand, have always lived with a small television screen. In most companies, the conference room VCR screen is 20 to 27 inches in size. When you think in terms of multimedia being shown on a 20-inch screen (or even a 14-inch computer monitor) you can see that visual subtlety can tend to get lost among the digital pixels.

Before you ask for an aerial shot of the company's industrial campus, think of how it will look in a window as part of a 14-inch graphic screen with accompanying navigation buttons, the corporate logo, and other design elements. For best results, digital video appearing in a window should offer close-ups, single products, any visuals that make maximum use of the available space. Lighting should easily delineate edges and textures. People should be large enough to see the character in their faces and recognize their gestures. Close communication between the designer and the video producers will guarantee a good result.

Another consideration is color and brightness of the subject matter. Film can handle an almost infinite range of brightness from black to white with all the subtle shades of color in between. Video is limited to an electronically reproducible range. Upon setting up a tape for editing, the editor will put the reel's color bars up on the screen and adjust them until they fall with the preset calibrations of two oscilloscope-type monitors. Colors and brightness falling outside these calibrations will be "clipped" and "crushed." Bright highlights will show static noise on the video screen. Video producers have learned to light subjects to provide an acceptable range and to avoid colors that might "smear," such as bright red next to an electric blue, or a hot yellow next to almost anything. When shooting on-camera talent, even with today's most sensitive digital cameras, producers request that no white shirts or glittering jewelry be worn. Herringbone pattern jackets and thin-striped neckties seem to "crawl" because of the tight pattern of the fabric weave. Black velvet goes "dead."

These restrictions are placed on subject matter that will be presented on videotape. When you take the same restrictions and then digitize that video signal, compress its data, and squeeze it through the computer's skinny pipeline to the data monitor screen, the result is further degraded.

A piece of film or a video image palette is comprised of millions of colors. To reproduce it on a multimedia program, those millions must be funneled down to 256 colors in most programs. Next, if the graphic

screen in which the video window appears uses a warm palette of reds, oranges, and yellows and the video image is cool blues and greens, the range of total screen colors may be far too wide for an accurate or even pleasant presentation. The live-action footage must be coordinated with the overall design of the total screen image through close cooperation between the designer and the video producer.

Sometimes, the client, in order to save money — an admirable concept — offers up stock footage from the company vaults. If the footage comprises a major portion of the presentation, then the tail wags the dog and the graphic screen encompassing the live-action window must conform to the palette of the footage — a restriction that can severely limit the designer's choices. This caveat also applies to still photographs, either original or stock.

AUDIO ASSUMPTIONS

When computers first spoke, then played music, everyone was enthralled. Adding audio elements to a multimedia program brings one more of our senses into the experience. The use of .WAV and MIDI digital files provide us with audible clues to training sessions, remediation and explanation from content experts who appear in video windows, and musical and sound effects clips to enhance and entertain.

If audio is to be effective, it must be reproduced through a system that complements the venue where the multimedia is presented. The computer workstation in an average office has limited sound reproducing ability. It usually has a two- or three-inch speaker buried in the electronic guts of the box that can reproduce "sounds" such as a beep, a squawk, or a human voice that sounds like it is coming through a telephone — an old telephone held two feet from the ear. The use of stereo surround sound in a program that will be used in this environment is a huge waste of time and money.

This limited sound reproduction also exists for many laptops except for those multimedia models that have a CD-ROM player and sound reproduction chips built in — and even then the speakers are tiny out of necessity. Some models have an auxiliary stereo outlet for add-on speakers, if you're inclined to lug them around.

Virtually all multimedia computer desktop workstations sold today offer up built-in or attached speakers that are fed by a *sound card* capable of high-quality audio reproduction. CD-ROM and CD-i disks output superb stereo sound. Knowing the environment in which your program will be presented has a direct impact on the amount of disk real estate that should be set aside for audio. Three basic levels of reproduction are

Figure 5-5. A major automobile manufacturer contracted a computer-managed video wall as part of a large national auto show display that would tour the country. The display would feature any one of three cars depending on the manufacturer's choice at any given venue. Since the cars would all be shown in action shot on 35mm film, an equivalent audio track was ordered to point up the gutsy sounds blasted out of the exhausts of the roaring vehicles. No expense was to be spared in re-creating the cars' audio performance. The display builder incorporated 30-inch woofer speakers into the columns that supported the display area roof. Four LaserDisc players provided both the images and high-quality stereo sound. Following installation and testing, the client was very pleased with both the quality of the film images and the gut-thumping thunder of the engines. Unfortunately, the bass resonance of the huge speakers worked all too well. Manufacturers in booth locations on either side of the display began complaining that their water glasses and anything that wasn't tied down were "walking" across desktops and dumping on the carpets. Bits of their booths were coming undone and panels were separating. The management of the venue was concerned over the structural integrity of the building. Officials feared for attendees wearing heart pacemakers. Wanting to be good neighbors, but hating every minute of it, the client ordered the sound turned down.

(1) *telephone quality,* which takes up the least space; (2) *AM radio quality,* which provides good midrange reproduction; and (3) *FM radio quality,* which fills the air with CD level stereo sound and gobbles up a nice chunk of data space.

GRAPHICS ASSUMPTIONS

In the past, the graphics in a multimedia program were always the key attraction of a presentation. Back in the dusty days of multiscreen slide presentations, a phalanx of projectors went into full marching clatter, clanking through a number of static shots, photographed in sequence, attempting to simulate motion. Today, 2-D and 3-D animation is a no-brainer. Any good computer artist choosing from a vast collection of application software can cause logos to turn into products, feature/benefits to gallop across the screen, pigs to speak, and CEOs to become cunning cartoons, or vice versa.

The most common assumption concerning graphics in multimedia is "more is better." Just because there are so many ways of giving life to images of the imagination, of tampering with preexisting images, or of taking the ability to reproduce a palette of 16 million colors as a challenge doesn't mean we have to dig right down to the bottom of the bag. Graphics allow us to communicate visually those ideas that would require far too many words. They appeal to the visual senses as music appeals to the ear in order to create a visceral response. Graphics are a language. They use color, line, volume, luminance, and, when required, movement to produce an emotional and intellectual response. A single image can create a total concept. For example, two restaurants on the same block hang out their signs. One is neon and simply states "EATS." The other sign is scribed with sensual script reading "Ristorante." In a glance, you can visualize the respective menus, the price range, and the clientele. Graphic use in multimedia projects has the same effect. With the first screen, the visual treatment communicates the shape of things to come.

The most elegant examples of today's multimedia operate under premises similar to Mies van der Rohe's architectural edict of "less is more" and take a very tailored approach to the user interfaces. This means each image and the structures containing them appeal to the sensitivities and expectations of the intended user. In the presentation of language — and we're talking about the disappearing skill called *reading* here — a thick binder of legal pages with its numbered lines and meticulous syntax would scare away the average reader, but to a lawyer, this is the rich fabric of ideas that holds together our society.

While the legal page appears incredibly wordy to an untutored reader, the very use of language is precise in order to eliminate ambiguity. A haiku poem is a distillation of observation into a strict form, creating images in the mind using three lines, each containing five, seven, and five syllables, respectively. Each form clearly communicates its message to the reader. Multimedia graphics use must pursue its "reader" with equally elegant intent.

Another assumption most likely to create chaos rather than clarity is jumping on a trendy bandwagon. Every time a feature film hits the screen with a new and powerful special effect, within days of its release, multimedia developers — some in midproject — are besieged to somehow work that effect into the graphic design. Morphing is a good example. First came the films — *The Abyss* comes to mind, in which the water tentacle becomes the face of the person observing it — then the commercials on TV that turned tigers into automobiles and redesigned car interiors before your eyes and, finally, Michael Jackson reordered his pixels into numerous forms on a music CD. Before long, software application engineers made it possible for multimedia developers to morph everything in sight. Some of it made sense, but in a few months, the process became a cliché. Overuse also applies to zoom lenses, fish-eye cameras, the Steadicam, anything having to do with *Star Wars* and/or General Patton addressing the troops. All of these phenomena were dredged up again and again during the 1970s and into the 1980s. Today, they appear excruciatingly dated.

All advances in graphic imaging are tools to be used. Overuse turns them into insulting visual boiler plate, plugged in for the sake of decoration rather than to make a contribution to the project's effective communication. As noted elsewhere in this book, when proposals are returned from vendors that make use of multiple print fonts on each page, the overall look is that of a ransom note rather than an effective document. Employing trendy graphics for their own sake leaves the same impression.

A final assumption we'll touch on here is the mistaken desire to create fewer (read perceived cost savings here) screens by clustering information or query elements in staggering numbers of "windows" and pop-up menus. This is the "Is it an interactive screen, or is it a rat maze?" concept.

The use of "hot" buttons, pop-up boxes that go away when the user is finished with them, and simpler screen layouts can make training presentations comprehensive without obscuring both the query and the answer. The same can be said of game screens and multimedia that present the features and benefits of a product. Good graphics simplify and clarify the interface for the intended audience.

Figure 5-6. At a recent seminar given by an association of multimedia developers, a presenter for a multimedia think tank demonstrated a project created to teach telephone service personnel how to deal with customers. The teaching elements simulated a series of screens that would be presented to the service person offering all the possible customer complaints and queries. It was a monumental work involving two years of planning and the use of artificial intelligence (AI) tools. The result was a daunting presentation of menu boxes, pop-up graphic screens, and video windows that was a paean to computer programming and a testimony to what can be stuffed into the confines of a computer monitor screen. The process of building AI tools to solve the training problem seemed to have gotten in the way of presenting the solutions to the blue collar, high school educated employee who would use the system. While the project has achieved a degree of success, it has obviously perpetuated the need for rigorous prejob training.

Listening to van der Rohe, the planner of exterior space and his philosophy of "less is more," and adding Thoreau's dictum "simplify, simplify, simplify" applied to managing inner space, together suggest a winning guideline for multimedia design.

FINAL REVIEW

With some basic assumptions attended to, a final review of the project should be made before the RFP is shipped to the awaiting vendors.

- Do you have a general understanding of multimedia's capabilities and how those capabilities relate to your specific project?
- Are you comfortable with your content experts and people who will work with the multimedia developer–vendor?
- Have you evaluated the user base for your project?
- Are you confident that your estimated return on investment will be achieved in terms of bottom-line goals?
- Have you evaluated a number of multimedia programs produced by other companies at trade shows, or through their sales efforts with your company?
- Has sufficient time been set aside to produce the project?
- Is there a sufficiently broad test group available to evaluate the product at the conclusion of production? Does the group accurately reflect your user base?
- Has the budget money been earmarked and approved?

With the RFP in preparation for launching and the time allotted for the vendors to prepare their creative best, the next step is to determine your select list of creative recipients.

WHO WILL RECEIVE YOUR REQUEST FOR PROPOSAL?

How do you find the people who can produce the project?

Finally, with the project outlined, team selected, and media format chosen, the moment comes to dangle the worm, to tether the goat at the jungle's edge. It's a big lake. It's a very big jungle. One would think that seeking qualified vendors to produce your project would require skills in direct proportion to your production experience.

This *sounds* true, but it's not that simple. Companies that produce a variety of projects every year have a *Number One* list of vendors with whom they've successfully done business and the *Other* list of potential vendors who would sell their firstborn to get on the *Number One* list. Companies that are just dipping their toes in the multimedia waters have no list except the Yellow Pages and some direct mail pieces from vendors they don't know from deep center field. These opposite poles in the multimedia market search have distinctly different challenges, but can benefit from the same solutions.

The company that produces many projects in a year has the advantage of having gained experience dealing with vendors and pursuing the bid process. Staying current with the multimedia evolution is their challenge. A sophisticated company maintains its edge by constantly pushing the envelope — always looking for new ways to carry their message to their customers and employees. All too often, the *Number One* list "old boy" network they have cultivated over the years has developed rust — those vendors who have not, for lack of capital investment or talent, kept up with multimedia possibilities. Those vendors must extend beyond their in-house capabilities, going to subcontractors and thereby reducing gross profit by increasing direct, out-of-pocket costs. They may or may not have the in-house talent capable of supervising these high-tech subcontractors to ensure a satisfactory result.

Going to the *Other* list — those vendors with whom the company has had no direct dealings — does not guarantee the discovery of a new wonder-vendor. This is especially true if the project is critical. The best time to test new vendors is on projects that have a comfortably long time line and help can be sought if the new kids drop the ball.

The company that does only a few projects or just wants to upgrade their image and customer communications ability suffers from the "too small boat in too big lake" problem. They don't have a *Number One* list *or* an *Other* list. A recent perusal of the Yellow Pages in a large city revealed that of the multimedia vendors with the biggest ads, two had gone out of business and the other was now renting projection and staging equipment. The direct mail pieces sent by vendors based on cold calls have value if they offer services that complement your needs. Tread carefully until their qualifications are presented.

Look to the Subcontractors

So how do we find the talent we need? When new blood is needed and the old reliables are not appropriate, one of the best sources for creative talent is the *subcontractors* who work for the production houses.

These subcontractors are the equipment rental shops, postproduction (editing) houses, audio recording studios, and staging design companies. They all work for the production houses in your area and many of them provide services for out-of-town operations, which should not be ruled out considering today's cross-country communications capabilities. The subcontractors can recommend production shops who have been good customers and have rented the latest equipment, or have taken advantage of new design ideas and—most important—have paid their bills on time so that dealing with them has been a good experience.

Industry Trade Shows

Another excellent resource for locating a production house for your project is your *industry trade show* or any trade show where the kind of multimedia you anticipate needing is featured. Saying to a company whose multimedia presentation is impressive "That's great, who did it?" flatters the company and nine out of ten times, they will root out a business card or pass along a phone number.

In many metropolitan areas, a directory is available that features every form of production resource complete with ads touting specialties. Chicago has a creative directory that is updated every year and *Screen Magazine* publishes a yearly production "bible" of local and out-of-town resources who do consistent business in the Chicago area.

Another alternative is to hire the services of a professional project manager who can not only find talent that will match your project and budget needs, but will also help decide which multimedia format will best showcase your requirements. Look for someone who has a successful track record with a variety of projects. The cost of this manager will be more than offset by the comfort factor of working with a professional who has your interests in mind. Locating a good project manager can also be done through local subcontractors, locally published production directories under the "Producers" section.

When is the best time to seek out production people—if you have a choice?

Many deserving projects requiring multimedia are dusted off when a manager discovers extra cash in the media account that must be spent if that manager is trying to justify an increase in outlay, or at least fend off a budget cut next year. At other times a project that has been proposed every year for eons suddenly becomes doable because of a market shift or new management. Do it—or lose it—but do it by the next sales meeting in five weeks. Sometimes a product or service suddenly

becomes hot and requires a brisk flurry of market support material. Occasionally, a manager will awake at three in the morning screaming "Eureka!" into the darkness and next day a "brilliantly conceived" project is born — or, at least, dumped into the laps of the soldiers.

Whatever the reason or need for a project's birth, it usually emerges between September and April. This seven-month birthing period has become known among multimedia production houses as "The Busy Season." From May through August, multimedia production houses give back what profits are made during "The Busy Season." This has been the case for years. Like the swallows' return to Capistrano, on September 1, RFPs come fluttering out of mailboxes and the telephones begin their mating call. Ragged freelance subcontractors who spent the summer on enforced, stomach-churning "vacations" or asking "Do you want fries with that?" find themselves in freshly pressed suits sitting in client input meetings taking notes furiously. Everyone in town is booked. Row faster, the captain wants to water ski!

On April 30, the madness comes to an end. Steep discounting begins. Editing and shooting schedules suddenly open up. The begging period starts once again.

Is there a time to produce a project if you have a choice? Yes, in the summer when production house salespersons are getting carpet burns on their knees promising anything to get a job on the books.

6

Ground Rules for Submitting a Request for Proposal

Why a *written* request for proposal (RFP)? What should be included in your written RFP? Phone-in RFPs are usually dispatched because the project has either just leaped out from behind a bush and needs to be done in two weeks, or the project has not been thoroughly thought out and the company is groping for guidance. Regardless, the telephone-initiated RFP usually ends up either not being done, because the guesstimating "guidance" submitted by the baffled and groping production house prices this stab-in-the-dark airball out of the park, or the amount of follow-up work thrust *back* in the inquiring company's lap to even have a hope of producing this balloon launch isn't worth the corporate manpower. For every 1 telephone RFP produced, 20 disappear into the mist of unreturned voice-mail queries. Sometimes, to save face, companies have told everyone who bid that the project was ". . . given to another house because your bid was 40 percent higher than everyone else's. . . ." Another answer is ". . . the project is temporarily on hold. . . ." Sad to say, many worthwhile projects have been jettisoned because of the maddening shortcomings of the telephone RFP.

With today's fax technology, there is no excuse for the above nightmare. But just because a few notes scribbled on a legal pad have been thrust under the nose of an overworked executive assistant to be faxed to the waiting production houses does not mean an effective communication has been crafted. A good RFP that is a clear communication of

the client's innermost wishes takes some thought and follows minimum guidelines. Also, turn a kind thought to the production house that is spending manpower dollars in good faith — dollars and effort they may never get back — to produce their estimate of your needs.

Here are the minimum RFP information guidelines:

- **Who** is requesting the project? To whom should all queries be made and who will judge the proposal's merits? Who will be responsible for writing the script? Who is the audience?

- **What** is the project all about? What is its reason for being? What are its goals? What media is suggested at this stage? What graphics are required? What specific background information is required of the proposed vendor? What is the target budget?

- **When** is the proposal due? When is the project due? When will the result of the proposal judging be announced? When will people/products be available for photography?

- **Where** will any proposal review be held? Where will any videotaping/filming/interviewing take place? If applicable, where will the project be presented?

These minimums are a mix of proposal questions and project questions and follow four of journalism's famous *five W's* rule.* The fifth W is "Why?" and is the most frequently used W once the project is begun as in "Why aren't the graphics in our FedEx delivery?" or "Why did they change the schedule of cities in the videotaping tour?" or "Why does this animation cost so much?" Some people add "How?" to that rule, but "How?" is the reason for the entire book so let's just let it go.

Government RFPs request such items as proof of minority hiring practices, percentage of profit expected, and insurance bond proof. They usually require the services of the vendor's accounting department and legal service to complete. It is an interesting phenomenon to observe a group of multimedia producers gathered together at a government agency to receive an RFP. Usually, there is a large group present, many of whom have never bid on a federally or state-funded job. First of all, the RFP appears to be as thick as the Chicago telephone directory. Next, there are forms that bring to mind grim reminders of midnight sessions with income tax levies. One by one, the lights go out behind the eyes of the uninitiated. It's a shame that some of the most creative developers are so overwhelmed by the government bid process

* Who, what, when, where, and why?

that the jobs go to the same outfits that have the accounting and legal horsepower to interpret these typographic minefields.

Some companies produce a stock RFP that uses the same categories as RFPs for other suppliers such as building contractors, steam fitters, waste removers, and brick layers. A form is a form, right? How many computer graphic artists to a truckload? They are funny to read, but hell to interpret.

What is the value of "reading," or presenting the RFP with all the requested bidders present?

This type of proposal presentation is referred to as a *cattle call* for obvious reasons. It is usually assembled when a large number of prospective bidders are expected. There are a few good points to this type of presentation:

- The bidders get to see their competition. This could be good, or bad (as discussed earlier, if you represent a small shop and see the table ringed with large, prestigious shops, this could be bad for your morale), but at least all of the players are out in the open.
- Everyone gets the same information at the same time. The proposal review team is usually part of the RFP presentation so everyone also gets to put faces and personalities to the telephone voices they will hear later when they make follow-up queries.
- A competing vendor may ask a question that had not occurred to some of the other vendors — everyone shares this information.

There are also some bad points:

- Fear of looking stupid in front of their peers may constrain vendors from asking a question that is really important. This is called the "Emperor's New Clothes" syndrome: "I see what appears to be a huge omission here, but if I speak up and am wrong, I will look like a geek. Nobody else has said anything so I must be wrong." The RFP may have a glaring gap in its information flow and if no one speaks up, the gap can later become a chasm.
- Vendors who have worked for the client before can make this obvious to the other bidders, intimidating some shops who may be very creative and have something unique to offer. Fear of an "old boy" network has soured many cattle call readings.

Is the deadline you have set for the submission of proposals realistic? Is it fair to the bidders? Can you expect a well-conceived and detailed proposal in the time allotted?

The time required to assemble an intelligent bid is usually measured in direct proportion to the complexity of the project. The more elements

Figure 6-1. At a cattle call RFP presentation given by a former client of mine, the bidders—about 15 companies—were gathered in the client's large conference room. I noticed a feature in the room and chose to remark on it before the client point person began the session. "I see you found a place for that Film Festival award we won for you last year," I said looking at the marble and gold plaque that dominated one wall of the room. All eyes swung toward that glistening award and I could almost hear the collective sigh. Naturally, we won the job with a "brilliant presentation," and (ahem) the fact that only three bids were submitted had nothing to do with that casual comment.

that require the attention of element specialists, the more time it takes the vendor to collect everyone's best guess at the required time for execution, materials needed, processes involved, and problems anticipated. Most often, the time allotted by the client is insufficient, but experienced vendors make do using *previous experience* jobs as guideposts. Some projects have consistent elements and previous jobs similar to the RFP in hand can be mixed and matched to create a facsimile of a researched bid. The scale of the project also adds to the time factor. If the job is a big one from a major (read deep pockets) client, then the proposal takes on the life of a piece of art, or the density of an illustrated guide to the Normandy invasion.

In the past, the proposal was a simple collection of typewritten pages outlining how the vendor was going to produce the project. Language was everything. Also included were a few key storyboards and a warm, stirring cover letter. Then, when word processors came along, the thickness of the proposal increased exponentially. It became a novel. As word processing software became more sophisticated and graphics became more universally available, the number of fonts used for text made every page look like a ransom note. Soon, desktop publishing tools introduced page layouts to rival the self-conscious and barely legible spreads in the ultra-hip *Wired Magazine* (Wired Ventures, Ltd.). Integrated clip art visuals and still photos were laser printed onto the pages.

By means of computer-based multimedia tools, some proposals are now presented on a laptop computer screen complete with music and live video clips.

All of this proposal preparation takes time. For large projects, allow two to three weeks. For a more modest effort, allow no less than one week. A rushed proposal may contain errors of assumption that will haunt the project later causing no end of finger pointing, wasted time, and wasted dollars.

Are all the bidders asking the same questions? Have the questioned elements been clearly and accurately presented?

Whether the RFP is faxed, read out during a cattle call, or (curses) telephoned to the vendors, if almost everyone comes back with the same questions, that part of the RFP was, obviously, not clear—or liable to wide interpretation. In either case, damage control is required. As soon as the gaffe or omission is made obvious, fax all the bidders the same clarification:

Figure 6-2. A production house showed up at its prospective client's proposal review for a middling-size interactive multimedia project. The entire client review panel of six members was present. Bringing up the rear of the four-person vendor team was a burly production assistant shouldering a large cardboard box. When everyone was seated, the developer–vendor began to hand around 10 copies of the proposal from the box. Each copy was spiral bound between burgundy simulated leatherette covers and weighed about two pounds. The bemused client soberly riffled the pages, hefted the weighty tome and asked, "Is this the King James version?"

> *. . . Sorry, under the heading "Target Budget," move the decimal point one space to the left. Also, by "graphic animation" we mean the text on the screen must scroll as the chairperson reads it.*

If not answered immediately, these small misinterpretations can snow-ball into wildly unrealistic bids.

Is there a huge disparity in costs between bidders if no budget target was part of the RFP?

Large disparities could mean that the RFP was unclear in some areas — or, again, open to wide interpretation. Carefully compare the high and low bidders' specs. That should turn up the differential. If it does not, then compare the bidders. If one production house is significantly larger than the other, then their margins may be high to cover their overhead. Smaller shops can lowball because of lower overhead, but they may rely on freelance people to get the work done, which may cause them to cut corners to preserve what margin they have or to indulge in *pass-throughs* where, to avoid contractor markups, you must deal with subcontractors yourself. Note, however, that pass-throughs can be legitimate cost-savers, especially for basic perfor-mance elements such as equipment rental for presentation-type venues. The vendor stands behind the chosen subcontractor and pro-vides the essential middle-person services such as budget negotiation, specifying the necessary hardware requirements, passing along the venue location, times for setup and teardown, etcetera. The invoices for the subcontractors' labor and rental charges go directly to the client instead of passing through the vendor's bookkeeping (for subsequent markup).

The problem comes when the subcontractor provides complex services requiring ongoing project supervision. This kind of supervi-sion should remain in the hands of the vendor, not be dumped in the lap of the client to save up-front budget dollars on paper. Those sav-ings will vanish later as company supervision time mounts and mis-understanding-based rework begins to hit the subcontractors' cost sheets.

If none of the bidders is even close to your target budget (not revealed to the bidders), then the RFP was not clear or your expecta-tions were higher than the realities of production. Raise the budget, lower requirements, or resubmit a target budget to everyone.

To eliminate this over-budget problem, the best solution is to state a budget target up front. If you don't want to do that, then provide a

Figure 6-3. Two young men from a very cutting-edge production house flew to New Jersey to present their proposal at the imposing headquarters of a major pharmaceutical manufacturer. They arrived with only an expensive multimedia laptop and a request for a telephone line. Their entire presentation would be piped into the laptop via modem from their major computer in Ohio. As they stood in the paneled conference room with their phone connector in hand, a technically versed member of the company team said, "You need an analog phone line and our entire phone system is digital." The young gentlemen went pale above their constricting shirt collars. "Doesn't Lazlo the programmer have a modem?" suggested another company team member. The entire group trouped down to Lazlo's office, a squirrel-nest of a cubicle buried deep in the bowels of the building far from the public eye. There, amidst empty soda cans, heaped reams of coffee-cup-stained computer code printout, and crumpled food wrappers, the state-of-the-art presentation was made.

Figure 6-4. A good vendor sales rep or producer, on understanding that no target budget will be forth-coming, will attempt to force the issue with a statement such as ". . . a project of this kind can cost as much as fifty to sixty thousand dollars." I've seen two extreme reactions to this ploy. The first client almost spewed coffee across the room, then gasped, ". . . we certainly haven't got *that* kind of money. . . ." The vendor's man nodded in victory. "That's good to know. Just where is the budget pain threshold — as you see it?" The other client when confronted with the gee-whiz dollar prediction simply tilted his head quizzi-cally and replied "Do you *really* think so?" Without another word, he made a note on his pad and smiled back. Defeated, the vendors immediately launched into damage control.

not-to-exceed amount or a high/low range. This is fair to the bidders and allows them to see your expectation/reality understanding. If they are good bidders, they will be consultative and offer suggestions if you are unrealistic as to dollars, requirements, time allowed, etcetera.

How many meetings are necessary between bidders and your staff? Does there seem to be a communications problem during the proposal writing process? Who is requesting the meetings?

This problem is an outgrowth of the RFP's clarity and communication of the project's elements and goals. Meetings with the bidder's creative team eat up development dollars that will appear on the project's cost sheets once the project is won. Vendors gamble the time of their in-house people more readily than direct-cost subcontractors. Subcontractors that sit in on the meetings may be donating their time for the first meeting, but after that, the clock is usually running. This meeting-mania can balloon costs to a point where the project becomes unprofitable for the vendor and frustrating for the client.

Is someone available to answer bidders' questions during the proposal writing process? Is that person fully aware of the entire project? Can the designated answer person make decisions?

There is nothing worse for a vendor than, having received the RFP, discovering that the client's project team has scattered like a covey of quail. There are inevitable questions and clarifications that require additional input. However small these are, the fact that there is no one to provide answers puts the vendor on guard that the project itself may become an orphan. Voice mail is a wonderful bit of technology, but it does not replace the give and take of an actual conversation.

Another time and dollar waster is the poor soul who is left behind to field questions from vendors and is little more than a note-taker.

Figure 6-5. A client extended an RFP that was presented at a meeting to the assembled vendor's creative team. No target budget was forthcoming, but it seemed obvious due to the scope of the project that a considerable portion of dollars in the $100,000 to $200,000 range had been set aside for its three-phase accomplishment. The team went back and put together a very complete budget. Eventually, they received word that they had won the job. Then the meetings began. Additional information required a revised set of needs. Language describing the three phases changed and clarification materials had to be prepared to keep everyone on the same track. Professional storyboards were contracted by the vendor and were enthusiastically approved by the client. Then the client "suggested" some ideas with story-boards of their own. A proposal based on these boards was created. The project's scope narrowed from three phases to one. By the time the job had been boiled down, the client revealed that a budget outlay of about $40,000 was expected. The vendor had already spent more than $35,000 in time and direct costs over a seven-month period—all of it billable. As of this writing, the project is still "on hold."

Figure 6-6. A large medical supply company was bidding out a serious interactive project for dealers and their RFP had been an "old boy" telephone call to the vendor's sales rep — a golfing buddy. There were vast chasms in the information flow as interpreted by the salesman to the creative team responsible for the proposal. A list of phone numbers was provided for "any questions." The client's project team had all decamped for a trade show in Florida leaving only one phone number with a live person at the end. The department's sole executive assistant was the communications linchpin. She had just returned from her vacation and didn't even know the project had been conceived let alone put out to bid. The warning flag went up. This casual attitude eventually cost the client extra dollars as a result of communications miscues. The project was a success, but the following year, the company's stock dropped in value, their sales staff was in chaos, and their marketing budget was cut in half. Casual communications gaffes can reveal a pervasive, deeper running problem.

7

Meeting the Developer-Vendors

You have shipped the request for proposal (RFP) and now it is time for a face-to-face meeting with the developer–vendors to see what they have produced. Most vendors prefer to deliver their proposals in person rather than by mail, or worse, filtered through the fax machine. By meeting each vendor, a company project staff can make a more enlightened judgment call. The vendors also have a chance to "punch up" features, bring samples of work to show their track record, and show off their creative capabilities.

THE PROPOSAL REVIEW
The Vendor Production Team

Besides the folks you meet across the table, the budget will refer to other members of the production group responsible for the project's successful conclusion. Often their titles will be used without explanation of their role in the joint effort. Here is a breakdown of production people paid for with your dollars.

Account Executive The account executive (AE) is the head of the team and is a company salesperson. The AE usually has the first contact with the client and is responsible for the project's result both for the client and the vendor's bottom line. AEs are either paid on straight commission,

commission plus a small salary draw, or on full salary. The latter are usually heads of sales teams and receive a piece of the pool commission earned on the jobs worked by the team. The best AE is a skilled people person who follows the project step by step and also has some technical knowledge so he or she can work independently of a producer or creative director if necessary. The great skill here is anticipating tough client issues and defusing them before they can come to a head. Often an AE runs a number of large and small jobs simultaneously and demands good team members from both the in-house and freelance talent pools. He or she is always aware of the project's status through updates from the producer. The AE is always available when required by the producer. He or she makes critical appearances with the client to show the flag and is prepared to deal with the hard client questions.

Executive Producer Account executives sometimes adopt the title of executive producer, but it usually connotes the person who is managing the project's "big picture." Other team members report to the executive producer for guidance and updating. The executive producer usually has enough technical knowledge to be able to talk to all of the team's artists and designers and to create budgets. He or she may also have maintenance experience. Acting as a stand-in for either the producer or account executive, the executive producer is usually found on large jobs where a number of elements must be coordinated.

Creative Director The creative director (CD) is paid to think creatively, come up with killer concepts, supervise proposal formatting, and attend large project meetings, usually to present the document and to choreograph the attending sideshow of talent, scale model reveals, custom videotape screenings, and storyboard presentations. CDs represent the creative "style" of the shop. Today, CDs are hands-on designers with computer graphic skills as well as the ability to sketch and write. There are also "idea" creative directors who create their concepts in written form then turn them over to artists to be fleshed out. A creative director's contribution is usually in direct proportion to the size of the job, because the CD bills almost half again as much per hour as a producer. Even the smallest project can usually afford a couple of hours of brainstorming from a good creative director and then the producer follows up.

Producer The producer is the heart of the project. Complete understanding of all the project's creative and technical requirements is required. The producer is responsible for creating the budget and stick-

ing with it. He or she is the vendor's point person, always in contact with client team members. Often, the producer is also writer and director as well as crew member and caterer on location video/film shoots. In some shops, this function is becoming more pigeonholed. At one time, the producer came up with concepts, sold them with a written proposal, presented the proposal to the client for review, and went on to maintain control throughout the production process. Lately, in large shops, the producer has become subordinated creatively to the creative director and has become a project traffic cop and keeper of the budget. Whatever the nuances of responsibility, the producer is the production team's key person responsible for everything from computer programmer and scriptwriter to seeing that there are lights on the set and hot coffee nearby.

Director In Hollywood, the director's fortunes have been a roller coaster running from studio hack to cinema idol whose name appears above the title. In business communications and multimedia, the director partners with the producer and may also be the producer on smaller productions. Jobs with heavy talent requirements usually need a director to handle the action on the set, so the best performances can be obtained, and a producer to provide food, shelter, costumes, and makeup for the actors. Directors are also responsible for the final edit of what has been created. A good director–producer partnership can make any job flow smoothly as long as each understands the ultimate goal of the project.

Associate Producer The associate producer (AP) handles tasks designated by the producer, taking responsibility for critical errands such as arranging talent auditions, locating specific props, following artwork though computer graphic conversion, creating approval check discs for CD and LaserDisc projects. This is the learning ground for ascendancy to the rank of producer. On large jobs, the AP often works under the title of "Line Producer."

Production Assistant The production assistant (PA) is a step above a minimum-wage intern. This is an on-staff or freelance person who reports to just about anyone who needs fundamental tasks performed: Pick up the props the associate producer located, stuff floppy disks into client packaging for shipment, set up chairs for client screenings, make script copies, etcetera. Often, the PA also takes care of jobs that used to fall under the responsibility of what was once called a "secretary" and now has several more politically correct titles.

Writer The writer is almost always a freelance hired for a specific project. The reason for this is that every project coming into a production house requires a different type of writing. To try to maintain a staff of writers for every kind of job would be prohibitive. Some writers specialize in scripts for video; others are technical writers. Interactive programs require instructional design training. A few writers have the great gift of versatility — they can write in a number of voices to a number of audiences. These craftspeople are always in demand. Good writers work well with the client, can sift through mountains of input to come up with a clear path for the project's message, and can maintain a good working relationship with the rest of the creative team. Their rates depend on the length of the required written material, the number of client meetings, the amount of input available, and the number of interviews required. Most quote on a package basis from a simple "polish" of a client effort to a finished interactive program running many pages.

Art Director The overall design of the production is the responsibility of the art director (AD). Working with the creative director and other members of the creative team, the AD interprets the ideas into visual elements: theme graphics, set designs, costumes, screen designs, etcetera.

Director of Photography (Videography) The quality of the video images is the responsibility of the director of photography (DP). All camera work, lighting, and quality of sound recording are part of this person's craft. The director works with the DP to establish what should ultimately appear on the screen. The DP then uses all the necessary tools to achieve that image. On smaller jobs, the DP also serves as camera operator.

Video Technician The video technician has responsibility for monitoring the consistent quality of the video image using a vectorscope and waveform monitor. Acceptable video images must be recorded within a specific range of brightness between the lightest and darkest segments of the screen image (luminance). Colors must also fall into calibrated areas on the vectorscope (chrominance). The video technician makes sure the DP and the director arrive at their vision within the technical requirements of video.

Video Grip The grip aids the director of photography with all tasks dealing with lighting, microphone placement, props, camera moves, equipment logistics, etcetera.

Production Manager In many shops, this person assigns in-house and freelance staff to a project.

Stage Manager All persons working on the stage come under the direction of the stage manager. He or she helps direct rehearsals, sees that talent is ready to perform, and works with the lighting and sound people to make sure sets and performers can be seen and heard. The show cue-book is his or her bible.

Choreographer Shows that use dancing talent require a choreographer to design movements, work with the musical score, and blend the performance numbers into the show's theme.

Instructional Designer Interactive computer-based programs used for training projects require the skills of an instructional designer. This person interprets the education needs of the users and translates these needs into instructional elements geared to produce the needed training and feedback.

Computer Programmer (Author) Programmers are an integral part of the design process and the best ones can contribute significantly to the elegance of the final result. The programmer has seen expanded horizons as new authoring software have added many tools to the computers' capabilities.

Clients rarely meet the programmer if the job is written in a language such as C+ requiring hundreds and thousands of lines of code. These individuals are unique in their ability to shut out the world and see life as a subroutine of instruction sets, look-up tables, and matrices. Sometimes, social skills tend to suffer.

Where should the proposal review be held?

The place where the review is held can be an important factor for both participants. A vendor with an impressive facility wants to show it off, to make it a part of the proposal presentation. The company project team can look forward to an outpouring of good fellowship from the vendor, a well-laden food selection that would make anyone salivate, a tour of the departments where busy, creative artisans are working away, and the overall atmosphere of a project already awarded. Following the presentation, as the limo departs for the airport, the vendor reps exchange high-fives in anticipation.

At the other end of the scale, there are vendors who work out of a less than palatial facility who prefer to go — or insist on going — to the client's offices for their presentation.

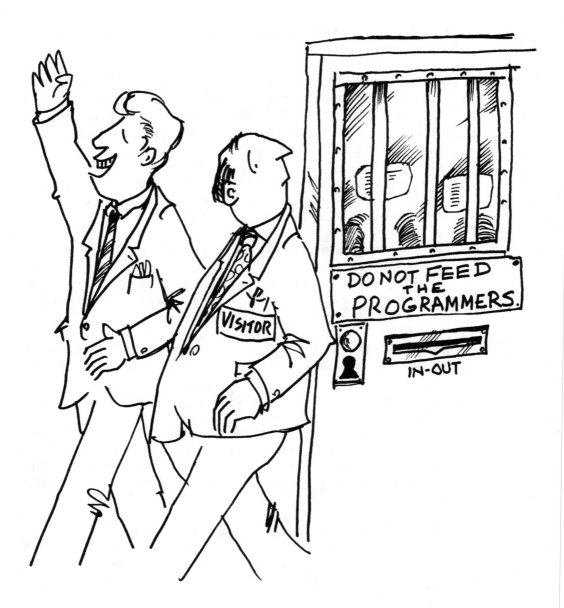

Figure 7-1. The client was concluding a tour of the vendor's large facility after awarding the shop a large interactive training program. The account executive and producer were about to return the client to the conference room two floors above when a weird specter appeared in the narrow hall. Seeing them, the person stepped quickly back into a small, littered office and slammed the door. Not, however, before the client took in the "I LUV CODE" baseball cap, "MANUAL LABOR SUCKS" T-shirt, fluorescent shorts, black sneakers, and a gargoyle cup filled with herbal tea. "What was that?" demanded the client. "Oh," stammered the account executive, "just a handyman. Kind of eccentric." They hurried on, leaving the high-salary company programmer to finish coding the introduction to the client's project.

Then, there are clients who require that all vendors come to the cor-
porate offices and present their proposals in the same conference room.
This approach requires the most effort from the vendors and can level
the playing field between large and small operations. It focuses the
client's attention on the quality and content of the presentation rather
than on the quality of the bagels and cream cheese.

Should the bidders' proposal presentations be scheduled for the same day — a review marathon? Is this method unfair to the bidder presenters if they know the order in which they are called to present?

In most cases, it is more convenient to assemble your bidder review
committee according to their busy schedules and allow a fixed period
of time for all the bidders' presentations. Allow at least an hour between
reviews if possible to let the previous vendor collect their materials for
departure and allow the next presentation to be set up without bidders
running into each other.

Are past successful bidders given any advantage over bidders proposing for the first time? Is an unspoken "old boy" network filtering out new approaches and ideas?

Considering the stakes on the table for large, multi-bidder projects,
every advantage is sought. The first-time bidder faces a crap shoot
when pitted against vendors enjoying a history with the target company.

What are the advantages/disadvantages of "under-one-roof" production houses compared to production companies who must employ independent freelance personnel?

Often, large facilities with numerous departments and many employees
come into the review touting the "under-one-roof" feature of their busi-
ness. Today, however, it is almost impossible to have all the needed dis-
ciplines to produce the wide variety of multimedia under one roof. The
large facilities have begun to be anachronisms in the current market-
place due to their very size and their glacial movement toward new
technologies while slowly shedding mature formats. While the simple
AV needs of the past required a limited palette of offerings to compete,
the bewildering levels of choices offered today require nimble feet, good
credit, and low overhead to survive in the marketplace. The largest
grossing production house with offices around the country has only *two
percent* of the market share. The rest of the pie is fragmented among the
thousands of "boutique" shops who specialize in working with certain
multimedia tools. As new systems that produce exciting visual/audio/

Figure 7-2. Three new bidders for a multimedia project from a large pharmaceutical house were early for their presentation and chose a corner of the lobby to go through their rehearsal one last time. Into the lobby swept a group of six, all chatting amiably and having a swell time in each others' company. They paused at the elevators, made some notes on tee times for an upcoming company golf tournament, checked their watches to meet for lunch at a nearby restaurant. When the elevator arrived, three of the people left and three, still chuckling, returned to the conference room where the reviews were being held. One of the new bidders walked to the receptionist's desk and asked, "Who was that group?" The receptionist smiled warmly. "Those were the Pitchem, Hookem, and Greedy Agency people. Been with us for years. What was your name again? You can go in now." If there is any justice in the world, the little trio went in there and knocked them dead with a killer proposal.

graphic/animation capabilities appear on the market, the financially flexible shops are the first to adopt them. Specialization has fragmented the marketplace into the a la carte menu previously mentioned. The we-can-do-everything-in-house shops groaning under the weight of large employee rosters, heavy capitalization in maturing equipment, and major property expenses are as difficult to maneuver through these turbulent waters as a cruise ship navigating a trout stream.

At the other end of the scale is the really small shop consisting of a few basic tools and a well-worn Rolodex. The caution here is weighing the qualities of the shop's key project manager and the artisans assembled into the creative team in relation to the size of the job. Very small shops can exist comfortably as bottom feeders, making profit from jobs too small for the large houses to consider. For large jobs, however, the management horsepower in a larger shop can better cope with keeping the project on track. Small margins keep small shops hopping to pay off their monthly nut. Their attention to your project may suffer if its size and complexity demand more of their time than they can afford to allocate.

Ultimately, while the size of a shop can have a bearing on its ability to handle your project creatively and efficiently, the quality of the shop's assembled talent and its dedication to producing a successful program are more important. All talent being equal, the project management capabilities of the chosen vendor have a greater influence on the outcome of the effort than the number of employees who punch in every day.

Does the bidder seem to be pushing a particular technology?

As multimedia production shops make course corrections while navigating the latest available technologies, serious dollar investments are made. These investments can be in the form of whiz-bang hardware, or talented people who allow the shop to enter a new market. As the shiny new hardware system is run through the hands of the staffers responsible for its output and/or the newly signed-on talent sits at the office desk sharpening pencils and awaiting the call to duty, the sales reps have stampeded into the countryside ballyhooing the good news and drumming up business for the new market service and attendant *wunderkind.*

There is a driving need for production house management who signed off on the Big Investment to see it pay off and vindicate their judgment. Often a new technology comes out in various forms from different manufacturers. Guessing which black box or which technical skill will win the tech lottery is an agonizing judgment call. Multimedia hardware and software have dismally short life cycles

between trumpeted arrival and eventual updates—or abandonment. Therefore, the need to wring their investment out of the latest addition to the toolbox drives production house management to sell the day-lights out of it.

For the houses that guess right and tie into the successful version of the black box, just letting the world know they have it will bring in the first customers who want to ride the crest of the wave. But soon, lots of houses have it and suddenly there are many skilled hands who can make it work. At that point, the new black box must be stuffed into any kind of job that could remotely make use of it. Vendors' producers and creative directors find themselves being asked to design a client's solution around what this box can do rather than explore other approaches that may have more merit.

How can a company point person reviewing a vendor's proposal know if the suggested solution is driven by the project's requirements for success or by the vendor's need to keep the black boxes busy? One way is to compare all the proposals and if most of the vendors suggest using this black box, then it is probably valid. If you mention this black box to a vendor who does not suggest its use and the vendor gives you valid reasons why it was not specified, then be wary. This is especially true if the black box is still on the cusp as far as industry acceptance is concerned. There's nothing like having a system installed in 600 stores that in two years must be totally redesigned because it is obsolete and can't be updated easily.

What should you expect from the bidder in the way of samples?

The presentation of samples by the vendor at the proposal review is their only way of demonstrating that they have had success with projects similar to what you wish accomplished. If the RFP was definitive concerning the nature of the end product, its suggested media, and its audience, then how close the samples reflect the proposed project measure the vendor's understanding of what needs to be done as well as their experience.

On-target samples have won bids.

How much weight should be placed on the "look" of the bidder's written proposal in your decision making?

The written proposal reflects the vendor's style, selling philosophy, and understanding of the client's culture. It will remain behind after the dust has settled from the hoopla of the presentation. It contains the hard information, the commitment, and the estimated dollar investment, and it

Figure 7-3. At a proposal review for a client who had not revealed a target budget but represented a Fortune 1000 corporation known for expensive collateral, TV commercials, and point-of-purchase materials, the sales team pulled out all the stops. The client received the VIP treatment: a tour of the facility, expensive lunch at a nearby restaurant, and a half-hour capabilities presentation in the upholstered and paneled conference room. Samples that closely paralleled the client's long discourse on what was wanted were rolled through the VCR. As the best piece of video finally faded to black, the client clapped and said, "Yes, that's exactly what I'm looking for!" The smiles around the table were blinding. "Now," asked the client, beaming with enthusiasm, "how much did that program cost?" The producer beamed back, "We brought that one in for just under $60,000." Looking at the producer as though he had just spoken in Esperanto, the client mouthed the words, "We're just the Human Relations Department. Can you give us something close to that for about $10,000?"

represents the creative juices expended on the project. A professionally prepared proposal containing the necessary information without padding and obfuscation deserves major points when the decision time arrives.

What about the bid's completeness? Does it state the project's objective, provide a script sample, offer some storyboards, maintain concept clarity, describe production team summaries, and delineate budget line items?

A good proposal begins with a restatement of the RFP's objectives to reinforce the fact that the vendor understands what is expected. Then, it goes on to demonstrate how each element of the proposal meets those objectives. The complexity of the project generally dictates the length of the document as each need is addressed. There is no best form of proposal because each proposal should be tailored to the project and customized to speak to the client's culture. A proposal aimed at a conservative health care provider should differ from the same kind of project proposal crafted for a computer game manufacturer. These clients live in two different corporate worlds, speak different languages, reach out to different audiences. The proposal's language and style should reflect these differences.

It is sad to see how some proposals offered up to small companies with small projects often look as though they were created with a rubber stamp. The use of boilerplate mail-merged into a cookie-cutter document becomes so obvious. Although a vendor will agonize over the style of their logo, they allow a boilerplate proposal to completely undermine their image.

A sample of script accompanied by a few pen-and-ink or felt pen storyboards gives the flavor of the concept beyond the hype of the selling language. Even the production team summaries — though usually boilerplate — can be customized if some elements of each member's experience touches close to the project at hand. Each element should complement the original concept, should build on it to create a whole picture. Finally, the proposal should explain each element and what it represents to the total scheme. At what locations does the client need two days of video shooting? How does the graphic artist's time break down and what software is being used? What does the amorphous heading "project management" really represent? A proposal should be a communications document, not just a laundry list of technical jargon. A complete proposal is a portrait of the job as seen by the vendor and communicated to the client in the clearest possible way.

8

Examples of Proposal Project Description

In this chapter, we look at a sample of the project description section of an actual proposal for a shoe company that was very conservative and wanted to change their interactive LaserDisc point-of-purchase program. They wanted something different from their past disc, which was 10 years old. They were also looking for a consultative vendor to critique the current program, which was no longer working.

FERGUSON POINT-OF-SALE VIDEO DISC PROGRAM REVISION

Ferguson has been a pioneer in point-of-sale (POS) interactive systems. The current disc is the twentieth in the series. The old adage goes "If it ain't broke, don't fix it." But corporations such as Ferguson, the market leader, don't keep that market share by turning away from change. Customers' lifestyles change, their buying habits change, their footwear requirements keep up with the world that is changing around them. Wingtips, the classic business shoe, have been joined by more fashionable styles as customers' awareness of the world of business fashion has accelerated. Individuality has entered the office while the need for classic elegance in footwear is still the norm.

Outside the office, the habit of choosing well-made, fashionable footwear continues. For casual occasions, or on the rugged trail, the

Ferguson customer receives full value for his and her choice of shoe. To meet these expanding office fashion and lifestyle markets, Ferguson has added new styles and a new look to the classic elegance that has made the Ferguson name synonymous with high quality.

Likewise, the POS screens and video segments presented in the interactive kiosk must also reflect this new direction while maintaining the classic Ferguson image. The current disc is composed of:

Attract mode: dynamic video, 45 seconds
Choice menus: still graphics with data overlay
Choice sample screen with audio: dynamic video
Shoe feature/color selection screens: still photo/graphic frames
Data overlay frame (sizes)
Infomercial with Denton Davis: company spokesperson
Commercial spot w/Denton Davis: 30-second spot
Training: includes history of Ferguson and how the shoes are made.

With this considerable amount of material, the disc is virtually at, or near, its 30-minute capacity. So what can be changed to make it more effective; to reduce walk-aways and bring potential customers to the kiosk and involve them in the interactive selling process?

1. We add excitement using the dynamics of video to its best advantage in the *attract mode.* We see shoes on people's feet. They are on office carpet, striding across rich parquet, legs crossing next to a mahogany desk. We see Ferguson casual shoes crossing a rough stone patio, propped on the rail of a whitewashed fence, walking between other men's and women's shoes past a fireplace. We see a heavy-duty boot climbing over rocks and another in the grass next to a rushing stream. These images flow one into each other, displaying the range of Ferguson's commitment to provide footwear for office fashion and our active lifestyles. The colors are warm and attractive. The moving feet in real settings suggest action and show off the good looks of these shoes against familiar upscale scenes.

2. For all voice-over segments, we suggest a woman's voice. For the sample screen (described later), we suggest that same woman on camera. She is mature, well dressed, and gets to the point with a rich, friendly voice. We debated about this. Then we considered who men dress for. Who is it that makes fashion suggestions to husbands and boyfriends? Who bought most men their first shoes — their mothers. Then, we considered whether this was a sexist stance. We decided that this woman represents all the women in our lives, not as an object, but

as a warm reminder that fashion is a part of our lives and we owe it to ourselves and to these important persons.

3. What if Ferguson doesn't want a woman? What's the alternative? A sports figure? Doesn't work, because athletes as voice-overs are rarely effective. These guys run, jump, throw, drive, skate, whatever — they don't talk. Their use on the sample screen would be a waste, because they would be too small and their part would be to show a person how to use the sample screen — not really their venue. Besides, we've already got Denton Davis standing next to a big shoe.

The alternative is a guy in his mid-thirties, a professional voice who looks good in either a suit or a cardigan. He's what younger guys who are shopping for Ferguson's shoes want to be and he represents the look that older customers want to perpetuate. He's not threatening (like some sports figures) or a celebrity (whose baggage gets in the way of the message). He's just a guy who's on the success track both in and out of the office.

4. The sample screen needs to be revised. What's wrong with it now? To begin with, the customer chooses a casual style and the first thing he sees is a wingtip shoe. Forget that it has "SAMPLE" in a green box over it — the first choice comes up with a jarring miscue. The voice-over talks the customer through the navigation and color choice buttons as we watch a static screen. Behind the kiosk, that laser disc is spinning at 1800 revolutions and we are looking at a static image, listening to a voice telling us what to do. We might as well have some action going on — we're paying for it in disc space for just an audio message.

The screen comes up and we see an array of shoe styles representing a cross section of designs that must include a sample of the style the customer has chosen. We see image "samples" and then reinforce this first image with the SAMPLE text in a box. Not so jarring. Next, our voice-over from the opening now becomes a real little person walking out onto the screen to point out the navigation and color choice buttons — then opening a door in the SAMPLE box and bidding us adieu. This is a very easy video technique and gives the sample screen a touch of visual class, while not requiring any more disc space than the current sequence.

5. In terms of the overall look of the screens, what do we want to see and feel about this POS presentation? How do we duplicate the shoe buying experience with images on a screen? We can't. Buying shoes, especially premier quality shoes, is a tactile experience. We handle the buttery soft leather, smell the mixed scents of the shoe's composition: polish, hides, rubber, cloth. . . . We see and touch the tight stitching that binds the uppers to the sole and we slide our hand inside, feeling the

space where our foot will have to spend many hours at a time. Fine quality shoes are a very personal purchase. Any video images will be a poor second to the firsthand experience of a fine shoe.

We must reflect that richness, workmanship, and elegant design with background colors that complement the earth hues of the leather. The typefaces must be easy to read and navigation buttons must look "right" to the customer.

PROJECT DESCRIPTION INTEGRATED WITH COST BREAKDOWN

The following sample for an appliance store chain combines the consultative proposal with a cost breakdown showing not only dollars being spent, but where dollars are being saved using the client's resources.

Rippemoff's Customer Interactive Displays

"Soundhouse" Interactive Audio Proposal

In response to your request for the addition of customer interactive features to our "Soundhouse" proposal, the following description and volume cost breakdown has been prepared.

Even though we use the word *manufactured* when referring to multiples of the visualization and unit switching system, the small quantities involved (under several thousand) are still considered to be handmade. The first unit includes development costs so the big price break occurs with production of the second unit.

It is expected that the system would take one day to install following advance department shelf preparation by Rippemoff's personnel and each installation would be supervised by Mindmeld Multimedia with the assistance of at least one of Rippemoff's staff in each location. If scheduled multiple installations preclude direct Mindmeld Multimedia supervision, Rippemoff's installers can be easily trained. All systems are turnkey including this training as necessary. Also included would be a laminated page in-store reference guide. Installation does not include travel or location per diems.

The project supervision cost required for the first unit would also cover additional installations (logistics, consultation, billing, handling, etcetera).

The original design system made use of a central button panel and router, operated by sales personnel. The music from any demonstration player unit would be routed to a selected pair of speakers and also to the color visualization screen. These revisions place the player unit selector buttons at the location of each unit on the shelves. The speakers will be selected from a separate panel situated in a prominent, central location. An LED light will also indicate that the player unit, or speaker pair, is "alive." This allows the customers to select their player/speaker combination when salespersons are not available. Appropriate signage will alert customers to this new advantage.

This interactive feature is applied in two degrees: the first (revision 1) supplies a speaker system selection panel and 20 individual selector/indicator modules for player units. The second (revision 2), in addition, provides a time-out timer that shuts off a player after a predetermined interval. Also, when one player is operating, all other players are locked out of the system and their LEDs are off. When the player has reached its play time limit, it goes off and all players and their LED indicators are made available for selection.

The interactive features added to revisions 1 and 2 require more wiring and individual indicator/selector modules, adding to the cost of the original design per installation.

Hardware includes:

1	Custom 20 × 20 router
1	Remote panel for speaker selection
1	Speaker source selector
20	Source selector, or remote selectors with lock-out/time-out feature where applicable
60	Custom speaker/indicator cables
1	Front projection screen and frame
9	Light fixtures, wire, and wiring
1	Pulsar color organ
1	Power electrical package

Labor includes:

Custom engineering
Assembly
Testing
In-store installation

Design	Quantity: 1	Quantity: 50	Quantity: 100	Quantity: 150
Original design	$33,001	$18,147	$17,498	$16,885
Revision 1: individual source switches	$34,849	$19,995	$19,346	$18,733
Revision 2: as above with lock-out/time-out feature	$35,465	$20,427	$19,960	$19,390

Archway Video Wall Cost Breakdown

Also requested at our last meeting was a cost breakdown of the individual elements that make up the archway video wall concept. Including all the selected options and programming elements, the hardware would be available for Rippemoff to purchase directly if desired.

Quantity	Description		
9	27-in. RGB Hantarex monitors		$16,854
9	30-ft RGBS cables		$832
		Subtotal	$17,685
1	Imagemag 3 × 3 microprocessor		$12,310
1	VCU video replay controller		$3,498
1	128K reprogrammable memory card		$180
1	Rack for system		$1,194
1	Cooling fan		$381
		Subtotal	$17,563

LaserDisc System

1	Sony LDP-1550 player		$1,842
1	MIDATL rack mount		$122
		Subtotal	$1,963

Programming Hardware and Software

1	"C-through" 36 software package		$2,676
1	AT compatible computer		$1,865
1	30-ft RS-232 cable		$80
1	"C-through" show storage		$322
		Subtotal	$4,943
		Total	$42,154

Project Management for Hardware Installation, includes input meetings, logistical planning, and supervision of installation to completion

Subtotal $3,640

NOTE: The sound system can be provided from Rippemoff's inventory, or Mindmeld Multimedia can supply a turnkey system installed with the wall featuring variable volume, balance, etcetera, for CD-quality music. System will be made standard with all installations. Sound systems of this type range in cost from $2,000 to $8,000 per installation, averaging $4,000 to $5,000.

Also included:

- Provision of electrical requirements and drawings
- Complete preinstallation setup and testing
- Delivery to the installation site
- Testing and commissioning
- Four hours of training for on-site Rippemoff's personnel in operation (turn on/off) and simple troubleshooting.

Total excludes store installation, power supply, support for display and surround for the display, monitors, and support equipment. Total includes a one-year warrantee on all wall system components.

Reprogramming the wall design (memory card) will be accomplished at the Bloomberg store using Mindmeld Multimedia portable equipment and programmer.

Archway video wall Total $45,794

Optional Reverse Wall Video Attract Three monitors for opposite side of the wall including monitors and distribution amplifier.

$5,798

Quantity Pricing for Video Wall Systems Each includes the ImageMag 9 screen wall with all electronics and the Sony LDP 1500 LaserDisc player.

50 stores $30,279
100 stores $28,372

"Wall of Eyes" Video Wall Test Mindmeld Multimedia, in cooperation with Imtech, has worked to implement a video wall display in the video department using TV sets that are on sale rather than specially designed Sony monitors.

A special decoder/converter is being constructed that will accept the RF signal from Rippemoff's LaserDisc video system and produce a large picture spread over nine television set demonstrators. This approach requires that all of the Rippemoff's demonstrator TV sets have AV input and to have the same size screen for image continuity. Our engineers have designed the decoder for maximum output resolution. The capacity for accepting this feed and outputting a sharp picture segment will depend on the image quality of the individual TV sets.

On a recent tour of the video department, we noted that the TV sets now occupying the area where we demonstrated the Sony monitors are a mix of 25- and 26-inch screens. Of the 9, 5 had AV inputs. Of all the TV sets on the shelves — 28 total — 23 have AV inputs and 5 do not. They range in screen sizes from 25 to 27 inches. What this boils down to is that in order to have the "Wall of Eyes" function with Rippemoff's demonstration TV sets, a reorganization of the shelves will be required such that 9 AV input-capable sets with similar size screens are grouped together.

Cost for this system rental for one week including delivery and installation* would be $5,214.

The decoder attached as a part of the microprocessor cost would be $2,823.

A project supervision charge of $437 would also be assessed.

Total project cost: $8,474

* Installation would occur after store closing hours.

9

More on the Proposal Style and Implications

Does the proposal seem excessive in length, or is its use of elements such as ornate graphics, full-color storyboards, specially prepared custom tapes, the use of professional talent, etcetera, excessive?

Many production shops allow for about three percent of the total estimated budget to be spent in winning the business. That's their gamble. The bigger the potential job, the higher the stakes, the greater the effort. If the salesperson forecasts a high probability of getting the big business, then the coals are really heaped on as insurance, because all the money spent will be recouped on the cost sheets as part of project development. It is crushing to the bottom line when a "sure thing" worth $200,000 bites the dust with $15,000 in proposal costs hung out to dry.

Sometimes a dense proposal graced with an extensive design and flawless typesetting will frost over an idea bereft of originality. It is very popular in this age of computer-driven layout and graphics to create a confection in the Swiss cuckoo clock school of proposal layering. This year, oddly shaped proposals are the in thing: horizontal (landscape) instead of traditional vertical (portrait) formats, pyramid shapes, shapes cut to look like the corporate headquarters, lozenge shapes, polyhedrons, dodecahedrons, etcetera.

Read the proposal carefully. If its creativity and killer concept match the flash and élan of the document and its supporting players, all the better. Enjoy it. If you award it, you'll be paying for it.

Is there amortization beyond the project?

Does the bidder suggest any ways to amortize the project elements if you haven't considered the possibility? Any multimedia venture requires a significant outlay of funds. The end product is not something you can use later as a doorstop or a planter, nor can it be melted down and recast into a pair of bookends. It is an abstraction that appears and disappears with the touch of a button. It comes when called like a genie from a bottle, then returns to be corked up again. Its creation is the sum of many parts. In Disney's *The Sorcerer's Apprentice,* the broom carrying water from the well is chopped into splinters, then each splinter becomes a broom. The video, graphics, music track, and many of the elements compiled into the final project can be used again. Once the bill is paid, the client owns these elements.

A proposal that suggests ways to recycle the paid-for elements into training programs, commercials, employee communications, etcetera, is truly consultative. Of course, the vendor wants to be the creator of these offshoots and develop a long-term relationship, but that possibility will be predicated on performance with the job at hand; however, its very suggestion conveys a sense of confidence and good client relations.

Do you sense that you can work with the bidder's team? Do personalities and styles match up? Does your point person and the bidder's chemistry seem compatible? Do the bidder's production team members seem compatible with your project team?

Over the long run, although professionalism is critical to a smooth running project, personalities also count for a considerable portion of the eventual success. The project review brings the client team and the vendor team together face to face. At least you hope so.

Sometimes a vendor will send in the heavy guns to sell a project, then when it's won, they'll hand off critical chores to personnel who were not in on the sell. This does not always signal that a red flag should be run up. Quite often, a critical person such as the eventual producer or director is finishing up another program and cannot make the project review. The vendor then appoints a qualified "designated hitter" to stand in, help with the sell, then pass along notes and observations to the person who will take over. Smart vendors announce this substitution so there are no surprises later. While most houses like to convey the idea that your project is their sole concern, common sense should dictate that there are other jobs going on and, usually, a producer, director, or creative director is working on more than one project at a time. Cut them some slack. These people are used to compartmenting their professional

Figure 9-1. A new client had been won with a low price in the bid process and visited the production house in the person of the elderly president of the firm flanked by two gentlemen who were actually responsible for the work. The first meeting at the client's factory had gone well, but now it was time to review some new ideas the president had suggested. The production house account executive and producer sat and listened as one of the minions went over these "ideas," reading from a legal pad filled with the broad handwriting of the boss. The producer, as was his habit, made notes to himself and did a little math equation at the end of each idea. Since the bare bones budget could not accommodate most of these changes, the producer chose to make that fact known to the client, but added that a Change Notice would be cut to show the cost addition for approval before it was implemented. Unfortunately, he made this little speech following each of the president's ideas. After three readings and three admonitions, the elderly president suddenly stood up, jabbed his unlit cigar at the producer, and shouted, "What is this bait and switch crap! You got the job and now you're jackin' up the price! (Epithet) you and (Epithet) your company! If you think I'm gonna bend over and take this, you're (Epithet) crazy!" Chagrined, the account executive threw himself on the grenade to save the job. Later, it was discovered, the president had used this tactic throughout his life to browbeat concessions from vendors. When the job came in, barely making any money at all because of the giveaways, the president (probably laughing to himself) took the company's business elsewhere.

lives. Shifting gears from one program to the next goes with being an effective time and project manager.

Chemistry is important between teams, because you will be in close contact throughout the process. Some of the longest relationships I have maintained with corporate clients have been based largely on a meeting of minds not just within the confines of the project's needs, but philosophies, work habits, off-campus recreation, and mutual interests. The ability to "schmooze" comfortably adds enjoyment and efficiency to the project's progress. People who see eye to eye on interests outside of work, or who simply fall into an easygoing rhythm within the project's boundaries, have no trouble being frank or anticipating each other's needs.

One of the endless parade of national surveys collected by obscure think tanks managed to come up with percentages attributed to "Why Companies Lost Business After One Project":

Ten percent sighted dispute over the final price.

Twenty percent said the product received was not satisfactory.

Twenty percent mentioned there was little follow-up (read schmoozing).

Fifty percent stated they were not happy with the representative relationship (read bad chemistry).

A bit of wisdom: It costs ten times the money to get new customers as it does to hang onto current ones.

Is the bidder consultative? That is, if some of your requirements may negatively impact any facet of the project, does the bidder sight those negative elements and suggest alternatives, or does the bidder simply rubber stamp all of your suggestions?

During the process of determining the goals of the project and pairing them with a desired media, the company project team sometimes makes judgment errors in demanding more from the medium than is possible within the allotted budget, or suggests a time frame that is not practical given the combination of elements that must be completed, or any number of stated requirements that could jeopardize the project or reduce its effectiveness. These little time bombs are not intentional, but stem from lack of experience with a given medium or project type, from the need to squeeze the most from a budget, or from plain old enthusiasm and drive to produce a killer program. If they are apparent in the RFP, one of two things can happen:

1. A vendor can see the anomaly and mention it to the client, offering an alternative that will produce the desired result with no risk to the project. This is being "consultative." A conscientious vendor prefers to team with a client

Figure 9-2. An electronics equipment manufacturer asked us to create an employee video newsletter on a low budget. We succeeded and soon the budget per show increased because reaction to the newsletter was very favorable. The client point person played amateur hockey and frequently showed up at editing sessions with his duffel bag packed for that night's game. Our account executive was often able to get free tickets to the local professional hockey team's games and he passed them along. The client was also interested in electronic music and was encouraged to create music cuts for the programs. At one point, the client was asked by his management to create a mini-editing studio at the corporate headquarters to perform simple edit jobs. Though this would cost us those jobs, we helped him buy some good equipment that met his budget. After two years, he introduced us to his training department and we developed a computer-based training program for dealers. That relationship also blossomed and by the time he and the training manager had moved on to other companies, my production house had achieved billings of more than a half million dollars. Yes, we had to produce to maintain the professional side of the relationship, but a no-bid synergy between a client and a production house can be very profitable for both.

and offer consultation to make the project run smoothly from the start, to iron out the bumps before the work begins. Doing this in the proposal review stage could endanger the vendor's bid if the alternative suggestion costs more dollars, but should build confidence in the company team that this vendor has their best interests at heart.

2. A vendor can choose not to notice the anomaly, bid to simply match the client's specs, and add cost to the project later on when the client's judgment lapse surfaces. This tactic can sometimes win jobs with a low bid, but the hassle later on when the client must go back to the corporate well for more dollars can affect the future client/vendor relationship.

Equally important is the discovery that the client has required a step or procedure that is redundant or otherwise not required. If there is a target budget stated in the RFP, removing this redundancy could reduce the dollars available to the vendor. Not mentioning the overkill keeps the dollars in place, allowing a chance for a larger profit, but if the mistake comes to light later in the project and the client demands a reduction in the bill, once again the client/vendor relationship could be strained.

In every case, a vendor should take the high road. Sometimes no one spots the ticking bomb until it's too late, but it is the vendor's job to be as much consultant as hired gun and to provide a clear path to the project's conclusion. The client should expect this consultation, not surprises, as the project progresses.

Does the bidder ask about the competition?

Either at the time they receive the RFP, or during the review meeting, often bidders will ask about their competition. It's always nice to know the other players. Since the multimedia production houses have usually bid against each other before, they know each others' teams and styles. They know who usually "lowballs" the bid (goes for the lowest possible price to get the job in house at any cost) and who will be a middle to high bidder, but brings heavy guns to the table in the form of a large organization and big "comfort factor" for the client, especially if the project is a large one.

Some account executives and producers—when they learn who they are competing against—can't resist the casual slam. "Oh, are they still around? That's great to hear they finally got financial backing." "That's a good shop. Must've gotten some new equipment to be able to bid on this kind of job." "Oh yes, terrific people. We go way back. We sold them our old editing machines for next to nothing."

When this kind of "no prisoners—no wounded" type of campaign begins, most people in the room with an ounce of ethics begin to grind

their teeth. Giving the competition a taste of the cold steel should signal to the company team that no one is safe from skewering around these people. In the close relationship that develops around a multimedia project in the making, who needs bad-mouthing?

In light of the above, should you reveal the identities of the competition?

No. Knowing their competition may affect how they bid, which should have no bearing on the requirements or successful completion of your program.

Should you make it a rule that if one bidder asks a follow-up question, you will then make your answer available to the other bidders?

Some companies set up this proviso at the RFP reading in order to level the playing field for everyone. Vendors' questions often involve part of their proposal strategy. They are loathe to tip their hand and reveal too much to the competition. They would rather work under an assumption than spread the answer to their question to the other bidders. Questions not asked can result in bids that are far off the mark or are laboring under a false assumption. The tattletale proviso helps no one, especially the client.

Is the vendor's cost breakout on the budget clear?

Three schools of thought come into play when vendors present the budget estimate or amount to be invested in the project. The first school sends out a spreadsheet form showing all the categories of expense for a generic project of the type for which they are bidding. Only the elements to be used for the particular client's needs have time and dollar amounts filled in. Due to the lack of space for each category in a spreadsheet cell, often the description of what is being paid for is somewhat cryptic. This presentation is very thorough, but has the look of patchwork boilerplate—which it is.

401	DP kit w/cabling	10 hrs @ $12/hr	$120

This cost for a portable lighting kit for one day of videotaping may be unclear for a client unfamiliar with spreadsheet shorthand.

The second school veers to the opposite type of presentation. They either do not want to (1) belabor the client with a great deal of detail or (2) reveal where some of the unforeseen padding may lurk that will allow them to discount down later if price becomes a sticking point.

Video Production: *All location video production including cameras, crew, support equipment, transportation and tape:* $10,500.

The preceding budget item seems a bit sparse in spelling out where the client's money is going.

The third school draws a balance between the two. Because clarity and understanding are key elements to the proposal as a whole, then the budget estimate should also meet those criteria.

Video Production: *Three 10-hour days on location at plant 2 with full broadcast-quality Beta SP camera package including TelePrompTer™ for interviews, portable lighting package, additional lighting for factory area shots; crew of director of photography, video technician, lighting grip, TelePrompTer operator; camera dolly and track, all grip accessories, videotape and van transportation portal to portal:* $10,500.

This budget line item spells out what is being paid for in simple language customized for the client's project. For a proposal, this format is the most helpful and informative.

Here is a sample budget estimate from a project that was produced in three segments: Graphics Segment, Video Segment, and Program Segment. Added to this budget are models of the sign-off documents and payment schedule. This is a typical package presented to a client.

Binkley Screw & Bolt "Better Bolt" Video Segment

This budget estimate is based on the following project requirements:

- A linear video program with a maximum length of four minutes.
- Script created by Mindmeld Multimedia and Binkley Screw & Bolt.
- One 10-hour day video production on site at Binkley Screw & Bolt.
- Location set and props provided by Mindmeld Multimedia.
- Graphic elements provided by Binkley Screw & Bolt and borrowed from the Graphics Segment program as needed.
- Professional voice talent for script and music selection at Big Earfull Studios.
- One 8-hour day Avid digital off-line at Mindmeld Multimedia (date to come).
- One 8-hour day on-line edit at Mindmeld Multimedia.

Budget Estimate Budget figures cited in the following sections are estimated based on agreement of the individual program elements and development of specific details and options and are valid for 30 days. Occasionally, this will require adjustments in activities and/or budgets. In any case, Mindmeld Multimedia will seek client approval of significant changes in the form of a project change notice before proceeding.

Project Management: Includes producer, production coordination and clerical services for duration of the project: $1,211.

Scripting: Polish and create video version of script created by Mindmeld Multimedia and Binkley Screw & Bolt: $622.

Video Labor: Includes Mindmeld Multimedia director and camera operator plus crew of video tech and grip for one 10-hour day on location at Binkley Screw & Bolt: $2,390.

Video Equipment: Mindmeld Multimedia broadcast-quality Beta SP camera package, lighting, camera support equipment, purchased props, transportation, tape stock, for one 10-hour day at Binkley Screw & Bolt: $2,515.

Graphics Production: Conversion of Binkley Screw & Bolt-provided Photoshop elements into video format for ADO insertion into program: $645.

Voice-over Talent: Professional voice-over talent for one hour to record four-minute script, agency negotiations and fees: $1,152.

Audio Production: Includes engineering, studio time, library music (two cuts), voice-over recording time for a session maximum time for four hours: $1,030.

Video Postproduction: Transfer of video and graphic elements to Avid digital off-line system, eight hours of off-line editing in the Avid suite, eight hours of on-line edit including Ampex Digital Optics (ADO), Abekas electronic type, three broadcast-quality Beta SP editing machines, music and voice mixing, tape stock, and handling: $7,061.

Miscellaneous Expenses: Includes telephone, fax, deliveries, disposable items: $303.

Total Estimate: $16,929.

PROJECT PAYMENT SCHEDULE

CLIENT NAME:	Binkley Screw & Bolt
BILLING ADDRESS:	3825 Pennsylvania Ave.
	Smokey Hollow, IL
CONTACT NAME:	Leonard Henderson
PURCHASE ORDER #:	
CUSTOMER #:	
JOB #:	1659GR
DATE:	4/30/96
PROJECT:	"Better Bolt" video segment
TOTAL ESTIMATED COST:	$16,929

Payments based on the estimated budget will be due ten (10) days after receipt of invoice due to shortened one-third billing schedule, unless otherwise noted below.

	PAYMENT AMOUNT	INVOICE BY	INVOICE DUE ON
➪ One-third billing of approved budget.	$5,643	5/3/96	5/10/96
➪ One-third billing of approved budget.	$5,643	5/8/96	5/15/96
➪ Final third billing of approved budget.	$5,643	5/15/96	5/22/96

To continue to provide quality production and service, it is our policy that two-thirds of the total cost estimate be received by Mindmeld Multimedia, Inc., prior to delivery of program, or show travel.

If the final working budget is less than initially costed, the final one-third billing will reflect this decrease.

Additions or variances from the original estimate will be billed following completion of project (approximately 30 days) and will include a detailed breakout of costs for all services.

If all of the above specifications and cost items are agreed to, please sign both copies of the document and return one copy to me. This will become our base budget. Should delays or changes in the program occur resulting in additional costs or credits to this working budget, we will request your signed approval by Project Change notice prior to any action on our part.

APPROVAL OF TECHNICAL SPECIFICATIONS AND PROGRAM BUDGET:

Binkley Screw & Bolt
"Better Bolt" Video Segment
Job #1659GR

APPROVAL OF TECHNICAL SPECIFICATIONS AND PROGRAM BUDGET

_____	_____
For CLIENT	For MINDMELD MULTIMEDIA INC.
_____	_____
Title	Title
_____	_____
Date	Date

Does the bidder seem willing to discount in order to underprice the competition?

What might be the actual cost of such a discount in production value? Are they cutting dollars or are they substituting elements of the process (switching from Beta SP to Hi-8 video, going to a video wall with less capability, suggesting a keyboard in place of a touch screen, reducing the graphics' resolution to cut rendering times, offering two-dimensional animation instead of three-dimensional, etcetera)?

Has the bidder supplied a production schedule?

A production schedule should accompany every proposal. The schedule that comes with the proposal has no real validity as far as actual scheduled times for events to take place is concerned. Only after the project is awarded and the vendor team has a chance to discuss real time lines and real commitments can specific days and hours be scheduled. The schedule that comes with the proposal will generally spell out the events that will take place and the time it will take to accomplish each one. It will also indicate which events can happen concurrently. That is, for example, while voice-over talent is recording the narration, the artists are preparing the theme graphics and the production assistant is searching for props for the video shoot. Other events are linked to each other and are very time specific. For example, programming an interactive segment can't happen until the flowchart is approved. A video can't be edited until the narration is recorded. The entire project is stalled until the script is approved. A proposal schedule will spell all this out.

On page 106 you'll find a sample production schedule form in its most basic format. Once completed, this would constitute a guideline for finalization at the project's start.

With this production schedule in hand, before the job is awarded, the point person should check with key team members to see if they can commit the necessary time. If the video edit has been estimated to take three eight-hour days, can a team member with sign-off authority be present for a three-day block of time to supervise this critical step? Will the necessary sign-off people be available during the one week estimated to complete script approval? These are the questions that must be asked. When the job is awarded, actual time commitments will be easier to allot to the events.

Client:

Job #:

Date:

Production Schedule

To maintain an efficient and cost-effective production process, it's important that this schedule be adhered to. Should delays occur on receipt of any client-supplied materials/approvals, or if changes are made in creative/technical requirements that will impact key delivery dates and/or project costs, Mindmeld Multimedia will inform you and seek your approval before proceeding with production.

ACTION DATE: 6/4/96	RESPONSIBILITY	COMPLETE ON/BEFORE
Define	MM/Client	Date
Production outline & schedule	MM	6/6/96
Production outline & schedule approval	Binkley	6/13/96
Script input meeting	MM	6/17/96
Script — first drafts	MM	7/15/96
Script approval	Binkley	7/22/96
And so forth...		

Are the rights to the final project's ownership spelled out?

Once the bills are paid, the client owns everything created for the project. For the sake of convenience, most clients leave the elements stored at the production house if the house has sufficient space and good storage conditions. In this way, any updates or retrieval of last year's elements to reuse are easier to accomplish. Be aware that, unless stipulated by the client, the production house may use the material for promotion and as samples for future sales calls. In some cases, theme graphics created for one company have been modified and used for another company to save costs and keep a bid low. Usually, the other company is in a totally different business to avoid any conflict. The same holds for video footage that is commandeered as "stock" footage for another project. This footage is usually generic and not directly associated with the previous project such as street crowd scenes, aircraft taking off, cars on the expressway, clouds in the sky, etcetera.

Some clients specify that footage, graphics, original music, or any other elements created for their project may not be used for any other purpose without express permission. The usual vendor reaction to such a request is the same as Yul Brynner's pharaoh in *The Ten Commandments,* "So it is said . . . so it is done."

Is any of the material proposed (or requested by you) covered by third-party copyrights? If so, are the rights to use the material available?

Sometimes, a project is inspired by a movie, a popular music recording, or a celebrity character. The RFP will breathlessly state, ". . . and we'll end with Frank Sinatra singing *I Did It My Way.*" Now, in the free-booting past, the producer would have simply sent out a production assistant to get the latest copy of Sinatra's recording. Today, that has changed — we like to think — and the producer would lift the phone and ask the client if an alternative to or parody of the song would suffice. To get Sinatra's song — if it was available at all — would cost thousands of dollars. The same holds true for movie clips. Celebrity look-alikes are thriving as the actual celebrity charges skyrocket.

In some cases, the client gets no such ethical response from another bidder and a sticking point develops. With a huge meeting hanging in the balance, many otherwise ethical production teams get sweaty palms wrestling with the moral dilemma.

It is considered very bad form to put a bidding production shop in this position. Besides, if a lawsuit develops from the unauthorized use

Figure 9-3. A producer bowed to a client's request and used a popular rock song by a very popular female trio for a high-energy opener to a small sales meeting in a Las Vegas off-strip hotel during the winter Consumer Electronics Show. Following the meeting, the producer and his crew had time the next day to see the show. On entering the huge hall, an unmistakable heavy music beat filtered through the noise. Rushing to the client's booth, the producer stared at his meeting opener video booming from some 20 screens and the popular song and trio ringing out to all and sundry. The true horror hit home when a crew member mentioned the trio was playing in a casino just down the street — *live.* Following a few frantic moments of great expostulation and wild gesturing, the screens switched to the product video and the trio tape left the hall at a dead run in the producer's bag.

(remember, it takes only one phone call from one disgruntled employee to blow the whistle), the lawyers go after the party with the deepest pockets, which could be your company. One such lawsuit can destroy a production shop, because the court can subpoena the shop's output for years back, and if other instances are found, impose fines and damages for each. The best reason to avoid using copyrighted material is it is wrong. Whether it is Michael Jackson or Michael Stoopnagle, stealing is stealing.

Is company "talent" going to appear in the program either playing themselves, or character roles?

If so, then model releases must be signed by every employee. This protects the production against any postproduction problems with employees who leave the company and object to their image or words being used. Some executives can get very nasty on this point. More than a few productions have had to be reedited since permission was not secured in writing, nor was participation in company projects spelled out in the employee's contract. A sample model release used by a production company follows on page 110.

If changes or course corrections are needed, is there some mechanism available from the bidder to notify you of the cost or other impact on the project before you commit to the changes?

Every project needs a safety valve. Multimedia programs are composed of a number of elements and many places where an estimate can be derailed. Even basic video programs, graphic designs, and sound tracks are composed of steps, each dependent on the other, to achieve the final result. When the estimate is composed by the production house and presented in the budget, all of the elements and steps are configured around hourly rates based on experience and past performance. Equipment needed is cost estimated by machine hour rates and, if necessary, rental costs. The spreadsheet I used to calculate basic video estimates ran to 300 items. Not all were needed for every project, but video would be only one part of an average multimedia project.

With all these elements being worked on, a change in direction can have an explosive result: schedules altered, additional equipment required, processes added. Most often, the direction change comes from the client. Either a last minute addition is needed, an element completion deadline is shortened, or other such deviation. The project is hammering along like a freight train through the night and the client

TALENT CONSENT AND RELEASE*

FOR: {PROGRAM TITLE}

I, being of legal age, do hereby give Mindmeld Multimedia , Inc., an Illinois corporation, and its assigns, full and unqualified permission to take and use photographs, still or motion, and/or voice recordings of myself for the non-broadcast commercial use in any manner whatsoever. (alternative line: "for consideration stated herein.")
I hereby release Mindmeld Multimedia, Inc., and its assigns, from all claims arising out of the foregoing.

NAME _____

SIGNATURE _____

(If under the age of 18, signature must be of parent or guardian)

DATE _____

JOB NO. _____

* The forms used in this book are based on designs created by Motivation Media of Glenview, IL, one of the pre-eminant multimedia production companies in the U.S. The designs evolve as one company sees something done by another company, and adopts it. The designs shown are the result of this process, but have many of the features used by Motivation Media up to 1995. They are not, nor can they be, copyrighted.

makes a change. Some shops will simply make the change with a "whatever it takes" attitude and press on. Others provide the safety valve in the form of a change notice.

The change notice has saved many a job. This simple form on page 112 describes the client's requested change and shows how it will impact the project in time and/or cost. Changes that seemed so important at the time are suddenly seen in context with the successful completion of the job for the estimated price. Often, those changes suddenly pale in importance and are canceled. If they must be made, the client is made aware of the cost before action is taken and is required to sign the form as an approved go-ahead. There will be no surprises at the end of the job when the final bill is toted up, no "Why didn't you tell me?" cries from a wounded client. Explaining the project change notice process during the proposal review is a confidence builder for the client. Knowing the vendor has a system in place to monitor costs can free a client to concentrate on the objectives of the project and not be afraid to suggest course corrections if they seem to be necessary.

Even a casual scanning of this chapter so far reveals a delicate balance of relationships between client and vendor — a ritual dance upon which hangs the success of the project. A thorough understanding of steps in this dance will guide the participants to a mutually satisfying conclusion. There remains only the final spin around the floor — the evaluation of the proposals, cleaning up the details, and awarding the project.

THE QUIET TIME AFTER THE BALLYHOO

The reviews are over and all the proposals are in hand. Now, the critical work begins. With large, ambitious projects this can be an untidy process filled with storyboards, sample tapes, and enlarged theme graphics on foam-core board. There can be scale models, 3D viewers, floppy disks, audiocassettes, and CD-ROMs. With smaller projects, there may only be a thin sheaf of papers in a presentation folder. Equal care should be given in either case.

Assemble the review team and anyone with technical evaluation skills that may be required. Go through the proposals together in order to be able to debate points as they come up rather than going over proposals in isolation and circulating chain memos.

PROJECT CHANGE NOTICE (SAMPLE)

Mindmeld Multimedia, Inc. Date: 4/30/96

Client:	Binkley Screw & Bolt
Job #:	1659GR
PCN #:	1
Requested By:	Leonard Henderson
MM cc:	Gerry Souter, Thurmon Leonidas, Accounting

✓ **Effect on Project:**

Addition:	Deletion:	Change:	Schedule Change:

✓ **Description:**

Total:	

✓ **Effect on Price:**

Plus:	Minus:	Total:

✓ **Client Approval**

Signed:	Date:

The Good, the Bad, and the Surprising

The fruits of the entire process now lie on the conference room table. The vendors have come and gone, their creative presentations spent, their dollars gambled. The marching band has left the parking lot. The clog dancers and bagpipers have changed costumes and departed. The tiger's handlers finally got it back into the cage on the rear end of the pick-up truck. The house custodial staff is working on the stains caused by the clown's gag that went awry. It's been quite a day. When all the hoohah, ballyhoo, and blue smoke have dissipated, there remains the creative concept, the path to its creation, and the budget.

Six or eight proposals lie in small piles of binders, storyboards, videotapes, floppy disks, and one gold-painted brick that was part of someone's metaphor. Each member of your review team's shirt pockets bulge with a wad of business cards. There is a certain gladiatorial moment that comes and goes, surveying the vendors' packages. All have fought bravely, but now the wearers of the purple must turn thumbs up . . . or down.

Since your review team probably represents a wide cross section of different levels of involvement, everyone will probably have a favorite vendor. There are many ways to glean through the first pass, and having each person on the team state a preference can quickly cut to the chase. If the choice is unanimous, then 50 percent of the work is done. If, on the other hand, everyone has her or his own champion, then a discussion of the merits of each is in order. This first pass should take place as soon as possible after the presentations are concluded, or at the end of each day if the presentations are spread over a week of appointments.

It is natural for everyone to turn first to the back of the proposal where the budget resides and recheck the estimated cost. Vendors who have covered this ground many times keep the copies of the proposal to themselves until their presentation is finished then pass them out to the review team. This prevents the reviewers from thumbing through to the back pages to find that dollar amount. If a target budget was not provided and some vendors are way over the top in cost while others are way under, a problem with the request for proposal interpretation probably exists. If most budgets are in line, but are all over the top, then a problem of RFP interpretation *truly* exists.

If clarification is required, contact the vendors and ask them to mail in a brief, amended follow-up proposal allowing for the new information. This is a common occurrence and no face is lost. Of course, had a target budget number been provided at the outset, all this dancing about could have been eliminated.

Figure 9-4. The representative for a world-class consumer electronics firm tendered a six-figure RFP and a vendor was chosen from a large field of bidders. The vendor's team was ecstatic and approached the first input meeting with enthusiasm. At the meeting, the representative dropped three small bombs. First, the client would select their own subcontractor for hardware rather than the one bid by the vendor. Second, the cost of project management would have to be cut since the client representative decided to do that himself, and third, the client would pay the bill only after the project was finished and they were satisfied rather than in thirds as stipulated in the project payment schedule. The vendor team was devastated. They tried to negotiate back some semblance of their vanished profit, but received a reply from behind folded arms, "If you won't do these things, then we can't use you." End of argument. After a week of phone tag with the representative, the vendor had to walk away from the business and ate a substantial cost-of-proposal write-off. The representative went on to cobble together a semblance of a project on his own and when the result was less than satisfactory explained to his client that the vendor had ". . . not bargained in good faith."

Many diverse criteria are used for determining a winning proposal and most have been discussed earlier. Sometimes, however, two or three of the submissions strike a creative chord and have a price tag in line with expectations. A second review is in order.

The Second Review: Making the Cut

To receive a phone call that you have "made the cut" is a happy occasion for a vendor account executive. If the project required a mailed or faxed proposal, the second review generally requests a face-to-face meeting for discussion of the proposal. This allows the vendor to present the creative team, maybe some samples and storyboards—anything to help put a lock on the sale.

If the first review was a full-blown dog-and-pony show, the second meeting should be more intimate. Specific questions, both technical and creative, should be answered on both sides of the table.

The second review provides the vendor with the chance to strike a creative and personal bond with the client review team. The client must decide if the chemistry is right and the answers to critical questions make sense. This meeting can become a mini-brainstorming session where new ideas or spin-offs occur. For both parties, this is the best of all possible worlds.

What about further negotiation?

Does negotiation figure this late in this process? By the time everyone has arrived at the second cut, the proposals have been on the table and the dollar amounts have been put in writing. The vendor wants the job, but also faces certain fixed costs such as subcontractors (programmers, writers, instructional designers, animators, etcetera) with whom the negotiation process may have already taken place and internal rates necessary to keep the net profit within minimum guidelines. By this time, if any discounting has been considered, the numbers on the table include some of those management-authorized parings.

Last minute browbeating of a vendor to further shave an already cut-to-the-bone budget by holding out the carrot of "future relationship" or "a number of projects to be produced next year" (hinting at a no-bid love feast to come) or flexing corporate muscles is considered very bad manners.

What negotiation is acceptable on both sides?

Reviewing the final proposals does leave some room open for further negotiation. It's the very rare vendor who comes to this point in the

process with the absolute rock-bottom bid and it is the rare client that has disclosed the absolute top-end dollars authorized for spending. In most cases, it is the potential client that has the fewest negotiable options due to the complex nature of the average multimedia project. Yet trade-offs are available that can ease the corporate privy purse without seriously damaging the vendor's profit margins.

CLEANING UP THE DETAILS AND PROJECT CLUTTER

While "project clutter" may seem a bit flip, the following items, when properly parceled out, can make a significant difference to the bottom line of the job.

Duplication, Packaging, and Distribution

Every multimedia project must finally be thrust upon its intended audience. In the case of the Internet, of course, the end product is cast upon a hard-drive server of the chosen provider and everyone sits back with a sigh to await results. With portable media, however, the master disk or tape must be replicated and distributed. This part of the project is, essentially, a manufacturing process.

The developer–vendor can design the labels for floppies, the insert for the CD-ROM plastic box, and even produce a bit of artwork to be silk-screened on each CD-ROM disk. With the packaging elements in hand, if the distribution volume is small—100 or fewer—the production house may make a bid if it has CD disk burning capabilities such as a Yamaha or Hewlett Packard CD-R writer. The process of turning out duplicate CD-ROMs is labor intensive, even with a machine that can handle small batch replication. The price will probably be higher than if a duplication house is contracted. This holds true especially for large orders and for floppy disk and videotape replication as well.

A duplication house is set up to automate as much of the process as possible while still providing adequate quality control and random inspection. They buy disks and tapes in huge volumes as well as the accompanying package materials. They also employ legions of workers who do the handwork such as sliding disks into sleeves or jewel boxes and tucking tapes into clamshell boxes, then sliding the labels under the clear plastic holders. Shrink-wrap machines swath floppy disk sets to minimize shipping problems.

Production houses consider this to be *nuisance work,* requiring the hiring of temporary workers and tying up their small batch facilities for days at a time. The same goes for boxing and shipping. While there is money to be made doing these chores, the attendant gross profit is minimal and the person in charge — producer, executive producer, etcetera — is tied up in this postproject clutter when that person could be starting another revenue-generating job. Putting this work in the hands of a duplication house saves money and energy on both sides.

Hardware Rental and Purchase

Hardware rented for a one-shot presentation or a short touring production will generally be handled by the production house with a mark-up for dealing with the logistics, paperwork, and the guarantee that everything required will show up at the venue on time and ready to operate. Most clients are glad to have this part of the project taken care of since they are busy with other internal matters that go with the presentation.

Major equipment purchases, or very long-term rentals are another matter. Most production houses will be happy to specify what technology is required right down to the model numbers. They will even prepare two or three levels of cost versus features breakdowns for the corporate purchasing agent. This service is invaluable to the client. The problem with trying to make money off the actual purchase or long-term rental is a bit sticky, however, for the house. Since most multimedia delivery system materials are available off the shelf at wholesale prices, quoting the retail price then pocketing the difference leaps off the page when examined by the corporate bean counters in purchasing. Most production houses will seek the best deals on off-the-shelf equipment and make their money supervising installation or adding custom-designed elements. Some houses charge a flat fee for their consultation and let the client enjoy savings on equipment that are available to volume purchasing production organizations. A few piratical vendors try to sponge profit off anything and everything, raising the Jolly Roger and handing the Black Spot to Blind Pew as soon as the job is in house.

Often, the client to can do quite well in the purchasing department by receiving a list of specified equipment from the developer–vendor and then handling the buying or long-term rental agreements through company channels.

Travel, Hotels, and Per Diems

Large production houses usually have a designated travel person on staff to deal with all travel arrangements associated with a multimedia project. Others have a contract with a travel agency. A few have both. If a video crew has to travel to a remote location or a distant corporate headquarters, a good producer will ask the client at the outset if the company has any internal travel facilities, or if there is a separate travel budget that can support the costs. If the client can provide airline tickets, hotel accommodations, and rental cars to production house staff during the project's acquisition phase, considerable money can be saved. All work done by the production house, including making airline reservations, will be marked up.

A word on airplane tickets. Everyone likes a bargain. When we plan our vacations, we beg weary travel agents for the best fare packages or pour through the airlines' ticketing facilities on the Internet in search of the stingiest ticket. When shipping video crews from location to location or sending staff persons on fact-finding trips or personnel interviews, providing cheap, nonrefundable, travel-on-Saturday-return-on-Tuesday, open seating type tickets is a bad idea. Weather or machinery breakdowns delay crews. Personal emergencies cause missed interview dates. There are dozens of possibilities for missed connections and when that gaggle of production house people is on the road, the clock is running. They must have the flexibility to change departure times, cancel flights, and reticket to later/earlier ones. Whenever flights are booked to locations, always budget for full fares. This is one time where saving a few dollars can cost a client dearly.

While we're at it, a word on hotels. Having traveled to every state in the Union and over a good patch of the world, your author has experienced a broad range of accommodations. The most terrifying words a producer traveling with a crew can hear from a client are: "We booked you into the local Least Eastern because it's near the factory." A crew usually puts in at least a 10-hour working day. They work hard and lug valuable equipment. At day's end, they should not be on their knees in the shower stall killing roaches with a rolled up newspaper. They should not have to spend the night trying to digest the "Thursday Surprise" spooned up at Bubba's All-You-Can-Eat because no rental car was provided. This is not an exaggeration. A producer is responsible for the well-being of his traveling companions, but if the client assumes responsibility for their welfare and pinches pennies, who might be the loser in the long run?

Pass-Throughs

The *pass-through* relates to any portion of the project that the vendor can "pass through" to the client without charging a mark-up. It is a common term used in fashioning a budget estimate and applies to many of the project elements mentioned earlier. This part of the proposal generally applies to any part of the project where the vendor's margins would jump off the page when compared to the accepted costs of the service or hardware. Charging standard company mark-ups might jeopardize the entire bid. It also applies to any service that is beyond the core competency of the vendor and would require additional clerical work, additional temporary personnel, or farming out project elements to outside sources who discount the work, allowing the vendor to keep the discount and pass on the service to the client at full book rate.

Pass-throughs can sometimes be a double-edged sword. If an element of the pass-through will require the client to interface with a technical aspect of the project that is beyond the competency of the client's staff to monitor, the pass-through might be a bad deal. Paying for the vendor to monitor performance of the proposed pass-through element to ensure a smooth ride for the client should be a consideration in any negotiation. Vendors want to build long-term relationships. They add the pass-through to a proposal as a way to keep their bid competitive, but if by doing so, they hang their client out to dry after their production participation has ceased, that future revenue relationship will be damaged. Realizing this, most savvy vendors will be cautious about exposing their client to problems with pass-throughs.

Before accepting the pass-through as a given, the client should make sure there will be no future cause for regret.

Maintenance Agreements

The maintenance agreement concerning future service and updating of hardware and software is usually a value-added element in the proposal. The vendor offers to provide these agreements to maintain an ongoing relationship with the client. If the vendor does not have the staff to cover the agreement, they usually subcontract the work to specialists. The cost of the agreement is usually based on a flat fee based on established time periods or on a fee tied to actual service calls or client requests for updates. To earn the fee, the vendor offers to monitor the subcontractor and provide the final verified invoice for the work,

making life easier for the client's bookkeeping so no strange invoices cross the accounting manager's desk.

As a negotiating element, the agreement and responsibilities of all parties should be clearly spelled out.

"How can we help . . . ?" These words spoken during the final pinning down of the budget open the door to everything above that the developer–vendor would rather not deal with. Once uttered, the client should remember the list of "project clutter" and think before making the leap to "Sure, we can do that."

10

Managing a Multimedia Project

WORKING WITH THE PRODUCTION HOUSE

This chapter deals with management from the client's side of the desk. Since our premise remains that an outside compilation of talent is responsible for the actual production of the program, client management is seen as being divided into two parts: supervision and approval of the elements leading to the completion of the job. Pert charts and Gantt charts are the preserve of the developer–vendor contracted to do the work. They will present the schedule and check in at the predetermined milestone, supervision, and approval points.

AWARDING THE PROJECT

Awarding the project to the house with the winning proposal is a sweet moment for the client's point person. You telephone the account executive and announce the news. At once, you are loved and cherished. The follow-up meeting is planned. Everyone on the vendor team, you are assured, will be thrilled at the news. Promises of undying fealty are implied. You can imagine the account executive doing a small dance of joy at the other end of the phone. The word will spread through the vendor company and high-fives will be exchanged.

Then come the other phone calls. It is good form to notify the other bidders that they have not won the job. Each call will be a bit draining. Questions will be asked. "Who won the job?" "Was the loss based on bidding too high?" "Was the loss based on . . . (the toughest blow of all) . . . the creative concept?" Answer the questions honestly and let each house know where they were found wanting. Also, let them know their strong points — what your team really liked. It's only fair that they be given the opportunity to review the loss with the idea of improving their process the next time around.

THE FIRST INPUT MEETING

The first meeting will be conducted as teammates with the vendor's people. The proposal will be brought out once again and every item double-checked. This is the time to bring up any anomalies in the proposal that were apparent, but did not seem to gravely affect any portion of either its creativity or budget. These include titles of corporate officials who will be contacted later, locations of materials that may be needed such as graphics, photographs, video clips, or people to be interviewed either for the camera or as content experts. If the vendor is new to your company, they may not be fully acquainted with your culture or key people who were not part of the project review team. Ease them into your company's way of doing business.

The vendor's people will also bring their culture to the table. While every vendor wants to be as chameleon-like as possible to fit into a client's working operation (remember that long-term, no-bid relationship is uppermost in their minds), they bring a certain style to each project. While this style was somewhat reflected in their proposal, the document was crafted to appeal to the company's review team; it was designed to reflect your needs and to make the sale. The interaction at the first input meeting should signal the actual working relationship during the balance of the project. There will be questions concerning what parts of the proposal seemed to really hit home. Was there anything that missed the target? Is the client "comfortable" with the proposed budget? These are important questions and will shape the project envelope in which the vendor will work.

Also, introductions will be made of vendor team members who were not on the proposal presentation team, but worked on it, or will be handling various elements of the job. Included in this round of introductions will be *creatives*, the artists and designers who will do the actual work. Account executives usually request these people to "dress

up" a bit for this critical first meeting, especially if the client company's culture is conservative and has a formal dress code. Cut the creatives some slack. They will do their best, but the odd silver toe-capped cowboy boot, earring, necktie that seems to have been tied once in 1976 and left that way, Bugs Bunny socks, or hair brushed back into a long ponytail will be noticed. This is their "uniform" — the supposed "nonuniform" of the right-brained folk. Creative people may seem uncomfortable at the meeting or may get tangled up in jargon answering what appeared to be a simple question. The conference room is not their environment. There are wonderful exceptions, but what might appear to be gaps in social skills are more than compensated for with facile creative invention and execution.

Another feature of the first meeting, usually coming at the end, will be the contract requiring a signature to bind the deal. Read it carefully or take it with you to send back with a signature after having had time to make sure it is in order. Sometimes, this contract is nothing more than a sign-off page at the back of the proposal. This sign-off means you agree to everything stated in the proposal. Make sure the "project change notice" or other mechanism for altering elements in the proposal is part of the document you are approving. A project payment schedule may also be included. Check to see if the payment method offered fits into your accounting procedures. Sometimes, the persons who approve each payment are limited in their dollar sign-off capability. The amount may have to be paid in slightly smaller chunks to avoid passing the larger amount up to higher officials who may cause delays, because they, naturally, require information about what they are paying for.

In general, the first meeting will lay the groundwork for what is to come, gets everyone acquainted, establishes lines of communication, and provides the vendor with critical information about the project that was not contained in the RFP. If the product, or service about to be launched, or any other proprietary information to be revealed to the vendor requires secrecy, a letter of confidentiality should be presented to be signed by a ranking vendor representative. Production houses are used to these documents and respect them. They have seen corporate security in all its forms.

THE OFFICIAL PRODUCTION SCHEDULE

This initial meeting is also used to set up the official production schedule. If a proposed production schedule was included with the documentation, now is the time to begin to use it as a guide and to pin down

Figure 10-1. A large production house was hosting a very prestigious client who represented at least two six-figure meetings plus a number of video programs and interactive projects. This account executive, always proud of the facility, showed the client representatives from department to department. In each, graphics artists, producers, directors, production assistants, everyone seemed to be busy. At the conclusion of the tour, the client's entourage settled back into their seats in the conference room. As soon as the vendor team was seated, the leader of the client group shook his head slowly. "I'm sorry," he said, "but we can't work with your company." Dumbstruck, the AE asked, "Why not?" "Because," the client went on, "everywhere I looked there were client materials lying out on desks and on display. We couldn't possibly bring our proprietary projects in here." They excused themselves politely and left.

real dates. The average multimedia project has a number of critical milestones that must be met either with client supervision or client approval. Certain products or people must be available on certain days for specified amounts of time. As stated earlier, this production schedule is the "bible" of the project—a roadmap from its start to the conclusion.

The schedule takes various forms from a simple typed list of events and critical milestones to a very complete Gantt chart. Even flowcharts have been pressed into use revealing how each element related to another. Some vendors use specialized software such as Microsoft Project™ to produce very detailed client schedules, resource allotments, and "what-if" scenarios should any milestone fail to be met. Very impressive and not a little bit intimidating, when more basic communications can get the job accomplished.

THE UPDATING PROCESS

At this first meeting some form of updating process should be established. Every company and production house has its own style. Some favor the dated memo, which is printed and distributed. This format is virtually bulletproof since documentation has been created should any discrepancies arise later. Some internal communicators go so far as to send two copies to each person, asking that one copy be signed and returned to the sender's company mailbox—a true "cover yourself" procedure, but one that smacks of a lack of trust. At the vendor's shop, updating everyone as to the project's status, reminding critical people of upcoming milestones, and so on, falls to the producer. This person is responsible for seeing not only that the updates are forthcoming on a regular basis, but that they are *acknowledged.* Determining what form the updating should take sometimes requires trial and error.

It's the client point person's responsibility to keep the producer aware of progress on that front. Overcommunicating is almost impossible to achieve on a multimedia project, but the reason for updating is to motivate action, not provide 8 1/2 × 11-inch coasters to absorb coffee cup rings on people's desks.

APPROVALS

Sign-offs by the client granting official imprimatur to each element are critical in bringing the project to its conclusion. These approvals can be handled in two forms: the written signature or initials on a form or, in

Figure 10-2. A project input meeting was taking place and one of the vendor team leaders punched up the production schedule on a 35-inch video screen at the end of the conference room. From his terminal, he put on a flashy display of mousemanship, clicking through every step of the job and every possible ramification. At the end of this high-tech scheduling demonstration, he asked, "Any questions?" From the other end of the table, the client's senior manager nodded and asked, "When do you need me?" "The 5th and the . . . 25th of June," replied the vendor, clicking away. "Good," said the elderly gentleman, who wrote those two numbers on the very low-tech napkin in front of him, folded it neatly in two, and put it in his shirt pocket. "Please, carry on," he smiled.

Figure 10-3. A large, complex computer-based feature/benefit program was planned for distribution via floppy disk to run on specific company-designed computer systems located at each of their customers' locations. There were many steps in the process, many milestones, client photographs to be scanned into files, technical terminology to be proofread, alternate versions to be designed, and so on. The producer promised at least twice-a-week updating via fax both to the client and her own staff. She began with a chatty two-page newsletter touching all the bases designed to be compiled in a three-ring binder. A total lack of response from the client prompted her to switch to a bulleted one-page sheet for the binder. From there, everything went downhill until she arrived at a once-a-week voice-mail update. That worked and the project was once again in two-way communication.

the case of the script, on a draft of the element itself. The other form is the less satisfactory "verbal" okay.

Vendors often provide sign-off forms, not unlike the project change notice described earlier. For artwork and renderings or storyboards, a printed form for the required signature is provided to be affixed to the element. For any elements you can hold in your hand and peruse, the scribbled initial or sign-off tag is adequate. However, dealing with multimedia elements offers challenges to the approval process. Video clips, theme screens, and animated graphics require particular attention. Since these elements only exist as projected or scanned images, approvals require a dated viewing sign-off for complete security.

For video clips, if the material is original footage shot for the specific use, the "window burn" VHS cassette is a useful tool to facilitate the approval process. Following the shoot, a VHS cassette is created for each camera-original videotape cassette that was shot. This VHS cassette mirrors exactly its counterpart camera cassette and has a space imprinted, or "burned" over the image either at the top or bottom of the frame. In that space, or "window," numbers appear that correspond to the "time code," or identity of that particular frame on the camera tape cassette. As each scene is shot, the camera automatically places the time code on one of the tape's audio tracks or on a *control track.* This code gives every one of the 30 frames per second zipping past the lens a particular identity, or "address," so that frame can be located later for editing. That address is in the form of numbers: hours, minutes, seconds, and frames. The address for a particular frame of video would be, for example, 01:20:15:12, or

01 hours
20 minutes
15 seconds
12 frames

The VHS cassette, as it runs in your cassette playback machine, displays these rapidly changing numbers. By starting and stopping the tape, a segment can be selected by writing down the numbers at its start and at the finish. These segments are logged in the following format:

Scene From	(in)	To	(out)
Gorilla starts to climb building	02:10:21:15		02:10:45:10

This means the scene lasts 24 seconds and 25 frames. Going through the VHS time-coded "window burn" tapes and selecting the best "takes" of scenes allows the producer/director to build an "edit decision list" (EDL) for the first step in the editing process, the rough, or "off-line"

edit. Knowing the length of each scene allows the producer/director to roughly time out the total length of the program or screen time of the clip for the computer programmer. To speed the approval process, a set of these VHS "window burns" is given to the client for review. Today, almost everyone has access to a VHS video cassette recorder (VCR). In this way, the client reviews all the footage that was shot and can indicate "preferred" scenes, or spot anything that was missed during the shoot that could raise a red flag. By returning the cassettes with a simple log of shots, approval of those scenes is granted to the vendor.

If the client does not want to go through that process, then the approval process will wait until the assembled takes are presented in the *off-line edit,* which is described in the next section.

Approving computer-created graphics requires that each element be screened. Usually, this is done at the vendor's facility, especially if the graphics were created with high-power graphics software that is not found on most clients' computers. Changes are easier to make while the images are in their original environment. All graphics images are transportable. The more complex images require a considerable chunk of computer memory and data storage space. In this case, special cassettes such as Iomega Zip™ disks or SyQuest™ cartridges are used to move elements from computer to computer. Again, however, the drive units that record and play back these elements are not common to most business computer installations. If the element can be compressed using a data compression program, it can be transferred to a common floppy disk. A *run-time program* is included with the image. This bit of computer code allows the client to view the image on a compatible computer without needing the software that was used to create the graphic. Another method of transporting graphic images is to convert them to videotape using special digital-to-analog converters. The tape can then be played back on any VCR, with some loss of quality from the original computer image.

Transporting graphic images by floppy disk or videotape can often require at least one "conversion" to a floppy or video compatible file format. Conversions can sometimes alter image size or quality and this must be explained carefully to the client. *The approval process is a part of the whole project that must be addressed early in the budget approval stage.* Approval file conversions take time—billable time—and must be figured into the project costs up front.

Live talent approval when professional actors or narrators are required is another special case. Talent agencies furnish 8 × 10-inch photos with biographies attached. These pictures can be used for initial choices of the talent's "look" and professional background. However, not all agencies furnish up-to-date pictures. A five-year-old photo can

be very misleading. Auditions should be scheduled and budgeted for this stage in the approval process.

The best auditions are conducted live with the client present at the vendor's facility. In this way, the talent can be seen in three dimensions, can try different readings of the copy, and can work out an interpretation of the material on the spot. Unfortunately, the live audition is not always possible.

If the talent pool is located in a city where the shooting will take place, then the auditions can be videotaped or performed live for the client at the talent agency. Most agencies provide this service for a fee. When the audition must be taped, this requires the director, producer, or associate producer to go to the location and conduct the audition. The tape is then screened and candidates are selected and approved. This form of "canned" audition can also be used if the client cannot come to the vendor's facility.

Voice-over talent or narrators who will not appear on the screen can be selected from audiotape samples. Often a vendor will use a sample tape provided by most voice-over talent agencies and cut together a selection of voices considered suitable for the project. In other cases, when the client wants a wide choice of voices from which to choose, a copy of the entire agency sample tape is sent to the client to make a first, second, and third choice. At least three choices are preferable since talent and recording studio schedules must be coordinated to fit into the project schedule. Celebrity voices are particularly sensitive to scheduling since they are usually in demand. This consideration also applies to celebrity on-camera talent.

All talent selection and approval should be scheduled early in the project to avoid conflicts later in the process.

Music approval is best done at the audio house with the client present. Music and sound effects are often personal choices, but the client may have a better "feel" for the type of music preferred by the audience. The client should also have a knowledge of the "history" of other previous projects and can avoid re-using a music theme from the recent past. Again, if the client cannot be present, then it falls to the producer/director to make selections and send off an audiocassette for approval. Music should be selected from stock libraries unless the client is prepared to pay for researching licensing rights and the legal entanglements required by commercial music distributors.

Approvals provide the comfort factor for both client and vendor as the project proceeds through its stages. A checklist of every approval stage should be part of the production schedule and the "wheres" and "hows" should be determined at the start together with the costs involved.

SUPERVISING ELEMENT CONSTRUCTION

Sitting in on video shooting, editing sessions, and graphic art rendering sessions is part of the client point person's responsibility. These are, literally, the touch points where images and ideas are created and juxtaposed. Most point persons and often the retinue of team members look forward to these interludes away from their normal work routine. The darkened sound stage with its cameras and crew members bustling about, the artist at the computer making subtle changes with the swirl and click of a mouse, the dim-lit editing suite with images and sound tracks running forward and back amidst a glitter of colored light — these are different worlds.

The reality of supervising these events usually falls short of the expectations of point persons new to the processes. The actual process, after two or three hours, can deliver all the excitement of watching paint dry.

Once past the obligatory donuts and coffee, good humored bonhomie, and initial explanation by the producer of what is taking place and the responsibilities of the client team, the serious work begins. The people actually doing the work — the director, camera operator, director of photography, artist, editor — are serious professionals going through the necessary evolution of the process to achieve the desired result. These evolutions are often repetitive and time consuming.

In the sound stage, or on location, the director of photography is fussy concerning the placing of lights, the video technician is fussy concerning microphone placements and sound levels, the dolly grip is fussy concerning the movement of the camera down the track. They are all fussy, working hard to produce that quality of video that seems unforced and seamless to the viewer. The director is fussy about performance and camera framing to achieve continuity with not only the shot in hand, but the shot that precedes it and the shot that comes next.

At the graphic arts computer, the artist is aware of the software conventions and protocols needed to create changes in the screen image. Behind each evolution of prescribed controls lies a block of unseen computer code that must link with other blocks of code to form yet another strand within the sometimes fragile web that constitutes the total screen experience. Often, the path to a seemingly simple change requires a convoluted series of commands that have no apparent effect on what is visible other than a series of pull-down menus that zip past in an incomprehensible flurry of mouse clicks.

The editing suite is a cozy, quiet room that comes alive with sound and images as the editor manipulates buttons and controls to juxtapose

images and match sounds, voice, and music. Here, the process is measured precisely in frames. Edit lists must be typed in seemingly endless lines of time code and remarks. The images roll forward and back as frames are trimmed and added to achieve seamless joinings. At first, everyone chuckles when the music or voice tracks are run backwards to edit points. Familiar speaking voices sound like the cartoon chipmunks "Chip 'n Dale." After the fifth or sixth rendition of high-speed babble, the novelty wears thin. The editor is striving to create a whole from many parts. The hours begin to drag. The lunch break can be an oasis of relief.

The *off-line,* or pre-edit, part of this process requires an additional caveat. The off-line edit is where most of the creative decisions are made. This edit suite is less sophisticated than the on-line suite where the final product is completed.

The two basic types of off-line edit are *linear* and *nonlinear.* Linear editing is traditional videotape "crash" cutting using one or two machines for source tapes (those "window-burns" described earlier) and their images are assembled on the tape of a third machine to create an off-line "master" tape. This linear editing is crude (hence, the name "crash" edit) and requires much shuffling of the VHS cassettes into and out of the source machines. The edits are usually "butt" edits — no slick dissolves or effects from scene to scene, just hard cuts. The end product is a rough sequencing of the scenes complete with voice and/or music. From this off-line master, the in–out points of each scene are either laboriously copied onto a log sheet or compiled automatically on a printout or disk. Making radical changes throughout the edit requires considerable hand reshuffling of cuts and adds quite a bit of time to the process. The client supervising an off-line edit requires a visual leap of faith when the editor says, ". . . and here we'll use an effect to show the Blinder Grinder rising in its final form from the jaws of the Pocketa-pocketa machine. . . ." Selling this off-line edit also requires a bit more salesmanship back at the company review.

Nonlinear editing offers a closer approximation of the final product. All of the tape material is turned into digital information and, by using masses of computer memory and very fast video processing components, the editor cuts together digitized renderings of each scene. Here, dissolves and some effects are possible, making a slicker final product. Adding or swapping scenes can be accomplished with a few mouse clicks and the edit list is automatically corrected. At the conclusion of a nonlinear off-line edit, the digital version of the program can very closely approximate what will be seen in the final on-line edit. One exception is the digital "look" of the cut. The images do not look "sharp," because

they are made up of tiny, square pixels. When the digital version is laid off to VHS tape for review back at the company, this softness must be taken into consideration. Nonlinear off-line editing can cost about one-third more than linear tape editing, but the edit list produced by the non-linear system can often be fed directly into the on-line edit suite's computer for virtual auto-assembly of the final product except for special effects and changing tapes. In terms of on-line edit work, this saves from one-third to one-half of the time normally required — more than paying for the cost of the off-line edit.

Nonlinear or "tapeless" editing is now being used in the on-line suite as well and, taking advantage of refined computer innards and even more masses of memory, the final program image is as crisp and clear as the original tape footage. The "tape" used in this process is disappearing in favor of direct digital recording to a memory and the visual scenes are downloaded directly into the edit system for nonlinear assembly.

Fortunately, most clients are never required to watch the computer programmer work. An exception to this would be the programmer-as-author who is working with a shell program that manages images, sound, video clips, and text. Instead of using hundreds and thousands of lines of typed-in computer code, the shell software uses a simplified language, mouse-click icons, and real-time manipulation of images and sound. Macromedia Director™, available in both Apple and PC versions, is such a program. With all of the elements reduced to compressed data video files, graphic files, and .WAV or MIDI files for sound, the programmer becomes a combination author, director, and editor, producing the final version of the program right on the screen. This is fun to watch.

Supervision of these touch points can be a rewarding experience if the client is forewarned and the producer makes sure each step is understood by the observers. When the process is complete and the lights and cameras struck, the graphic files saved, and the edit master tape completed, the client observers will be responsible for approval of the final product. Acceptance of the rendered images and sounds constitutes approval. Changes will require additional time and dollars. To lose concentration and let decision points slip by costs the client money at a later date. To not speak up and question a part of the process as it is happening is to abrogate responsibility.

While it is the producer's job to make this responsibility clear at the outset, it is the client's responsibility to hold up his or her end of the bargain, to watch, listen, and question when something is not clear.

Supervising construction of project elements is a team effort between the vendor and the client. Each must accept their individual responsibility.

Figure 10-4. A client group had followed the production process closely through videotaping and graphics rendering. At the off-line edit session, the team of four had squeezed into the small edit suite and approved the rough cut. On the day of the on-line or final edit, the team of four again dutifully showed up. Before the edit began, the producer explained that each cut contained complex effects and would take time to assemble. At the beginning of the session, their attention was rapt. It was like having Mount Rushmore peering at every cut and nuance of sound. By the second hour, they began to make telephone calls concerning other elements of the overall project. They began to chat among themselves. The producer called for their attention as each final cut was ready to be viewed. They would nod collectively and get on with their other business. The entire day passed in this fashion and at its conclusion, the completed edit was run. As the final frames faded to black under the closing music, the edit suite was silent. Then the questions and suggestions for changes began to flow. The dejected producer and editor could only sit and make notes as the team tore apart the video they had been supervising and approving along the way. In the end, a second — unbudgeted — edit had to be scheduled just under the delivery deadline, costing the agitated client a significant amount of money.

THE HORRORS OF "CORPORATE ENHANCEMENT OF THE EVOLVING PROJECT" OR C.R.E.E.P.

The outline and objectives of a project are established at the beginning of work. Since some projects require months to produce, a certain discipline is required to keep focused on those objectives and the path established to attain them. Following the typical pattern of analyses depending on the objectives of the project — instruction, advertising, entertainment, or a combination of all three — the project flowchart becomes the bible. This chart showing the structure of the program and its paths laid out for the user is tied to specific tasks to be accomplished by the content and production team.

As the months of teamwork progress through each element, growing familiarity with the process often leads to an awareness by the client of fields yet unconquered. Some of this awareness is fueled by other members of the client's corporate community blue-skying a few "what-ifs."

> *What if, besides teaching the flimet grinder operator how to properly kernel the staging edge, the program offers inspiration by running information clips on the successes of Great Flimet Grinders of the past? All you do is add one more button to click on marked* Great Grinders.

While project developers cleave to their carefully reasoned flowcharts like a drowning man to a life preserver, the client is the 900-pound gorilla when it comes to deviations from the path. Walking into a developer's office often reveals a carefully computer-printed flowchart tacked to a cork board. On the chart, pencil and pen "additions" are usually present. This is C.R.E.E.P. In computer parlance, the client has "hung a bag" on the original design.

Immaculate reconception changes of this kind are not all bad. Often, some additional feedback need or line of communications is uncovered as the project proceeds. This is particularly the case with instructional projects. Corporate image projects are sometimes caught in company redefinition programs where emphasis has been shifted to other product lines or a new manager sees a different perspective to develop. The long production time for these projects really requires a seer with a ouija board to predict where any of these ambushes might occur.

The developer must understand that these changes are very real agendas to the client — even if they seem to be driven by whimsy. No client wants to jeopardize a project into which sums of hard-earned

dollars have already been poured. And the client must have respect for the developer's analysis if the suggested change suddenly devastates a critical part of the program structure and threatens to add considerable time and dollars to the original estimate. Economic considerations are the great leveler for most radical changes. What seemed a "must-do" suddenly becomes a "well-maybe" and finally emerges as a "we-can-live-without-it."

Immaculate reconception C.R.E.E.P. can almost never be totally avoided as long as people create multimedia, but the importance of planning up front and as much crystal ball gazing as possible at the beginning cannot be overstressed.

The techno-wow! type of C.R.E.E.P. is quite another matter. As discussed earlier, most complex multimedia projects take months to complete. Most of them make use of many different technologies: video, graphics, audio, and programmed feedback systems. As the project is planned and flowcharted, the technology becomes intertwined with the logic path. To illustrate this, many developers use at least three levels of flowchart.

The first level is an overview for the team and the client and demonstrates the basic logic and decision points and shows what will happen at each stage as the user progresses deeper and deeper into the structure of the system in search of enlightenment.

The next flowchart level is for the programmer. The client very rarely sees this series of charts, because of their complexity and the code conventions that are mother's milk to programmers, but are chicken-scratches to the uninitiated.

Farther along comes the chart for the media designers. This chart reveals the media choices and where they pop up as well as screen-time duration, number of screens, buttons, and icons, as well as a rough estimate of the memory usage required of the appointed computer data storage system.

These three levels perform different functions, but are nonetheless intrinsically tied together. They interweave, intertwine, and interconnect to form the whole reasoned multimedia concept. Techno-Wow! C.R.E.E.P. (TWC) comes to this carefully ordered universe like a full swing on a golf ball in a tile bathroom. Development time is the yeasty brew from which TWC emerges. As we are all aware, technology has been galloping along at an exponential rate, burping out new whiz-bangs in every edition of media and computer magazines. New storage systems, new language variations, new graphic software, new video compression standards, new transportable media options, new Internet browsers, new alliances between former rivals aimed at plunging us all

into bankruptcy trying to keep up with all the even newer stuff in the planning stages — all of these new things are swirling about us in a blizzard of press releases.

TWC thrives in this environment, because chances are that the core technology specified for any particular project will be "mature," if not on the road to being obsolete, before the project is completed. To the client project manager (and to some deranged developer–vendors) who can't wait to open each new Sharper Image catalog, this is blasphemy. To these folk, the phrases "state-of-the-art," "cutting edge," and "pushing the envelope" are concepts to live by (not clichés to gag over), otherwise why would they be committing to multimedia in the first place?

TWC usually starts out with a phone call from the client that begins with "We'd like to get your opinion on (fill in the blank)." If the contacted contracted developer comes up a bit ragged on the details concerning the latest *wunderthing*, then the client can suggest the vendor take two press releases and call back in the morning. If, however, the developer has seen the most recent specs on *whateveritis*, the response can be a brief pithy definition of the Velosoftraptor Version 1.0 and state with great honesty and a minimum of guile that it will be interesting to see if it survives to the end of the year based on actual user response. So much software and so many hardware "breakthroughs" end up the year as coffee cup coasters and paperweights. Parry, thrust . . . point taken.

The client that suggests midstream TWC corrections in technology for whatever reason should bring deep pockets to the discussion table *unless* knowledge of the proposed technology was available at the time of the project start and was never introduced into the possible media mix by the developer. In this case, the developer should be asked to defend the media chosen over this new technology that might have been "pie-in-the-sky" vaporware at the time of the media decision. As we've stated numerous times in this work, new isn't necessarily better, it's just new.

Any type of C.R.E.E.P. makes for an unsettling situation where second-guessing holds court. Good developers spend a great deal of time with a pencil in preparation prior to setting the structure in ink. Once begun, good developers secure a considerable degree of ownership over the success of the meticulously planned project. The client, who must live with the result of the money, time, and effort has an obligation to seek the best return on investment (ROI) on all levels of the final project. The best way to overcome C.R.E.E.P. is to revisit the maxim that states "the best multimedia is the result of two-thirds planning and one-third execution."

FOLLOW-UP MEETINGS

The follow-up meeting is a pleasant luxury that should be indulged as often as practical. Most of the time, the company team and the vendor team are working away in their respective camps, keeping in touch via phone, fax, e-mail, and scheduled element supervision days. Today's communications capabilities have tended to isolate working groups and minimize touch points except for designated hand-offs when an element is completed, ready for joining to the whole. This isolation denies the interchange that can jog new ideas and cross-fertilize the elements of a project.

The follow-up meeting provides the type of contact discussed in Figure 10.5 between client and vendor at various milestone times throughout the project. Face-to-face discussions of the project can help keep everyone's focus sharpened and also avoid miscues later that are not always clear in a fax, a clipped voice mail, terse e-mail message, or a little yellow sticky on a memo.

PAYING THE BILLS

While this may seem an obvious heading, the process of bill payment has caused more than a few projects to grind to an uneasy halt. As mentioned earlier, most project contracts will include a payment schedule designed to keep everyone content as the process rolls along. Often, this schedule is compiled by the vendor with the duration of the production process in mind.

Since most multimedia projects are long-term affairs often requiring months to complete, the most common payment format is in thirds. At the beginning of the project, one-third of the total estimated budget is required from the client. At the halfway point, another third is requested, and before the project is released to the client, the final third passes though the mail. Vendors prefer to work with the client's money in hand. Multimedia projects often require the services of specialty subcontractors such as animation houses, programmers, and video crews. These folk also require money up front. While larger production houses are usually sufficiently capitalized to shell out down payments to subcontractors before client cash is in hand, the smaller shops cannot always offer the same cash reserve largesse.

Since the vendor sets up the payment schedule with a time line in mind, the client must agree to the amounts of each payment and make sure they fit into the dollar sign-off capabilities of the production team.

Figure 10-5. A graphics department in a production shop employed many computer artists. They were ganged together in a bullpen due to the rapid expansion of the department and the limitations of space. Eventually, management decided to remodel the department, since most of the artists were complaining about lack of privacy and the ability to concentrate. The department was carved up into individual cubicles ranked in rows. Now, each designer had privacy and could concentrate. Soon, however, privacy became lonely isolation and the artists looked for excuses to wander about and meet in the cafeteria. They missed the human contact of their former quarters. The company, with an eye to productivity, reshuffled the cubicle partitions until the individual spaces were arranged in an open circle with a table and chairs at the center. Now, an artist only had to swivel his or her chair around to see what other people were doing and to feel part of the group again.

Figure 10-6. A project was begun with great enthusiasm, high-fives, and a flurry of activity on the part of the vendor to secure the long-term services of a writer, programmer, and instructional designer. The contract and payment schedule sailed through the client's project team signature routing. Two weeks passed as the elements and final production schedule fell into place. As yet, however, no first payment had arrived. After the third week, the vendor's accounting department sent a red flag memo to the producer and account executive. A phone call to the client point person brought forth a surprised "I'll look into it right away" response. The client had dutifully passed the payment schedule to the division manager as required by policy. The amount requested for the first payment was just outside the manager's sign-off approval so he bucked it up to the next level with an attached memo. The next level manager was at a team building conference in Florida for a week. To save time, his assistant bucked it up directly to accounting with an attached memo. Accounting didn't know this project from deep center field and sent back a funds requisition order form. By the time the project point person, who had been engrossed in managing the multimedia job, headed up this steep paper trail, he met the funds requisition order form coming down. The point person fired off some polite rockets, eventually requested a meeting with the head of accounting and had a special check cut. Following an embarrassed call to the vendor account executive, the project was once again on track.

Most companies assign maximum dollar approvals to different levels of management. The project point person must make sure the dollars required for each payment are within the approval range of the highest level of management that is familiar with the project. Blind acceptance of the payment schedule without this consideration can cause problems down the line.

Considering the scenario presented in Figure 10.6, by simply scaling back the payment schedule from three large payments to four smaller payments, the point person could have been saved time and embarrassment. Most production shops will be glad to make this accommodation to ensure a smooth cash flow. Project change notices, described earlier, that have been approved usually are invoiced separately from the scheduled payments unless they occur far enough along in the project to be included with the final billing.

Shorter term projects follow a truncated payment plan requiring two payments, one at the start and the concluding one at the finish before the project is delivered. Long-standing clients often squeeze in quick turn-around jobs without the up-front payment. Since most invoice terms are 30 days from receipt of the bill (an entire project can turn around in 30 days!), most production shops are flexible if the client has a good credit history. On the other hand, if the client falls into the cash-on-delivery (COD) category, then the project's deadlines and life expectancy become doubtful. The COD project also erodes morale on both sides of the table. The thought of cost hangs over every decision. Once a client achieves the dubious COD label, the client/production house relationship can never be the same.

FINAL REVIEW AND EVALUATION

The project has rolled through all the required processes and now stands in its final form as indicated by the string of approvals in its wake. The project review is the last critical step before entrusting these labors into the hands of the intended audience. This, possibly, is the first time all of the elements have come together to form a cohesive whole.

The vendor has pruned and weeded out the niggling faults and debugged the computer programming. The video has been refined. The control interfaces have been tested. All of the hardware has been set up and checked out. The bagels, coffee, and pop are on the sideboard. This is the client review. From the vendor's viewpoint, this is the moment of truth. Here also is the final critique for the client, the project that will be exhibited under the company name — theoretically the

Figure 10-7. An entrepreneurial client commissioned a series of three interactive, animated short subjects for use in a children's entertainment game. The production house accepted the deal based on payment for each subject as it was completed. Everything moved forward with a rush. The payments came in within reasonable time and the critical success of the project was enormous. The entrepreneur's company expanded, added manufacturing facilities and personnel. Copies of the games in foreign languages were requested as overseas markets opened up. The games won a national award. Then the vendor's accounting department ran up the first red flag. Two payments had not come in for the foreign translations. Phone calls from the vendor brought no relief. Unable to keep up with demand for the game hardware, the client had the vendor's software in hand so the vendor became the least squeaky wheel. All income had been diverted to building hardware. Within two months, the client was COD-only and long-term payment plans were being discussed. No additional games could be built to follow up customer demand. Everyone on the vendor side was burned. The company imploded and the money owed is expected to be repaid by the year 2010. Moral of the story: Never let euphoria overcome good accounting practices.

final sign-off. Everyone involved is anxious to see the project shine, to reflect the hard work, long hours, and creative efforts of both the company and vendor teams.

The more complex the program, the more user choices, the more elements, the longer the review. Now is the time to be hypercritical, to put yourself in the place of the audience. If the program is interactive, bring someone into the team who represents the audience, but has never seen any of the project elements in development. Let them approach the program with a fresh attitude; someone who hasn't had to sit through hours of editing, sheets of storyboards, and reams of text. To mix metaphors, "familiarity breeds a blind eye." If the program is transportable to the company computers, take a copy back to the office. If the final product runs on specially configured computers, make sure it is tried on more than one hardware setup.

Does each element complement or contribute to the audience experience? Do some elements seem to hang on the screen too long or too short a time? Does the humor work? Does the president's message seem sincere and is it in the right place in the project's running time line? Are the icons awaiting a user's mouse click too abstract to be recognized? Is the music intrusive in context with the other elements? Is everything absolutely wonderful?

Depending on the project, client reviews can last from a few minutes to an entire day. On complex projects, often a beta version is submitted to the client to be tested on the client's turf prior to the final review. Having the people who created the elements hanging about as the program is reviewed can be both intimidating and can create an atmosphere that is counter to really critical comment (". . . gee, the guy busted his butt getting this screen the way *I* wanted it. I hate to tell him it doesn't look as good as I thought it would."). Colors, music, images, and shapes are now brought together and it is no time to hide behind ego — or to bulldoze forward with what obviously isn't working — if the combined result is less than exquisite.

Another review option is the *focus group.* This collection of people representing a cross section of the intended audience is pulled together by the client if the audience is employee based, or if the audience is more general with the help of a survey company provided by the vendor. These companies specialize in drawing together demographic groups for advertising agencies and conduct very controlled reviews — for a price. The focus group can be used both at the beginning of a project to determine audience needs and at the end to review the product. Their responses are monitored, their questions noted, and modifications are made.

LAST MINUTE CORRECTIONS FROM ON HIGH

It is with a chilled spine that most company project manager/point persons present the finished product to upper management as a fait accompli. "Here is what we're sending out to the field, HJ." or "Thought you'd like to see this before we load it into 600 stores." or "Thought you'd like a personal copy of our multimedia extravaganza — the one you approved a few months back." Two days later, a memo arrives: "Jack, we're announcing an expanded equal opportunity program in two months. Put in a couple more African-American and Hispanic spokespersons." or "Find a different photo of the corporate headquarters. I'm tired of looking at that view."

Sometimes, an amended budget showing the effect of such a change — the ubiquitous project change notice from the vendor — submitted to the box atop the corporate organizational chart can filter out whims from real company concerns. If the changes really must be made, the vendor is sympathetic, but also realizes an additional few thousand will be added to the project cost and to the production shop bottom line. Hurrah.

To forestall this type of executive ambush, some companies send a copy of the beta version up to the carpeted offices. This is both courteous, good politics, and allows any changes to be incorporated into a version that is still malleable.

BON VOYAGE

In a crush-proof videotape box with custom label, on a set of floppy disks, burned into the micron-size hills and valleys of CD-ROM or LaserDisc media, applied to a whirling segment of hard drive, broadcast to a satellite transponder or uploaded into the busy ether of the Internet, the project is launched. Duplication, distribution, and maintenance agreements are the final elements in the project creation chain. (Refer to the section in Chapter Nine, "Cleaning up the Details and Project Clutter," for a discussion of these elements.)

IMPORTANCE OF FEEDBACK

It's nice to know if all the work was worth the effort. For the client, justification of the expenditure is reason enough, and for the vendor, the knowledge that their creation was a success is useful in bidding for

future projects as well as sending a positive reinforcement to all the staff who participated.

Often, following a big launch or major meeting featuring the multimedia project, a gushing letter is returned to the production house. If the experience was a good one for the company team and they saw smiling faces at the presentation, or applause was sustained and back-patting resounded through the hall, the letter is sent praising the vendor team.

This is not feedback. This is a gushing letter from the company team in the euphoria of early days. True feedback is a quantitative, qualitative measurement of success. Did sales show an upturn based on skills learned in the training program? Are copies of the tape or CD-ROM flying off the shelves? Is the sales force reporting a higher number of closings when they showed the project to potential clients? Are Web surfers of the targeted audience stimulated enough to actually fill out the questionnaire, or call the 800 number, or respond with an e-mail? Is the interactive kiosk delivering the expected new customer demographic? Did traffic at the trade show increase over last year due to the video wall and interactive computer terminals?

Arranging for some form of feedback in the design of the project is important; following up on the results is critical. Videotapes can include an 800 number for viewer response. Programmers can include "counters" in interactive systems to determine user frequency, user involvement, or length of time spent in the program. Built-in modems can relay these data to where they can do the most good. Web sites can have an e-mail link to send meaningful feedback to the client's mailbox. Web site "hits" can be recorded and identification of the "hitters" can be determined by their uniform resource locator (URL) address, which has been left behind as a "cookie."

IMPORTANCE OF DEBRIEFING

The dust has settled and everyone involved has a divided mind. (A) "Boy, I'm glad that's finally over" and (B) "Okay, what's next?" There remains yet one final step that should not be ignored: the debriefing session.

Most debriefings are called when the path to the final product has been a rocky one, or has had moments of finger pointing, or has escalated wildly over the original budget estimate. On the vendor side, these sessions are called "The Hunt for the Guilty" and can be grim affairs. The account executive rounds up the team, usually before or after work hours or off-campus and presides with the list of offenses. Wretched though they are, kinks in procedure are often discovered,

Figure 10-8. As a new computer was introduced to the sales force, a pair of floppy disks containing a training program on the machine was sent to each key distributor. The program consisted of a feature/benefits section produced as a series of catchy cartoon screens and simple animations. Following that section was a quiz. The distributor had to pass the quiz in order to get to the competitive equipment comparisons, package costs, acceptable discount ranges—the meat of the sales information. Upon passing the quiz, the score was automatically sent by modem to the company headquarters. This information not only showed who was using the system, but their learning curve—how many tries it took to pass the quiz—and what questions seemed to stump most people. Due to this feedback, the presentation of features and the quiz were constantly scrutinized for content and clarity from edition to edition. The programs became popular with the distributors who used the feature/benefits portion of the program as a successful point-of-purchase selling tool.

false assumptions paraded, and communications flaws unearthed. For the vendor or client, they can be a catharsis that indelibly stamps the need for change on the faulty aspects of the program's toolbox and management.

The best debriefings are the ones where the costs came in on the sunny side of the estimate and all midproject course corrections were handled with professional ease. The final project has the client rhapsodizing and long-term feedback estimates are rosy. Everyone is full of themselves and goodwill toward fellow workers. Here and there, a niggling stumble is massaged, but, in essence, all is well with the world.

Any debriefing on the vendor or client side of the table is worthwhile. Most fall between the extremes noted and all teach lessons about the ugly, the bad, and the good way of creating a multimedia program.

SUMMARY

Every multimedia project requires interaction between a diverse cross section of people with varying levels of job skills and interpersonal skills. It is an experience that blends the normally exclusive realms of art and commerce. The shirt-and-tie set meets the earring-and-ponytail set in a venture that requires high energy from each group. This chapter has attempted to shed light on how each party approaches any given job and suggests some methods and insights that can help smooth the way. It is a story about relationships as much as it is about procedures and protocols.

Every person who seeks to participate in this fast-paced evolution of audio, visual, and tactile communications must be equipped for a long haul of unique and enlightened experiences plus an enforced regimen of focused attention to details. They must appreciate the needs of the person who is seeking to communicate and the person who has the tools to communicate in this bewildering, brave new multimedia world.

Part Two

11

A Guide to Digital Media

INTRODUCTION

The chapters in Part Two examine the various multimedia delivery systems (media) available to the client. Suggesting a medium for delivering a multimedia program would logically be the job of the developer–vendors since they have their fingers on the technology pulse. Reality, however, usually reverses this process. Most clients call a vendor and ask for a video, a CD-ROM, or a Web page on the Internet. To be accommodating (and keep the job), many vendor shops will follow the client's lead and try to please. The pages devoted to the subject of choosing digital media were compiled to keep this book rooted in reality. It is a guide based on practical experience and research. Whether a developer–vendor chooses to be accommodating and follow the client's lead or be consultative and offer alternate technologies to better meet the client's goals, all too often a medium has been prechosen by the client. From the other side of the desk, clients in search of a medium for a project are sometimes approached by a vendor who, in an effort to snag the bid, offers a medium that is "new" or has received a lot of recent press and is a "hot" trend. Also, as presented in the previous part, sometimes a vendor will "push" a technology because they have a great deal of capital invested in it: hardware, software, designers, and programmers.

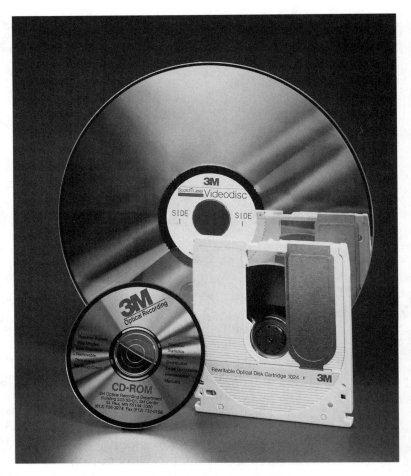

Figure 11-1. A variety of transportable media, including a video disc (LaserDisc), CD-ROM, and rewritable optical cartridge. (Courtesy of 3M, Minneapolis, MN.)

THE PROLIFERATION OF DIGITAL MEDIA DELIVERY SYSTEMS

Knowledge is power, so here is an overview of the proliferation of digital media since the personal computer matured beyond the word processor and spreadsheet phase. It touches on the relatively short time line during which all these media have been developed. This rapidly compressed time line produced by exponential jumps in technology is responsible for a wide variety of media options that coexist.

CHOOSE YOUR PARTNER

Since the variety of multimedia applications is constantly expanding, matching up the application with the best type of delivery media has become a quest. While many developers automatically reach for the CD-ROM tools, real-world multimedia needs cannot always be hammered and stuffed into that particular niche. Choice of media is made using at least four criteria: (1) the required job of the application, (2) the environment in which the audience interacts with the application, (3) the capabilities of the installed base of playback hardware used by the audience (Do they have a CD-ROM reader? Are they logged onto the Internet?), and (4) the costs of production, the interface system hardware, and distribution.

WHAT DOES WHAT THE BEST . . . AND WORST

Delivery media are developed to replace mature media now in use and to establish totally new resources for application capabilities. No delivery medium can fill every multimedia need. Therefore, while new media proliferate, this does not mean that not-so-new media become so much digital scrap. For example, no digital media at this writing produces full-screen, real-time video of the same silky quality as the mature analog video disk. No CD-ROM can deliver a small application (less than 6 to 8 megabytes) as inexpensively as floppy disks or as fast as the computer hard drive. On the other hand, the floppy takes an eternity to transfer data and the hard drive is often stressed for space in corporate workstations or network servers.

APPLICATIONS AND THE MEDIA THAT LOVES THEM

An application is designed with a job in mind. The job requires that human beings have a satisfactory experience when they interact with the application. They could care less about the arcane programming and complex production processes required to pop that screen up so they can trackball their little hearts out. Most applications come with a given set of requirements. For example, point-of-purchase programs should have the capability of updating prices and swapping SKUs or products as new ones replace last year's model. Training programs should have remediation feedback for students and often a quiz to

check progress. Kids' programs need graphics and fast information transfer catering to children's short attention spans. Big screen applications need highest quality video while portable applications have to cram the most into the smallest digital space.

WHAT TO EXPECT AND WHY WE DID IT THAT WAY

We examine each medium with multimedia in mind. While some are very well suited to large interactive applications, others fill a different, developmental role. With the trends in media rising majestically to the surface, then disappearing again, it's nice to know some of the background behind each medium's development and its current place in the media hierarchy. Each one will be examined using the following criteria, though not necessarily in this order:

A brief history of the medium's development
Description of how it works
Pros and cons of its operation
Unique development considerations
Best-suited applications

The major division between media categories is made up of two parts: *transportable* media and *wired* media. When the idea for this book was put forth about three years ago, the Internet was a vaporous place where gearheads thrived, huge databases invited exploration, and chat groups (the good, the strange, and the truly weird) flourished. New users groped about with file transfer protocols, gophers, and a new tool called a *browser* that would help you find pages in the empty, echoing halls of the World Wide Web. Today, the Internet and specifically the Web is a place of growing multimedia presence and interactivity that corporations are exploring with a vengeance. Each week something new evolves. We'll take a look at some of the possibilities of multimedia life on the Internet and in the future with the new cable modems after we look at our transportable media options.

12

In the Beginning
The Floppy and Why It Still Lives

The hard-shell, 3.5-inch floppy disk has been established as the low-rent digital transfer medium since it began to replace the 5 1/4-inch truly floppy disk in the early 1980s. Its common capacity today is 1.44 megabytes, but that capacity has been extended to 2.88 megabytes. It is simple. It has a slow data transfer rate. Virtually everybody's computer (personal digital assistants are excused) has a floppy disk drive. The disk is cheap to produce, to distribute, and to package. The drive systems are inexpensive and have a 20-year track record.

Back in 1982, at the National Computer Conference in Houston, Texas, Sony showed its SMC 70 computer complete with two 3 1/2-inch floppy drives. At the same show, Matsushita introduced the *compact floppy disk drive* using a 3-inch version. Among computer buffs in the United States, the reaction was a thundering silence. These disks housed their media in a hard-finish shell with a machine-activated protective shutter that allowed better protection for the fragile oxide-coated media surface than did the de facto standard, the soft-covered 5 1/4- and 8-inch floppies of the time. The Sony disk also provided considerably more data space by using a higher speed rotation combined with a more dense application of magnetic media on the surface.

Computers in the early 1980s were expensive affairs that used a fraction of the software available today. Introducing a new disk format that would make obsolete every drive system in use was a touchy situation. But computer manufacturers, always on the alert for products that

would make obsolete every piece of hardware in sight, gradually tooled up. In the United States, the Amdek Corporation produced the Amdisk, a 3-inch knock-off. Both Tabor and Seagate tried a 3 1/4-inch entry that "flopped," so to speak. Canon pushed the 3.8-inch micro disk, and IBM tested the water with a 3.9-inch version. All of them bombed. Seeing the writing on the wall ("In unity there is profit"), 11 manufacturers banded together in 1982 to establish the 3 1/2-inch Sony standard. In a very short time the manufacturer group numbered 22.

The watershed year of 1984 dawned with the introduction of the Apple Macintosh boasting a single 3 1/2-inch disk drive. The Sony 3 1/2-inch disk system had undergone some modification at the hands of Apple. While the Sony drive used a constant-speed motor, Apple's built-in unit favored a variable-speed motor to compensate for the fact that the outside of the disk spins more slowly than the inside. In the end, the Sony system won out. Data storage space was about 400K compared to about 140K for the 5 1/4-inch floppies. The Amdek "Amdisks" cost about $7 apiece and the drive system needed to use it cost $300. Those were the days when 256K and 512K memories were just beginning to arrive from manufacturers. A fully configured 64K dual disk drive computer with both upper and lower case text display (a big deal in 1982) capabilities complete with 12-inch green monitor and dot matrix printer tipped the cash register at about $3000.[1]

Due to their deadly slow data transfer rate, no one today would run a program from floppy disks, but they are used to transport data from one hard drive to another. Most software applications are provided on stacks of floppy disks, but the graphic density of many of today's programs requires the use of a CD-ROM for complete transfer. Industrial-strength CD-i players make use of a floppy disk for program information updates and feedback downloads and are discussed in Chapter 16.

[1] Gerry Souter, *Franklin — The Most Compatible Computer,* Scott, Foresman and Company, Glenview, IL, 1985, pp. 269–271.

13

Hard Drive
Speed Champ and Getting Bigger Every Year

Everybody has one. (Once again, personal digital assistants are excused.) The hard drive quietly hums along at thousands of revolutions per minute (rpm) in its pristine sealed container waiting with its magnetic read head hovering just above the high-velocity spinning surface to transfer data to the screen or accept new information by writing over old data. Properly configured with contiguous files, it is the speed and reliability champ. Stacked like records in a jukebox, current drives of multiple-gigabyte (one billion bytes) capacity are commonplace. They are used in conjunction with almost all of the media we will discuss and can stand on their own. One drawback is the challenge they present: "Build it and they will fill it."

The hard drive has continued to evolve and grow in capacity since its commercial debut from the hands of IBM back in 1973. IBM gave us the *30+30 megabyte drive.* That name stirred comparison, so the story goes, to the Winchester .30-.30 caliber rifle. For a long time thereafter, a hard drive was called a *Winchester drive.*

One example of a truly wheezy dinosaur hard drive was developed for the Franklin computer, the first Apple clone, back in 1984. Before being forced into bankruptcy by a long drawn out legal battle that Apple won, the Franklin folks produced the X-10 drive manufactured by Xebec. In an era when the average floppy disk held 140K (kilobyte = 1000 bytes)

of data, offering 10 megabytes, or 10,000,000 bits of information was a strong sales draw. The X-10 weighed at least 10 pounds, was shaped like a ranch-size block of processed cheese and its ferric oxide coated turntable spun merrily along at 3800 rpms. There were software commands that safely parked the read/write heads when the drive was not in use. The disk could be formatted for any combination of Applesoft DOS, Apple Pascal, and CP/M files. Data were stored in preset "volumes" on "pages" that were called up in a linear fashion to search for files. In effect, the X-10 was a load of hermetically sealed disks. Virtually no applications could be transferred to the X-10 because of copy protection schemes then being used. Since disk "hangs" and crashes were all too common, a vast amount of floppy disks were used to back up data — just about nullifying any savings from that quarter. You do the math for backing up 10 megabytes of data using 140K disks.

With the advance in digital video technology, tapeless video editing and image recording standards such as JPEG and MPEG,[1] the hard drive has entered the Land of the Truly Huge. For example, the Micropolis AV external storage subsystems offer pancake stacks of data turntables hustling along at between 5400 and 7200 rpms that hold up to nine gigabytes of data, or 9,000,000,000 bytes of information. Considering that one second of full-frame, 30-frames-per-second video uses up about one megabyte of space, editing a 30-minute video would require about 54,000 megabytes of storage.

Some hard drives are in portable cartridges, but portable storage cartridges such as the Bernoulli, DAT, and the SyQuest rely on linear tape. The popular Zip™ drives from Iomega store 100 megabytes of data on a slightly oversized floppy, while the SyQuest EZFlyer™ offers 230 megabytes in a disk cartridge. The cartridges are used to transport large amounts of data between hard drives or as data transfer platforms to CD-R disk writers.

[1] See Chapter 4 for definitions of jargon.

14

LaserDisc
The Format That Refuses to Die

The LaserDisc delivers analog video and still images, so what is it doing in a book on managing digital media? Because it is *there!* The LaserDisc, once the 1970s backwater also-ran to the VHS tape cassette in the Great Consumer Dollar Race, won its spurs as the most reliable, high-quality video/still image delivery system for many video-intensive interactive programs and any large screen display or video wall presentation. There are at least four levels of computer chip-controlled interactivity available and the players are industrial strength for nonstop use in point-of-purchase and trade show applications. *En requiesat vita.*

Inclusion of the LaserDisc echoes Mark Twain's surprise at reading his own premature obituary, ". . . the reports of my death are greatly exaggerated." According to *The Multimedia and Videodisc Compendium for Educational Training* put out by Emerging Technology Consultants, the LaserDisc is very healthy. The eighth printing of this standard industry source lists 3876 titles, a growth of 18 percent from the 1995 edition. By next year, the list is predicted to increase by 14 percent, climbing up to 4500 titles. The percentage of education and training titles — strictly interactive fare — holds a numerical edge of 2373 titles compared to CD-ROM titles numbering 1294. In truth, by next year, even though expected expansion of the LaserDisc interactive list is predicted to grow only slightly to 2400 titles compared to a spurt to 1900 titles for the CD-ROM, the comparison is still surprising to many.

Figure 14-1. A pair of videodiscs. The 12-inch discs have a capacity of 54,000 still frames or either one hour (CLV) or 30 minutes (CAV) of full-motion video or film. (Courtesy of 3M, Minneapolis, MN.)

Publisher and CEO of Emerging Technology, Richard Pollack, observes that there are three key reasons for the stubborn coexistence of the LaserDisc: (1) the large installed base of players, (2) a definite edge in picture quality and data capacity over CD-ROMs, and (3) LaserDisc's ease of use with large groups (in classrooms, meetings, large-screen point-of purchase installations and trade shows, for example). CD-ROMs require expensive computer display monitors for these applications. CD-i format, though designed for television display, still suffers on the larger screen. While this comparison is valid today, with

the arrival of the digital videodisc (DVD) and the dropping cost of computer display monitors, digital media will eventually rule.[1] The silky sharp analog image will fade away as did the warm infinitely variable sounds from the vinyl LP record.

But we are here not to bury the LaserDisc, dear Brutus, but to explain it. The LaserDisc concept dates all the way back to the mechanical image scanner invented by Paul Nipkow in 1884. A disc contained thousands of minute holes and when rotated in front of a lighted object, the holes allowed bits of light to fall on a photoelectric cell. The cell converted the light impulses into bits of light and dark illumination on a viewing screen, creating a crude, but recognizable picture. James Logie Baird applied the Nipkow principle to his semisuccessful "Televisor" in 1926. The idea would be shelved until three gentlemen from 3M—Wayne Johnson, Paul Gregg, and Dean DeMoss—began studying the reproduction of video signals from the surface of a phonograph record in 1961.

By June 1963, after sorting through various combinations of light sources ranging from x-rays to short-arc mercury and xenon lamps, they managed to establish the basic principles of LaserDisc technology. Instead of uneven tracks cut into a surface as used in audio reproduction, they used a micron-size pit. These pits, laid out in tracks two microns apart, were scanned by the light source. The light was reflected back by either a pit or a smooth surface where there was no pit called a "land," causing a modulated light response, which was converted to frequency-modulated electrical signals that could be scanned on a phosphor television screen. By 1965, they had accumulated more than 20 patents. In 1970, work with lasers as the light source pioneered by Philips, MCA, and Thomson-CSF created the first optical LaserDisc player (called *videodiscs* back then) that we would recognize today. Philips-Magnavox introduced the first commercially available LaserDisc player while MCA, who owned Universal Pictures, provided the movies.

Early marketing and product quality in 1978 was erratic. RCA created the CED disc player in 1979, which used a record-type stylus in place of the laser, luring away some potential market. When the VHS and Beta tape players that could also record programs came along and the RCA product died and was withdrawn, the LaserDisc market languished.

At about that time, industry and training groups recognized the capabilities of the LaserDisc. Interactive systems coupled to computers produced dazzling training programs for General Motors, collections of

[1] Rockley L. Miller, "The World Beyond Myst and Doom," *Multimedia Producer Magazine,* Knowledge Industry Publications, White Plains, NY, Vol. 2, No. 4, April 1996, p. 77.

photos from NASA and the Getty Museum, records from the U.S. Patent Office, and innovative point-of-purchase systems for the Florsheim Shoe Company, Budget Rent-a-Car, and other pioneer corporations. The LaserDisc had found a niche market.

Today, virtually every major feature film produced is also turned out in LaserDisc, making use of the disc's capacity and superior sound and image quality to offer very high quality entertainment for a low price. Through the 1980s and 1990s, institutions such as the University of Nebraska focused on the LaserDisc for education to produce projects for industry and the classroom. The Pioneer Electronic Corporation introduced players that also accepted music CDs and the consumer LaserDisc player market took off.

The LaserDisc now cohabits the media marketplace with the CD-ROM and CD-i as a true option for fine video quality, huge capacity, and the highest quality sound. Digital sound has been added and low-cost one-off DRAW (direct read and write) system disc writers are in common use where small reproduction runs are required. They do not require a clean room environment and are found in many full-service postproduction houses. The DRAW disc can be used as a check disc during the approval stage of the final program before committing to full production of the program at a stamping facility such as 3M, Pioneer, Sony, or Panasonic.

The thick LaserDisc is an aluminized disc composite of fused resin containing the pits to be read by the player's laser. Material created for the disc is produced on a videotape *premaster* configured to certain standards to aid transfer of both audio and video components. The audio and video signals are fed into an optical modulator that is aimed at a precisely polished optically flat glass master disc. The laser beam is directed at the photosensitive coated surface and switched on and off in response to the modulations from the video and audio signals on the tape. When switched on, it burns a pit into the surface on a track moving out from the center in a spiral for movie discs (CLV, constant linear velocity) and on individual tracks (CAV, constant angular velocity) for discs that hold programs where freeze frames and jumping from track to track are required as is true for interactive programs. Once the *burn-in* process is complete, the photosensitive surface is developed like a photographic print. In a vacuum chamber, a nickel coating is applied and after subsequent chemical processes take place, this nickel-coated master disc becomes the *stamper* for copies. In a clean room atmosphere, resin-coated aluminum discs are stamped to create the final LaserDisc.

This process varies for different types of discs available today, but the basic manufacturing principles remain the same. For example, some shops use a roller-coater to apply the liquid resin while others use sheet resin.

Sony introduced the CRV disc system that allows video Beta SP tape component signals to be transferred to a one-off disc writer, producing an even higher level of reproduction quality. This recordable disc system will be examined at length in a later chapter. A couple of paragraphs here are enough for comparison. Standard audio and video signals are mixed to a *composite* signal before transfer, losing some quality from the original. The CRV process is usually used for short disc runs and one-time shows. It costs more than DRAW process discs, but the end result is worth the additional expense. Transfer through the CRV process should be anticipated early during the image and sound acquisition stage of production to achieve the best results by maintaining video component separation throughout the editing process.

While the DRAW and CRV processes allow single and short-run discs to be written, the hardware is expensive and usually available only through production houses to complement their editing and graphics equipment investment. There is no low-cost equivalent to the CD-R recorder which now costs less than $1000.

LaserDisc players are industry proven for durability and come in many configurations for multiple disc play, or simple boxes designed to be connected to a computer for full control. While the reset times of modern players are from one to three seconds, depending on the program, the last frame of the program can be held in memory while this takes place so no blank screen is evident.

Video walls work best with LaserDisc players because they take advantage of the random access to images and the high quality of reproduction on the huge screen. There is no long rewind time as there is with any tape source, and multiple LaserDisc sources take full advantage of the video wall's programmed, multiscreen choreography and huge size.

Though recent manufacturers have blurred some of the distinctions, there are four levels of interactivity related to LaserDisc systems. Level 1 simply plays back a program from front to back. At level 1, the CLV disc is used since its spiral track allows an hour of material to be recorded. Chapter stops can be built into the disc, but it cannot freeze frames unless the player can "grab" a frame and hold it in memory. Level 2 uses the CPU built into the player to control certain functions and is programmable through the hand-held remote unit. This is a low-rent method used to

achieve interactivity through the remote and never did catch on very well due to the rather arcane codes required. Also, the remote's memory is volatile. Turn off the juice and, poof!, it's reprogramming time. Level 3 is the most used application of LaserDisc interactivity. A computer triggers the player through an RS-232C or other umbilical connection. Software programs can "call" the player, freeze frames, and address any specific frame through its numbered address. The CAV format is used with its concentric tracks and 30-minute capacity. Level 4 is a hybrid that provides digital audio for a sound track.

Today, the players have added features such as grabbing the last frame to hold on to the screen while the machine resets itself to begin again. Consumer level machines have been modified to play back every conceivable type of disc from Sony 2-inch music "singles" to standard music CDs and LaserDiscs.

The analog LaserDisc will continue to be a visual show-off for some years to come and is a very viable complement to the many digital media offered to designers and developers. Where large screen quality is needed, the LaserDisc still rules.

15

CD-ROM
The Ubiquitous Media for All Permutations

Once called "the new papyrus" by Bill Gates, the CD-ROM traveled quickly from a repository for vast amounts of text and still pictures to the standard delivery system for most computer entertainment and a large portion of training and industrial applications. Almost all desktop computers sold today include a CD-ROM drive with a relatively zippy data transfer rate. The newest CD-ROM drives read at ten times (10×) the speed of the original discs and now CD-ROM "burners" such as the Yamaha *write* discs at four times (4×) that speed. Data compression hardware using procedures such as those incorporated in the MPEG-2 (Motion Picture Experts Group) industry standard have made real-time, full-motion video common, and animated graphics data compression has allowed its use to be included as well. And the music — of course — goes 'round and 'round.

> *Microcomputers and optical discs have captured the imagination of computer scientists and users alike. What is needed is a coalescing of those two developments with the fruits of retrieval research, to make a quantum leap beyond current systems in all three areas.*[1]

[1] Edward Fox, "Information Retrieval — Research Into New Capabilities," in *The New Papyrus*, Steve Lambert and Suzanne Ropiequet, Eds., Microsoft Press, Redmond, WA, 1986, p. 143.

165

The preceding words quoted from Edward Fox, an assistant professor of computer science at Virginia Technical University in 1986, sum up the growing enthusiasm for the emerging optical media of that period. But, of course, the seer and visionary of that period—as he remains today—was William H. Gates and he said:

> In a few years, after the CD-ROM becomes commonplace, anyone looking back at the information, education, or entertainment applications of today will understand the limited appeal they have had. The combination of the CD-ROM with the microcomputer creates a medium that potentially is more interactive than any previous consumer product. We believe this interaction will result in a product that will stimulate and enrich a person in a manner that is far superior to passive systems such as television.[2]

The CD-ROM was just beginning to catch fire back in 1986. At that time, the 12-inch LaserDisc was the interactive love child being pursued and courted by educators and trainers across the country. The smaller optical disc was considered a repository, a data bank, a scholar's or researcher's tool. Video was still strictly an analog medium and compression algorithms were just beginning to squeeze text into smaller chunks. Twenty minutes of video took up the entire CD-ROM when encoded using the same process as the analog LaserDisc.

Great minds pondered. Since single frames of video could be captured and digitized using a set of specially designed chips, why not string them together to produce moving video? The transfer rate of early CD-ROMs was dismally slow, shutting down that line of thought. Eventually, digital video compression was achieved in the form of digital video interactive (DVI) created at the David Sarnoff Research Center. Because of the industrial strength computers needed to cram all the analog data into digital pixels, tapes had to be sent to the center's laboratory to be compressed and a pair of DVI cards was required in the computer to *decompress* the material. The process was expensive, slow, and clumsy. An increase in transfer speed was required as well as an improvement in the software that made use of the CD-ROM's capacious capacity.

With the arrival of the double-speed write/read process and the perfection of the MPEG (see Chapter 4 for definitions) standard for video compression, JPEG still image compression, and various audio and text file compression systems, the CD-ROM as we know it finally emerged.

[2] *Ibid.,* Foreword by William H. Gates.

A CD-ROM is built in much the same way as a LaserDisc. Data are converted into a modulated signal that controls the "burn" and "don't burn" cutting process, which leaves a trail of pits and "lands" (no pit) down a spiral track on the disc surface. The disc master is coated with silver from which a nickel stamper is made to punch out the duplicate CD-ROMs.

For all the obvious reasons, the CD-ROM is the most ubiquitous of transportable mediums used in multimedia. Because it has become a standard, there are endless lists of software available to produce programs, numerous hardware platforms that support it, and hundreds of vendors who can translate raw data into winning multimedia. To attempt to catalog all these variables is beyond the scope of this book and, for the most part, beyond the client's need to know in the preparation and management stages of the project. Two variables, however, do stand out from the rest and are critical to understand from the outset.

Managing disc real estate by correctly estimating what elements can be stuffed into your 650-megabyte sack will ease the design process, the acquisition process, and the method used to lay it down. Determining the transfer time factor before anything is created will ease all of the above.

A format such as CD-i has a proprietary structure that specifically sets forth how elements are handled with regard to the room they take up on the master disc, and the disc transfer rate is fixed into the equation—all givens. The CD-ROM is virtually a *tabula rasa*—a blank page. Like the script writer for television who must write 24 minutes of program and the brick mason who has an 8 × 10-ft space to fill between two pillars, transfer time and space planning is essential. For the manager contemplating this multimedia program, the contributing elements—the construction of graphics, video, audio, and text—are the bricks and the length of time allotted to offering up these gems to the user can leave you trying to cram 760 megabytes into your 650-megabyte CD-ROM sack. Even if you manage to fill the sack, your audience may not be able to empty it and look at the goodies.

Time and space are so intertwined, we'll look at them together. Time is a mechanical variable based on the transfer rate of the CD-ROM player. Early players moped along at about 150 kilobytes per second (kbps). Designers of text and simple graphic programs took that slow speed into consideration. Nothing moved very fast. The double-speed drives raised the ante to more than 300 kbps, but consider the competition for pure speed. Bernoulli and SyQuest tape drives pumped out *two megabytes* per second. Seek rates are another measure. How long does the system take to find something on the disc? A computer's

hard drive takes about 9 milliseconds. Bernoulli, SyQuest, and some magneto-optical drives chew up about 40 milliseconds. CD-ROMs droned along at between 180 and 320 milliseconds. To add the proper pipeline, a SCSI-1 (small computer system interface) port allows about 5 megabytes per second (Mbps) to shoot through while the SCSI-2 heats up with 20 megabytes during that same second.[3]

Today, we have quad-speed and faster drives that whiz along at at least 600 kbps, scooping up the data. These speeds allow full-motion video, stereo music and sound effects, 3-D animation, and fast seek times for interactive applications. With all this speed exponentially doubling every time we pick up a computer magazine, what difference does space make?

On a CD-ROM, files are laid out in tracks. Once written in pits, they are there to stay (of course, now there are erasable discs, but not in this discussion) and cannot be overwritten. The size of the files and their placement on the disc affect their speed of transfer when retrieved. Graphic files produced in 1064 × 728 lines of high resolution and 16 million colors take up more space than 640 × 480 lines of average resolution and 256 colors. The time spent transferring the image from memory to the screen is called the *screen draw* time. High-resolution pictures can take a while to appear on the monitor a line at a time. If you surf the Internet, then facing a very long graphics download time from a high-resolution Web site is a good example of the frustration.

Good multimedia can't really tolerate delays like that, so graphic files are designed both size- and palette-wise with delivery time in mind. Video files are treated the same way. Full-screen, real-time video chews up space, but smaller partial screen *windows* allow video to appear with less wait time and much less real estate plowed over. Audio files are measured by the quality of the sound and by the amount of it. FM quality sound—especially stereo—takes up more room than AM radio quality, or the ultra slim king, telephone quality sound.

Placement on the disc also affects how fast files are retrieved. Usually, the elements that are used most often, or those that link to each other, are placed in proximity or interleaved to avoid overlong seek times.

The whole process is a balancing act, trying to estimate how much of each element to include so that (1) you don't run out of room on the disc and (2) what is selected arrives in a timely manner. Before we leave

[3] Devra Hall, *The CD ROM Revolution,* Prima Publishing, Rocklin, CA, 1995, p. 238.

this discussion, the speed factor is critical in one other way. Early on, we laid down the absolute rule that the audience for the given multimedia program must have the hardware playback and interactive capabilities to use it. CD-ROM player speed is very critical if you create a program that requires a 600-kbps transfer rate (quad speed) piped through a SCSI-2 20-Mbps cable and your audience has a 300-kbps (double speed) player notched into an old parallel port.

One last reminder before moving on. If you create the disaster scenario mentioned earlier and have also compressed your video files using the MPEG or MPEG-2 standard, even if the audience matches the speed requirements, unless they also have the appropriate MPEG encoder/decoder card in their putty-colored box, that CD-ROM becomes an expensive coffee cup coaster.

"Know thy audience."

16

CD-i
Interactivity in a Box

CD-i is a unique, proprietary system developed by Philips for the purpose of creating a consumer product that would allow digital interactivity programs such as games, educational programs, and so on to be accessed on a television set. The disc is identical to the CD-ROM and it holds 600 megabytes of data (though it is arrayed to hold 650 megabytes, the same as a standard CD). The CD-i player was designed by Philips and is built by both Philips and Goldstar Electronics. A remote control with all the necessary buttons is provided and has line-of-sight access to the player. Besides the hardware, a complete design language and pro-forma set of construction specifications are available. The language is called Media Mogul and is distributed by Optimage, Inc.

CD-i stands for *compact disc–interactive.* The details of its industry standard specifications were first listed in the repository for all CD-ROM standards called the *Green Book* back in 1987. Its structure is a result of the extended architecture standard created by Philips, Sony, and Microsoft, called *CD-ROMXA,* an improvement over the early CD-ROM. The CD-i is a disc-based version of earlier *hypermedia* for personal computers defined by computer guru, Ted Nelson, in the 1960s. Apple Computer created *hypertext* in the 1980s for its Macintosh machines, a hard drive database of random-access information arranged on virtual cards with "hot" words or "buttons" used to search for other information under a given topic. Graphics, audio, and text clips access was possible.

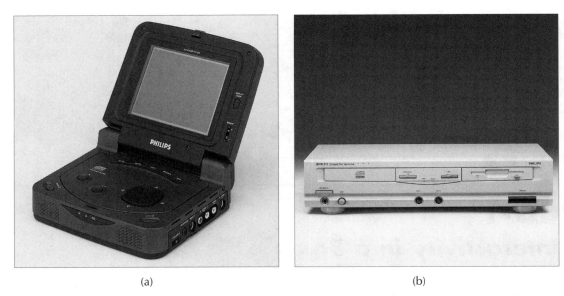

(a) (b)

Figure 16-1. Philips CDI 370 CD-i player with (a) a built-in screen and (b) a CDI 615 model for TV set-top use. (Courtesy of Philips Professional Products.)

CD-i expanded this search process, added video clip capability, and delivered the program on a 5-inch CD disc.

The late 1980s saw a quest for a consumer-targeted *computer book* that would feature video, text, graphics, and sound elements in a compact package read from a disc format. This concept evolved through Philips into the CD-i player, which was designed to attach to a TV set and play back interactive games and educational and consumer shopping programs using a CD disc. Each Christmas, these boxes resembling a small VCR are trotted out and each year they are ignored by consumers due to the lack of software and cost of the proprietary system compared to video cartridge games and the profusion of computer CD-ROM products. Where CD-i did find a home was in training, industrial interactive programs.

Though the CD-i player was designed as a consumer product, it contains a relatively powerful computer using a proprietary operating system called CD-RTOS to manipulate elements of the software producing real-time interactivity. Also included are NVRAM (nonvolatile random-access memory) modules that add to the memory storage and hold specific user data. There is also a chip for processing moving video data, a half megabyte of NVRAM memory for storing and handling moving images, and a megabyte of NVRAM memory also reserved for video. If you wanted to use only one element to capacity on a CD-i disc, you could run 72 minutes of full-motion video with speech (level C) sound quality:

72 minutes of CD quality sound

19 hours of speech quality sound

120,000 graphic screens

7000 photo still images

100,000,000 words

Because most programs use a combination of the preceding elements, thought must be given to the structure and elements included so the final program can be stuffed into the 600-MB disc capacity. (The maximum disc capacity is 650 MB, but Philips' own disc writer hardware will only write 600 MB on one disc.) For example, if the designer were to put the video image into a window on the screen that only required 40 percent of the screen size, then 40 percent of video storage memory would be needed.

The screen "stage" is divided into two planes, foreground and background, for the intermixing and overlaying of text, graphics, and video images.

Data transfer from the disc to the player's computer is at a rate of 172,000 bytes per second and up to 16 parallel sound tracks can be managed simultaneously though, usually, a maximum of eight for multilingual presentations is recommended by designers. Four levels of sound quality are available from CD-quality (20 kHz) through these levels: A (LP record) to B (FM radio) to C (AM radio).

Because the CD-i is a proprietary system, the structure for creating a multimedia program is fixed in place with a minimum number of possible variables and definite guidelines to speed the time required for programming. Only one language is used for the actual coding — Media Mogul — so we can take a look at the format's toolbox knowing it will not change depending on authorware or how elements are handled. This is a good way to look at the way designers approach the creation of a CD-ROM as well.

The CD-i structure has three ways to determine the sharpness and color capacity of a graphic image in order to make the presentation meet the program's requirements with an efficient use of real estate.

There is the highest quality natural image — RGB. If the image has been encoded using the standard RGB 5:5:5 (red:green:blue) method, then there is a range of 32,768 colors. With RGB, the value of each pixel is simply recorded without compression. The use of strictly RGB images will limit the number of graphics that can be used in the program. An RGB image uses about 200,000 bytes and about 100 disc sectors.

Next down the line would be a DYUV compressed image. This Delta Luminance Color System counts on the fact that data for neighboring pixels is often similar, so instead of laboriously recording each pixel, it looks

into the cracks and records only the difference between each pixel, line by line. DYUV also takes advantage of the fact that the human eye is more sensitive to levels of brightness than differences in color. Accordingly, DYUV saves space by recording less information about color changes than brightness changes. With this color snobbery completed, a DYUV image only takes up about 90,000 bytes and 45 CD disc sectors.

Farthest down the line is the CLUT. Homely sounding and homely looking, the CLUT (color look-up table) image relies on its coloration from a table of variable size and a selected palette of colors. Once an image arrives, the color of each and every pixel is not given a value; it is given a color from the table. There are advantages to this address method. By the time the painted-on dot is ready to be refreshed by another scan of the screen, another CLUT table can be loaded, changing the color of the dot. Simple "flicker" animation can be achieved this way — like the opening and closing of a winking eye. The size of the table and, of course, the number of possible colors can be set at three different levels: CLUT 8, CLUT 7, and CLUT 4. The number refers to the number of bits of data used to store the address of the color of the pixel. For example, CLUT 8 makes use of 256 colors chosen from 16 million. Both CLUTs 7 and 8 take up about 90,000 bytes and 45 disc sectors.

The use of CLUTs requires some organization. If a color photograph is scanned in, up to 16.7 million different colors can be stored if 24 bits are used for each pixel. CD-i has a built-in algorithm that automatically funnels the image into CLUT 8 with its 256 colors, selecting the colors that best match the colors of the original. If the artist wishes to bypass the CLUT system, a black-and-white image can be built up color by color, using an RGB paintbox.

Video processing is also built into the CD-i player in the form of a half-megabyte of dedicated memory set aside to handle moving video images. As mentioned a number of times in this book, moving video eats up disc real estate.

Partial screen video saves memory in direct proportion to the amount of screen needed; that is, a half screen saves 50 percent, a quarter screen window requires only 25 percent as much memory, and so on. While we have put down partial motion video elsewhere, its use in noncritical instances can save a ton of space. For example, if the video clip shows someone performing a task in close-up, partial video gives the person's moves a step-by-step look that somehow looks "right." If, on the other hand, the shot is a close-up of someone speaking, forget it and go to full motion, or their words will never catch up to their lips.

Yet another control process available is the use of the foreground and background *planes* for special effects. While CD-i lives in an apparent two-dimensional world, its "stage" is actually two planes, one

in front of the other and the area where the image is drawn can be shifted between them, dissolved back and forth, and combined to offer a number of visual possibilities.

For example, on one plane, the designer can cut between images, can scroll an image on and off, and can remove one part of the plane at a time. The image can also be broken down into a number of larger pixels resembling a mosaic. Adding the second plane and an image other than one created in RGB (an RGB image eats up all the color possibilities of *both* planes) allows a fade from one plane to the other, very instantaneous cuts by holding one frame in the memory of one plane and the other frame in the other plane. A wipe is also possible, appearing to bring on a new image as the old image moves off. There is also the *curtain* wipe in which the image on the back plane is revealed by the image on the front plane opening from its center like a stage curtain. The venetian blind wipe is self-explanatory and the square wipe grows one image from the center of the other in progressive stages.

Transparency between images is possible using both CD-i planes. A chromakey effect (used in television newscast weather shows) designates one color to be transparent, allowing action to take place over a scenic background. Also, a matte effect is possible when pixels of an image on the front plane are made transparent so it seems to become part of the background. Sky and clouds appearing through a car window that is part of an interior set would be a matte effect.

Being able to look at this proprietary system with its tools in place gives the layperson a good idea of the decisions that must be made by CD-ROM designers.

Having the advantage of designing both software and hardware at the same time and making them a compatible team, the CD-i designers could have the best of both worlds. Having looked at the software, the player takes on a new sophistication since so many features are part of its construction.

The player works by inserting the programmed CD-i disc and using a remote control with buttons and a small joystick to interact with the movable screen cursor. The players can be networked to classrooms from a central location for school use. Both commercial and industrial portable players are available.

The biggest advantage of the CD-i is the relative ease of programming and the flexibility available for mixing the elements to produce very rich designs. All the programming and disc production methods have been ironed out over the years and the process technology is considered to be mature.

The major disadvantage for *consumers* revolves around the need for a separate player as an interface. With high-speed CD-ROM drives becom-

ing ubiquitous among home and work computers to take advantage of the multimedia revolution, investing in a multifunctional player that has yet to be seriously supported by software producers seems a waste of dollars and effort. CD-i developers are not exactly thick on the ground due to the proprietary nature of the system and a small installed user base.

For corporate communications, however, this disadvantage becomes an advantage when the need is for low-cost delivery without requiring a full-blown computer. Industry has warmed to CD-i for its "plug in-and-play" feature for point-of-purchase and training applications. Only three pieces of hardware are required: a TV set and the CD-i player with remote control. General Motors, Sears, and Allied Van Lines are among corporations totally committed to CD-i systems.

While most CD-ROM projects can be programmed and designed using a number of tools such as Toolbook, Quest, Authorware, etcetera, and languages such as C and C++, CD-i is programmed using one shell language, Media Mogul by Optimage using the OS-9 compiler. A developer considering CD-i projects must invest in learning this language plus the graphics, sound, and video handling techniques unique to CD-i. Testing the program design can be accomplished by building a prototype version of the program that runs off a computer's hard drive, make use of an Apple Hypercard, or by creating a CD-R disc cut for the purpose. While the prototype does not reflect the exact characteristics of the CD-i master, it will offer the developer and the client a respectable mock-up of the final product.

CD-i's strong points are centered around cursor-based interactivity where the remote control provides the physical interaction with the screen. Excellent full-motion video and the split-plane graphic capabilities allow heavy use of colorful graphics at minimum memory cost. The controls on the remote are large enough for grade school kids and adults, or an even more user-friendly trackball can be substituted. In general, educational programs, information dispensing projects, and most basic interactive needs can be met with CD-i. The industrial portable machine should be used where the player is subject to heavy use such as a trade show, point-of-purchase, or industrial setting.

17

CRV

A Sony Recordable Solution for a Rushed Schedule

A medium for deep pockets in a hurry, or for building an archive, CRV (component recording video) is a recordable upgrade of the original optical LaserDisc. It is created for fast turnaround using a one-off disc burner much like the older DRAW disc process used in creating one-off video check discs prior to mastering. The CRV disc is more expensive to produce, but can generate RGB or component video with a higher quality than the standard video disc and it has other features including multiple track sound. The disc will only play back on a CRV player.

The secret of the CRV disc's quality advantage over the standard optical LaserDisc is the ability to produce superior images one disc at a time. This fills the bill for large video projection and video wall applications. The fact that this system is cost efficient for a medium-size production house allows low-cost fast turnaround when producing discs to check programming of an interactive system before committing to a full optical disc stamper and multiple disc distribution. The discs are also useful when producing a low-volume distribution disc since every disc produced is, literally, a master disc.

Physically, the concept of the CRV harkens back to the old CED capacitance system developed by RCA in the 1970s to compete with the Magnavox optical disc. Since the RCA disc used a system similar to

a phonograph needle bumping along over tracks carved on a flat surface, that surface had to be protected. To do this, each disc was sealed in a cardboard sleeve that was withdrawn when the package was inserted in a player. The CED system died an early death. The CRV uses a similar cartridge system for their optical disc since the production process does not allow coating of the recorded surface, as is the case with the standard LaserDisc manufacture. Sony has run accelerated aging tests and determined that the drop-out ratio (blips on the screen) will not exceed double the amount when recorded even after 100 years of proper storage.

The capacity of the CRV differs somewhat from the LaserDisc as shown here:

System Type	Video Capacity	Still-Image Capacity
CRV disc	24 minutes	43,500 frames
LaserDisc	30 minutes (CAV); 1 hour (CLV)	54,000 frames

This comparison of the two media should be between the LaserDisc CAV format since the CRV also uses one track for each image frame with two fields sharing the same frame number. This formatting makes the CRV a good choice for high-quality interactive programming, freeze frames, single-frame storage, and even animation due to the ease and speed of a search by the laser requiring no more than a half second.

Single-frame recording is made convenient by a frame memory incorporated in the recorder. This memory allows a frame to be stored and viewed for confirmation before recording. Following the recording process, the frame's location and quality can also be confirmed immediately. Frames from just about any format can be cooked onto the polycarbonate reflective layer including Beta SP, Hi-8, SVHS (component formats), U-Matic 3/4 inch, and VHS (composite formats).

To aid in visual continuity from one frame to the next, the frame memory retains the last image and outputs it to the screen while the head hunts for the next shot needed. When the shot is found, the new image is sent to replace the current one held in the frame memory. This process happens very rapidly, making the disc nicely compatible with cell animation techniques as our persistence of vision[1] knits the single images together to produce the illusion of motion.

[1] *Component Recording Video Format,* information sheet, Sony Corporation, 1994.

The other appealing feature is image quality. Most video produced before the recent introduction of digital and component camera systems produced an NTSC composite signal. This signal crams the luminance (Y) and chrominance (C) together, allowing bleedover and interference between them that degrades the image. Component video separates the two signals and processes each separately. The CRV disc recorder is designed to keep this separation intact and thereby produce a better quality image. If a composite signal is sent to the recorder from a camera or other source, the combined signal is separated into its components and the audio is encoded into digital signals for adding to the video signals. A separate synchronization signal is added and everything is fed to the recorder through multiplex connections.

The video elements and audio are fed to the recorder's high-power semiconductor diode laser beam in the form of a frequency-modulated signal that turns the laser off and on. As the laser touches the recording surface, the spot is heated, causing a phase change in the recording layer from two binary alloys to one four-element alloy. This change increases the reflectivity of the spot in a range from 10 and 15 percent to between 30 and 45 percent. This change in reflectivity is virtually permanent. It is the player's reading of these reflecting spots that returns a mirror image of the modulated FM signal, which is then converted back into the source images and audio.[2] The Sony LVA 7000 CRV player can be controlled by a computer through an RS-232C port. Both slow and fast motion speeds are available for playback.[3]

[2] *CRV Disk Component Recording Video,* information sheet, Sony Corporation, 1994.
[3] *Ibid.*

18

CD-R
Golden Solution for a Short Stack

CD-R stands for *compact disc–recordable* and is the CD equivalent of Sony's CRV video disc burner. It is produced by a one-off CD-ROM WORM (write once, read many) writer that uses different technology to create a CD-ROM than the standard mastering process. CD-Rs are gold in color to distinguish them and are used for short runs, for check discs that can serve as templates to create a standard master duplication disc, and for archiving text or image files. CD-Rs will play back on any CD-ROM or CD-i player.

The CD-ROM, as explained in its own section, is a read-only medium much like the LaserDisc. While the CD-ROM received an early endorsement from most computer gurus during the mid-1980s, it has always been a computer peripheral. The LaserDisc, on the other hand, has always been a television peripheral that also found an interactive niche market among the digital crowd. The main problem with marketing the LaserDisc was its own technology. Supporters tended to sell the amazing disc rather than what it could do. What almost sunk it was what it could *not* do: record information like a videotape. The CD-ROM answered a need for a storage medium. There was already a growing market for the CD music disc, so the mental jump to a disc that stored digital information instead of digital music was not difficult. But it still could not record information like a tape. Early on, LaserDisc technology was notched up a bit by the introduction of the Panasonic direct read and write (DRAW) disc system that did allow one-off discs to be created. The process was and is expensive and the early sandwich discs had a tendency to come apart. Today, this system is still available in

Figure 18-1. Yamaha CD-R102 2× record and 4× playback CD-R recorder. (Courtesy of Yamaha Systems Technology Division.)

postproduction houses, but does not offer the same degree of quality as the component Sony CRV system described in Chapter 17.

The CD-ROM was thought of as a database capable of storing 550 megabytes of data that eventually grew to 650 megabytes. All data had to be sent off to a disc mastering company for encoding onto the disc. As graphic images and then video became part of the CD-ROM scene, game and software developers endorsed the medium and its popularity grew. These developers still had no way to check their programs until the first one-off disc recorders or "burners" came on the market. Those early units cost $10,000 or more and, once again, as with the LaserDisc systems, became the province of the postproduction houses.

To accommodate these systems, a new CD medium was created, the recordable compact disc, CD-R. As mentioned, this new disc is gold in color and offers the full 650 megabytes of storage space for a 74-minute disc as well as a 63-minute disc that holds 550 megabytes. The CD-R can store audio, video, graphics, and text and meets all of the *Orange Book Part II* specifications.[1] Their layout can mirror the layout on a potential

[1]"Industry standard" specifications are set out in *Green Books, Orange Books, Red Books,* and by the time this book is published, there will probably be puce, heliotrope, and mauve books as well. Just be aware that these standards are accepted by most manufacturers as gospel so media will perform equally well in all hardware.

CD-ROM application allowing them to act as prototypes to check on accuracy and operation before a CD-ROM is mastered for duplication.

While a LaserDisc uses the heat of a laser to literally "burn" a pit, or fuse tracks, into a reflective spot, the CD-R uses a photosensitive dye layer requiring only the light intensity of the laser to create the surface data record. Accomplishing this photorecording process required the disc to have a soft gold dipolymer layer in place of the CD-ROM's aluminum reflector to enhance its reflectivity. Next, an organic dye layer was coated on the substrate beneath the gold to interact with the laser light.

While the stability of a burned-in pit or phase-changed spot on the surface of an aluminum disc is considered virtually permanent, the photosensitive dye had to be tested to meet rigid standards; otherwise data could be lost on a disc left sitting under any bright light for a period of time. Standards were established and met that allow the CD-R to be handled in much the same way as any CD-ROM, using common sense in respect to long-term strong light exposure.

In 1993, the cost of a CD-R burner was $10,000. By 1995, the price had dropped to $3000. In the year of this publication, CD-R recorders have dropped to under $1000. As software applications became memory hogs loaded with graphics and photos and music and dizzying lists of features, the CD-ROM grew in popularity as a storage medium to deliver these applications. Computer games took advantage of video, graphics, and data compression techniques to load their fun on CD-ROMs. Virtually every desktop computer sold today has a built-in CD-ROM player. The CD-R took off in popularity as the ability to burn your own discs came within financial reach of both the developers and ordinary computer users.

Today, the CD-R is used in a wide variety of applications from prototype tests of eventual CD-ROM titles to home-brewed file storage and even music recording. Industry has embraced the CD-R for short-run point-of-purchase interactive kiosks, training programs, and archival storage of every imaginable type of data. CD-R developments have also matched the increase in CD-ROM speeds from double to quadruple the original drive speeds, thus increasing the transfer rates of data.

To record data on a CD-R, the following items are needed: a blank gold disc, which is available from media companies such as 3M, software designed to transfer files through the hardware to the disc, a SCSI adapter card in the computer to act as a fast tunnel for data from hard drive to disc surface, and a disc burner to complete the package. The software takes the text, graphics, audio, and video files and lays them out in a specially ordered format that is then taken by the burner and transferred to the disc. Better software takes the files and creates what is called a *virtual image* of the files — not the actual files, but a picture of how they will lay out on the disc. Placement of files on the disc is

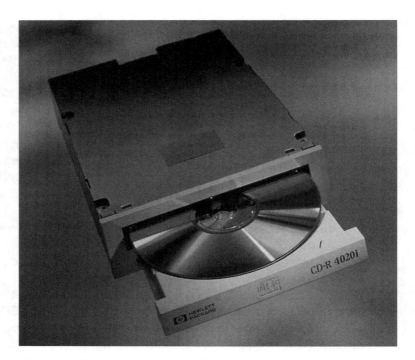

Figure 18-2. Hewlett Packard 4020i SureStore 2× record 4× playback
CD-R recorder. (Courtesy of Hewlett Packard Colorado Memory Systems.)

important, because of access times required to reach frequently used
files. Other software developers allow an actual duplicate of the disc to
be created on the computer's hard drive so the program will behave
exactly as it would on the disc. These two approaches allow for one last
check of placement, programming accuracy, and quality of images
before the disc is created. To accomplish these tasks, a comparable
chunk of memory must be set aside on the hard drive. Some develop-
ers suggest setting aside up to one gigabyte of memory on a dedicated
hard drive equipped with its own high-speed SCSI adapter to guarantee
fast, effective throughput to the disc burner.[2]

The disc recorder itself has undergone considerable reduction in
size and increase in features as its cost has dropped. The breakthrough
machine in 1996 was the Hewlett Packard SureStore, which records at
quad speed and plays back at double speed. While double-speed discs
are not as fast with the transfer rate of data from disc to computer (307.2
kbps as opposed to 614.4 kbps for quad speed), the SureStore provides

[2] Ron White, "Roll Your Own CD-ROM," *PC Computing Magazine,* Ziff-Davis Publishing
Company, August 1995, Volume 8, Number 8, pp. 183–186.

Figure 18-3. Yamaha CDE 100 II 4× CD-R recorder. (Courtesy of Yamaha Systems Technology, Inc.)

software to affect the transfer as well as a high-speed SCSI interface card to take the guesswork out of installation. Photo-CDs can be created as well as music CDs and databases that can be searched by anyone with a CD-ROM player. The slight "dumbing down" of the speed range has permitted more computer users and companies to take advantage of CD-Rs for a list price of around $1000.[3]

To achieve quad-speed recording times, the Yamaha CDE 100 II provides the horsepower sans software or SCSI card for about $3000. This CD-R recorder allows recording of the entire disc at once, or one track at a time, accessing up to 99 times to build the capacity over a period of time. Adding data to a CD-R over a period of time reduces its capacity somewhat since each write to the disc adds some data overhead that makes sure previous material is not overwritten. To keep up with the market, Yamaha's Expert series now features a lower cost read at quad speed, and write at double speed.

The CD-R format is the answer for situations in which multimedia projects will not require wide distribution or will need frequent updating after the initial installation. Hardware and software for CD-R recording is dropping in cost, making the format a truly affordable alternative to tape archiving of text, graphics, and image files.

[3] *New Product Information Bulletin,* No. PRIS0907509, Hewlett Packard, 1996.

19

Photo-CD
Digital Pix from Your Camera Store

Take your photos to your camera store and get them back on a compact disc. Kodak's jump into the CD arena has allowed many small multimedia production shops to hold off buying an expensive digital scanner and has allowed transfer of original photography into image files that can be manipulated with most Adobe Photoshop-type software. The Photo-CD has gone from being a consumer toy (at which it bombed) to a multimedia presentation tool.

A Photo-CD is a bargain. One hundred photos can be crammed onto a single disc at a cost of about 65 cents each—and that price is dropping. Compare that to the cost of a professional scanning job of $50 plus. Deals aside, the Photo-CD has come to stay for a while as far as multimedia developers are concerned.

In September 1990, the Photo-CD system was announced by Eastman Kodak. There were TV commercials showing happy families shooting away with their cameras, burning up Kodak film by the case. Then, voila!, they were crowded around the TV set watching their photographic handiwork cycle past in 27-inch splendor. Slide projectors were destined for the flea market or garage sale. Cluttered boxes of slides and easily misplaced slippery negatives were old hat. Now, all the family's photo history could be archived on CDs that would last forever. All you had to do was buy this $600 box and. . . . Consumers stayed away in droves. Professional photographers, print designers, multimedia developers, and every other profession that dealt with photographic images said, "Whoa, let's take a look at this."

Cheap paper-only scanners, which cost a few hundred dollars, wrap the scanned item around a drum. A decent flat-bed scanner costs upwards of $400 and doesn't do as good a job as a professional drum scanner costing thousands more. Converting still photos, artwork, any real-world image into a computer file in the past has required scanner hardware. The Photo-CD sharply reduces the cost of getting an image into a computer so the photo in its new digitized form can be manipulated, sized, color shifted, cropped, and adapted to any specific use.

If beauty lies in simplicity, the Photo-CD is a charmer, but there are some factors to consider. The most important one is who transfers the photographic images to the CD? A professional photographer friend spent weeks searching among local processors before finding a Photo-CD lab he could work with. Just dropping pix off at the local one-hour photo shop does not guarantee success. There are subjective judgments to be made along the way and the technicians who make them are responsible for the results.

"One outfit," my friend groused, "sent back a CD that brought up images that looked like they had been shot under water. Another consistently overexposed every frame and still another returned the shots with a little *tip sheet* suggesting ways I could improve my photography." My friend, a large person (6 feet, 4 inches and about 320 pounds) and a professional photographer with 25 years of experience, returned the tip sheet to the lab personally.

Consider the steps required to produce a Photo-CD:

- Negatives or slides are scanned to a resolution of 2048 lines × 3072 pixels with 12 bits in each of the three primary colors. The scan results in a 27-MB size file.

- The digital data are transferred to a heavy-duty computer such as the SunSparc Station (called the Kodak PCD Data Manager S200), which codes the data to create the highest possible quality electronic image. The image is translated onto a monitor screen where a lab technician makes a judgment pass at any corrections. The technician views the original image alongside the modified version and adjusts for color density in the red, green, and blue spectra using cursor-manipulated slider buttons and checks for optimum sharpness. This job takes some training and concentration. Color data are normally dealt with as RGB (red, green, blue) information. For the Kodak process, this RGB data must be converted to a YCC format PCD file.

The YCC format separates the color pixel into two components, a luminance component of 8-bit size with 256 gradients of brightness and a pair of 8-bit chrominance components used to define color gradations.

This separation is similar to the video component system discussed elsewhere in this book. The separation allows pixel components to remain untainted until combined in the final image, producing a better quality photo reproduction on the screen. The separation also allows easier transition to various output possibilities.

Lines of resolution or image sharpness is critical because the sharper the image, the more pixels that are used to fill in the spaces. A larger number of pixels requires more memory and a longer transfer time to the output device. If you are dealing with print, let sharpness run amuck, go for the pixels. With multimedia, however, sharpness can be cheated back to RGB quality since the computer monitor or television screen is capable of just so much resolution. Fewer pixels mean a faster ride to the screen for the data. A number of resolutions for a single image can reside in the final PCD file, which represents the photograph on the Photo-CD.

Picture Components	Resolution
Base/16	128 lines × 192 pixels
Base/4	256 lines × 384 pixels
Base	512 lines × 768 pixels
4 Base	1204 lines × 1536 pixels
16 Base	2048 lines × 3072 pixels

Base/4 and Base/16 are saved uncompressed on the CD, whereas 4 Base and 16 Base are compressed. Another resolution, 64 Base, is reserved for the Professional CD, a resolution of 4096 lines × 6144 pixels. This format produced the best quality reserved for print and large projection requirements.[1] Choose your resolution wisely!

Following the conversion and correction stage, the image is fed to the Kodak PCD Writer and all its data bits are turned into pits and lands on the CD surface.

As a service to the customer, a sheet of small thumbnail prints is then generated and included with the Photo-CD. The customer can see "if everything came out" on the way back to the car rather than waiting to boot up the Photo-CD player or computer at home. One warning here. Whether home snapshot or corporate cover shot for the annual

[1] Heinz von Buelow and Dick Paulissen, *The Photo CD Book,* Abacus Publishing, Grand Rapids, MI, 1994, p. 76.

report, don't lose the negatives or the original slide. Printing from a Photo-CD is an expensive proposition and the quality will not be as good as that of the original film.

The ultimate quality of the final Photo-CD image depends on the training and care of the technicians in charge of the conversion process. Some time spent running test photos through local Photo-CD producers is worth the expense when it's time to create the next multimedia project.

As multimedia people, we're not really interested in the Photo-CD player. It's good enough to know that it comes as a single-disc player or as a carousel model holding multiple discs, which is handy for boring your relatives into a coma. Kodak realized that its public reception was less than auspicious almost as soon as the product was introduced. With its low-end "Joe's Vacation" slides market in the dumper, Kodak appealed to the professional photographers, print houses, and computer artists. In January 1993, Photo-CD Access Plus software was introduced, allowing computer folk to boot up a Photo-CD in their own CD-ROM player and transfer images into software such as Adobe Photoshop for manipulation.

CD-ROM player manufacturers added the Photo-CD to the list of disc formats their machines would accept, joining Philips who had already announced the Photo-CD would perform on their new CD-i player back in 1991.

20

DVD
The Five-Inch Digital Video Disc

The (so-far) ultimate expression of the original video disc is the digital video disc (DVD). The DVD now crams a full movie or an equivalent amount of video data onto a 5-inch CD-size disc. As of this writing, the specifications are set in ink, but the disc itself is phantomware. A photograph exists of a Toshiba DVD player (Figure 20.1), but your author spent considerable time at a Fortune 500 communications giant photographing blocks of wood with a two-way radio shell wrapped around it. Let's just say there is every indication that by late 1996 or maybe spring of 1997. . . or surely by January 2000, we'll be using digital video discs.

Figure 20-1. Toshiba DVD-ROM player and digital video disc. (Courtesy of Toshiba American Information Systems, Inc.)

Figure 20-2. 3M artwork showing strata of digital
video disc in single-layer/double-layer configuration.
(Courtesy of 3M, Minneapolis, MN.)

The DVD is a multipurpose technology suited to both entertainment
and computer uses. As an entertainment product, the DVD is designed
to be used for full-length movies with up to 133 minutes of high-quality
video (MPEG-2 format) and audio. At the same time DVD can be used
with computers as an alternative to CD-ROM, providing as much as 17
gigabytes of storage capacity in its dual-side/dual-layer configurations.
 According to 3M, the DVD is offered in four capacities:

4.7 GB	Single side/single layer
8.5 GB	Single side/dual layer
9.4 GB	Dual side/single layer
17 GB	Dual side/dual layer[1]

The dual layering, which allows doubling of the disc's capacity, is
achieved by adding a second layer of pits and lands beneath a semire-
flective coating. This quantum leap in disc storage capacity adds many
new capabilities to the DVD-ROM. Aimed at the most responsive con-
sumer market, the DVD can hold an entire feature film complete with
six-track surround sound.
 The publishers of games and education and entertainment software
(which use multiple CDs) are expected to offer their titles on a single
DVD. With advanced video boards and high-performance PCs, game
and entertainment software will achieve new levels of capability using
the DVD technology. The DVD-ROM drive is expected to read existing
CD-ROMs and music CDs and will be compatible with installed sound
and video boards. Additionally, the DVD-ROM drive will read the DVD
movie titles using an advanced (MPEG-2) video board, which is required
to decode the high-resolution video format. In its minimal 4.7-GB sin-
gle-side/single-layer configuration, the DVD will accommodate Dolby,
AC-3, or MPEG audio and up to 8 different languages and 32 subtitles.

[1] Information courtesy of 3M, CD-ROM Services, Data Storage Optical Technology Division,
April 1, 1996.

The capacity of the single layer will hold 133 minutes, which is sufficient for 95 percent of today's movie releases.[2]

The path to acceptance and definition of the DVD standard has been a long and convoluted path as demonstrated by the history of the format to date. The following list is from an index of announcements made by those who would manufacture this product and the drives to run it as gleaned from various Web sites over the past months. This history also demonstrates the rocky road one travels when trying to prognosticate over the success of a medium that has not yet been delivered into the hands of expectant users.

Dec. 16, 1994	Philips and Sony propose high-density multimedia CD specification
Jan. 24, 1995	Seven other companies agree to make a joint proposal for another standard
	Sony to commercially produce DVD based on original standards
Feb. 27, 1995	Toshiba supports DVD business with new organization
Sep. 15, 1995	Toshiba statement on DVD format unification released
Sep. 26, 1995	Nokia welcomes single standard for next-generation high-density optical disc format
Sep. 28, 1995	Philips believes the unified format will be a blockbuster
Nov. 28, 1995	Samsung to mass produce DVD from September 1996
Dec. 4, 1995	EE Times: laser diode shortage could slow plans
Dec. 6, 1995	SEGA's DVD Saturn set for 1997
Dec. 8, 1995	Most technical details about DVD agreed on and published
	Sony: Technical specifications for video and DVD-ROM format announced
	Philips: Unified DVD format announced
Dec. 14, 1995	Japan Press Network: DVD fueling MPEG-2 production
Jan. 12, 1996	Philips to launch DVD this year
Jan. 17, 1996	Japan Press Network: First players available in August?
Jan. 22, 1996	EE Times: PC makers struggle with emerging DVD
Mar. 25, 1996	E-town News: Problems may delay DVD launch
Mar. 29, 1996	CEMA: Industry agrees to seek legislation on digital video recorders
Apr. 3, 1996	CNN: CDs might become thing of the past.

[2] *Ibid.,* 3M.

On April 1, 1996, 3M published a DVD technical bulletin that detailed the features and specifications of the format. With these specs frozen in ink, it is hoped the product will soon follow. The obvious advantages of the DVD are larger capacity and a faster data transfer rate. Since the DVD-ROM is designed to move real-time full-screen digital video as though the viewer were watching a movie, the speed advantage for other data is obvious. Most likely, the first wave of DVDs — like the venerable LaserDisc — will be aimed at the movie market in order to develop a consumer base. It is possible this innovation may hit the same snag as the CD-i format. Nobody wants to buy a new box when they can get movies on VHS tape (VCRs are present in 75 percent of American homes) or rent the flicks on cable pay-per-view. Only a small proportion of viewers in North America has a LaserDisc player and the LaserDisc has been presenting superior quality movies with killer audio tracks for more than 10 years.

The legislation problem also exists much the same as it did for DAT audiotape recorders. The companies who make films and music do not want their products to be copied, which can happen once the material is digitized. Copying a digital program simply means "reading" it with no loss of quality. Quality is lost when a VHS videotape or standard audiotape is copied to another tape. In December 1996, the companies participating in the development of the DVD agreed on an encryption method to protect data from being copied.

Like the LaserDisc, a scramble to produce equipment and features is occurring among manufacturers. Unlike the LaserDisc, there is already a strong, hip CD-ROM-savvy computer-user base eager to upgrade to this new disc format. Authorware tools will follow as the DVD player hardware demand increases. Jasmine Multimedia's (Van Nuys, California) *Inside the Vatican* program, which has a thousand works of art, hours of video, and millions of words, had to have much of the content trimmed for the CD-ROM version. Not so with the DVD.[3]

It is safe to predict that the DVD will be revealed in industrial circles in 1996 and will be slogging ahead for consumers in 1997. Its multimedia possibilities may not be available until the marketers can convince management that authoring tools should be pushed out the door. Until then, the DVD appears to be the next transportable medium darling.

[3] Tom Bunzel, "The Dawning of DVD," *Multimedia Producer Magazine*, April 1996, p. 31.

21

Transportable Media on the Cusp
A Digital Catchall

The technologies discussed in this chapter are on the fringe of multimedia use. These storage systems straddle the line between the development of the project and delivery of the final product.

MAGNETO-OPTICAL DISK

Magneto-optical disks are read/write disks that have grown from text-only to mixed media storage over the years. The standard capacity has also increased from 128 to 650 MB. These drives are popular for archiving graphics in some postproduction shops, but they are very expensive. They serve as backup hard drives as well. A SCSI controller interface keeps the data moving and the disks have the same 3 1/2-inch format as the standard floppy. Its data transfer rate is a speedy 1561 kbps and disks are available that can hold 1.3 GB of data.

Considering the cost and the proliferation of multigigabyte hard drives, the acceptance of the magneto-optical system has remained static except for its use in specialized networked archiving operations.

FLOPTICAL DISK

Take a hard-shell floppy disk and replace the magnetic media with optical disc media like a CD-ROM and you have a 21-MB capacity *floptical* disk drive. The 21-MB capacity leaves it considerably short of a CD-ROM, or other CD permutation, but it holds more than the most dense 2.88-MB, 3 1/2-inch magnetic floppy.

The floptical disk drive uses a combination of optical tracking and magnetic recording. The result of this wedding is very precise tracking that allows more dense magnetic writing than on conventional floppy disks. A SCSI controller channels the data and the drives also support standard 3 1/2-inch disks. One Photo-CD picture will almost fit on one floptical disk—hardly seems worth cheering over. This format is used largely for transporting data or archiving medium amounts of data.

CHIPS AHOY: THE ERASABLE/PROGRAMMABLE READ-ONLY MEMORY

The static nonvolatile erasable/programmable read-only memory (EPROM) has a lineage tracing back to the *bubble memory* modules of the middle 1980s. Although most of the programmable chips available today are used in sound applications, continued data compression improvement and circuit miniaturization will allow sound *and* images to come from nonmechanical (no spinning drive) sources.

The EPROM has its uses wherever a microprocessor is controlled by external data. It can time sequences, trigger events, and can even speak. Many voice-activated systems, or systems that cause a voice to speak, are EPROM based. Chip memory goes back to the earliest computers. The bubble memory was an early form of nonvolatile chip-based awareness back in the early 1980s. The bubble was wedded to an expansion card that fit into a computer's slot bay. Microscopic cylinders were placed at the intersections of a magnetized grid, held in place in a magnetic sandwich, and polarized in such a way as to be able to represent the 1's and 0's of digital data. Each bit was represented by a cylinder or the absence of a cylinder on the memory's garnet surface. Garnet was chosen for its particular magnetic affinity. When the power was shut off, the data remained. By 1984, bubble memories had been designed to hold as much as four megabytes of data. Their fussy manufacture, extensive support circuitry, slow access times, excessive cost, and the growth of the hard drive put them on the shelf as a curiosity of the time.

The EPROM is also nonvolatile and has no moving parts. To use one, an EPROM programmer is required to write the data to the circuit and an

EPROM eraser is needed to wipe out the data. There are any number of programming devices on the market. One system is available through Electrosonics in Minneapolis, Minnesota, and has found considerable use in museums and other unescorted tour venues where a short description of a painting or display is played over and over to be picked up by a personal radio receiver when in proximity to the display. Because an EPROM is solid state, there are no mechanical parts to break down. The major stumbling block to EPROMs is their lack of capacity unlike their nearest cousin, the PCMCIA PC-Card, which can handle up to 40 megabytes of storage capacity. EPROMs are normally "erased" with ultraviolet light and then rewritten. The manual for an EPROM resembles Cliff Notes for a quantum physics lecture — very dense and extensive. Their use in multimedia would be limited to environment-oriented shows and displays.

PERSONAL COMPUTER MEMORY CARD INTERNATIONAL ASSOCIATION — OR THE "PC CARD"

A flat rectangle about the size of a credit card and the thickness of two nickels, the Personal Computer Memory Card International Association (PCMCIA) technology blossomed in 1989 when computers were rapidly shrinking from laptop to notebook to personal digital assistants (PDAs) and all sorts of ideas were floating around about how to boost their memory capacity and add features that were expected. Hard drives had not yet compressed and stacked themselves into today's tiny recesses. The floppy disk was limited. Zenith Data Systems tried a 2-inch disk drive, then used in single-frame digital cameras, and bombed out. The leading manufacturers put their heads together and came up with the PC Card concept.

The first PC Cards were memory cards that jacked up small computers' storage capacities. Then came variants on popular software such as Lotus 1-2-3 packed into the cards. Eventually, three card sizes evolved, each differing in its thickness: the 3.3-, 5.0-, and 10.5-mm or Type I, II, and III cards, respectively. The Type I PC Card is used for memory devices such as RAM — working memory. Type II PC Cards are designed as input/output cards housing such hardware as data/fax modems, local-area network connectors, and mass storage. The thickest Type III card contains mechanical systems such as rotating mass storage devices. Storage cards have pushed past the 40-MB capacity on the rigid disk drive (RDD) up to 400 MB on a Type III and up to 121 MB on a Type II card.

Unfortunately, the concept for the PC Card and the reality skipped a connection. Originally, the idea was for the card to be plugged in and, *voila!,* things would happen automatically — the much valued

plug-and-play pot of gold. Sad to say, owners found themselves following software steps in attempts to configure the computer to recognize each card. Because most peripherals in a computer are installed at the factory or set up at the point of purchase, this throwback to the days when computer gearheads spent as much time with the top off the computer as on was a disappointment.

Today, the future of the PC Card is developing slowly, but, according to the PCMCIA, advances are taking place. The fax/modem card is a standard feature on laptops and memory boosters have been well received. New cards, using the Zoomed Video specification, will be able to capture hardware-encoded MPEG video images and write the data directly to the laptop's VGA controller. If it catches fire, this specification would also enable video teleconferencing via ISDN (Integrated Services Digital Network, 64 to 128 kbps) lines.

Noncomputer industries such as cable television see the PC Card as an ideal user interface to plug into set-top boxes. The user would receive programming through a preassigned password and would also participate in interactive programming.

As for multimedia applications, some vertical markets have created special cards to be inserted in portable computers. These include data acquisition systems, wireless communications, and security. Other adventurous souls have created cards for health care, inventory management, and office networking. Rapid uploading and downloading has been facilitated by SCSI cards.

The most challenging market seems to be the 32-bit CardBus, which would allow very high-speed applications such as teleconferencing and other data-dense information transfers.

As for multimedia application distribution — the subject of this book — the PCMCIA is actively keeping up the tub-thumping and ballyhoo as entrepreneurs attempt to work around the card's shortcomings and punch up their good points.

Without some form of automatic, plug-and-play configuration standard the PC Card's attractiveness to today's user is in question. A series of books is available for developers through the PCMCIA detailing all aspects of card design. Breakthroughs in applications with these rugged, highly transportable devices could jump computer technology a quantum leap. All they need to make the grade is a true "killer application" full of nonvolatile memory designed for PDAs and small notebook computers. Two types are available for inserting software into a machine or as a boost to memory storage. PC Cards have a limited capacity of 1 to 2 MB today and are a bit pricey to produce, but for small training programs with limited graphics for notebook computers, they are a possible solution as they proliferate among the PDAs.

CD-E: USE AGAIN AND AGAIN, BUT WHEN?

The CD-E (compact disc–erasable) has been the Flying Dutchman of the CD industry, dating back to the earliest LaserDisc experiments. Now, it seems, the first discs were due out in early 1997. Many discophiles claim the CD-E will spell doom for all magneto-optical floppies and giant floppies. For this to happen, the CD-E would have to have a format standard created for it and, so far, this has not happened. The idea of having a CD-ROM that can be recorded on like the hugely popular CD-R, but then be able to be erased like a videotape to start over again has been a distant dream. If they can be written to using the same software as a CD-ROM, then checking multimedia programs, creating one-time disks, and using CDs in much the same way as we use floppy disks today could become a way of life.

CARTRIDGE DRIVES

These drives are used primarily to supplement hard drive storage capacity and for transport of very large files such as multimedia graphics, video clips, etcetera, between computers. While many tape systems are still used, technology has created very dense floppy disk configurations encased in proprietary shells and operating in drive units that can be attached to a computer using either a SCSI, or a parallel port.

The original SyQuest® system was the most popular developmental tool comprised of a drive unit and a cartridge holding either 44 or 88 megabytes. The drive operates through a SCSI controller and was the favorite of multimedia developers and designers for holding graphic data. The storage tape systems' transfer rate is very fast, but they were never designed for direct multimedia interactivity. The latest SyQuest® EZFlyer™ uses oversize floppy cartridges holding 230 megabytes. Iomega™ offers the Zip Drive at a low $200 price tag. Each cartridge holds 100 megabytes of data and they cost about $25 each.

22

The Internet
What's There, What's Not There, and Why Not

If the reader wants to know about the Internet in general, walk into any bookstore and ask if they have a book on the subject. Oh, yes, bring a heavy-duty handcart and the checkbook for your money market. Everything is there from *Internet for Drooling Imbeciles* to a title written in C++ code. A twentysomething at the author's elbow pointed to the code title and chuckled. "Get it?" he asked. "It's a play on algorithms." Your author picked up the ". . . Drooling Imbecile" title, mumbled something about a gift for a 5 year-old and left.

The point here is that this book is not targeted at the Internet per se, but how the Internet can or can't be used as a multimedia vehicle. In most people's minds, the Internet and the World Wide Web are one in the same. This is not so. The Web is comprised of some 11 billion words on 22 million pages scattered at random around an ethereal library with no card catalog.

According to computer columnist James Coates, who writes for the *Chicago Tribune*, "The Web is an immeasurable repository of the planet's literature, artwork, scholarship, scientific research, business data, government reports and, increasingly, radio programs and even television clips. . . ."[1] Many companies are tripping over themselves in order to set up Web sites, trolling for surfers who might become

[1] James Coates, "Clearing a Path in the Web's Clutter," *Chicago Tribune,* Business section, April 28, 1996, p. 1.

customers, or seriously targeting their audience by having an almost mandatory Web site address on their literature and TV commercials (www.business name.com).

If you believe Bill Gates in his book *The Road Ahead*,[2] one day we will all be wired into something that resembles today's Internet, but is far more comprehensive in its scope. The personal digital assistant (PDA) many people carry with them will be connected via a wireless cell-phone-type link directly into this supernet and will receive video, audio, and color graphics as well as satellite location and how far they are above sea level. It's a wonderful, scary vision that predicts virtually infinite access to every facet of life at the click of a button or the sound of a spoken word. Looking back at the predictions in a 1986 Microsoft book, *CD-ROM—The New Papyrus,* offered by every guru from technicians and theoreticians to educators and designers—including Gates—about the emerging disk media, the reader has to admit they got that part right. Gates' blue-sky vision comes from not only his own experience with targeting technology to meet the consumers' desires, but also from the coterie of thinkers that surround him at Microsoft—a vision by osmosis. Face it, one day we will all be wired. Whether the outcome is an outtake from the films *Brazil* or *Blade Runner* or a more benevolent intertwining remains to be seen.

Accept the possibility that one day our grandchildren will look back at the practice of actually carrying media around with us on tapes and disks as sweetly arcane. Although 36 million TV sets are sold every year compared with six million computers,[3] kids are still leaving the passive entertainment of Saturday morning cartoons to fire up their PCs, Macs, and Nintendo 64s. According to Robert W. Stearns, vice president of technology and corporate development at Compaq Computer Corporation, in a recent *Wall Street Journal* interview,[4] ". . . we're developing a generation of children and therefore adults who are going to be very oriented to interactive entertainment and education."

So what about today and the World Wide Web as a multimedia alternative to transportable media that can also reach a targeted audience? What are the possibilities? We discuss three possibilities in the following chapters:

1. Direct Internet use
2. The Internet plus a CD-ROM
3. Future wired technologies that are in the wings.

[2] Bill Gates, *The Road Ahead,* Viking Press, New York, 1995.
[3] Thomas E. Weber, "Entertainment + Technology = Crystal Ball," *Wall Street Journal,* March 28, 1996, p. R21.
[4] *Ibid.,* "Entertainment + Technology = Crystal Ball."

23

Direct Internet Use
Standing There with a Handful of Web

A New York market research firm, FIND/SVP, estimated at the time of their sampling in April 1996 that 9.5 million U.S. Internet users visited Web sites. Of that number, about 12 percent found something worth buying from sites that offered the shopping option.[1] Adding to the data, consultant group International Data Corporation of Framingham, Massachusetts, maintains there is a backlash growth among major-league Web users. As many as a fifth of corporate users will be dropping their sites in 1996.[2]

There are obviously two sides to the Web question. On one side, the supporters are trumpeting its praise from the castle turrets while outside the gates there is a grumbling populace folding up their tents and stealing away. For anyone contemplating using the Web as a stand-alone multimedia vehicle in place of transportable media such as the CD-ROM, serious considerations must be investigated.

From the front end of this book to the last page, a great sign should flash on and off in neon: *KNOW YOUR AUDIENCE.* While this is the cardinal rule in multimedia, on the Internet its importance grows to fill the room.

The Web is a homogenized polyglot of interests, desires, and agendas. Earlier, the term *trolling* was used. This fishing metaphor, unfortunately, has

[1] Joan E. Rigdon, "For Some the Web Is Just a Slow Crawl to a Splattered Cat," *Wall Street Journal,* March 28, 1996, p. 1.
[2] *Ibid.,* "For Some the Web Is Just a Slow Crawl to a Splattered Cat."

Figure 23-1. A client called to request a Web site for its parts catalog, which to this point had always been mailed to customers. The client believed putting the catalog on the Web would help reduce all those printing and shipping costs. Fortunately, early in the conversation, the developer asked if the client's customers used the Web. A silence ensued. The developer asked how many of the client's customers frequently used modems. After a moment, the client asked about the possibility of making a CD-ROM. That was still state of the art. The same interrogation also netted a negative as to CD-ROM drives in the customers' offices. The project ended up going out to the customers as a packet of shrink-wrapped floppy disks — low tech, but customer friendly.

been business as usual for far too many Web sites. Sites that are not managed by in-house computer servers are maintained by Internet providers. They can furnish the Web site owner with a list of the number of "hits" made on that site. With a simple twist of design, the owner can also have those hits sent directly to an e-mail site for later perusal or have the visitor's URL (uniform resource locator or "address" for the Web-challenged: http://www.whatever.com) loaded into a database. The success of the site has often been gauged by the number of hits as though it was, indeed, an actual target. This method of measurement has fallen into disfavor because the sheer volume of sites on the network and the operation of some search engines can cause surfers to land on a site just through the law of averages. As of this writing, those 22 million pages ready for perusal mentioned in Chapter 22 were offered up by 9.4 million hosts in 129 countries.[3]

Successful multimedia targets its audience; CD-ROM and floppy disk distribution is sent along channels that will reach the targeted audience and the entire program with all its elements has been meticulously planned to appeal to that targeted audience. Why should a Web site be floated out there like dropping a bare hook into a big pond?

Most corporate sites fall into four categories:

1. An image piece showing off the client's products and trumpeting the holy mission statement

2. A demographic feedback piece looking for information from the people who have spent some time at the site in an attempt to generate sales leads or product development hints

3. The site-as-catalog for either direct ordering or telephone orders after disconnecting from the site

4. Some of the major sites combine parts of or all three of these categories into one big, many-paged production.

An image piece generally fires off all the big graphics guns from photography and animation to video clips and music. They are pitched at the company's customer demographics and provide ways and means to make contact with the key people who can set up an appointment: an 800 number, an e-mail address, or a form to fill in the visitor's important information.

Moving along, the feedback-centered site is for companies desperate for information about their customer demographics. Everything about the company's site identity from its URL domain name to its page layouts is designed to appeal to Demographicperson who will buy their product

[3] http://www.nw.com/zone/WWW/report.html, Network Information Service, Menlo Park, CA, 1996.

or service. They scream "We speak your language!" and make use of "hot" buttons, which can be highlighted words in the text or icons located in the screen design that respond to the touch of the cursor arrow by turning the arrow into a little hand. They "link" you to other pages in the site, or send you off to other sites relevant to your query. Through layer upon layer of amusements, factoids, graphic embellishments, interactive games, and so on, they act like the steerer in a con game until the mark . . . er, um, potential customer . . . arrives at the center of its Web site. After obviously spending so much time at that particular site (thereby validating its targeted design) to get this far, would the demographically dazzled Demographicperson please answer a few simple questions at the end of which his/her/its name will be dropped into a drawing for a brand new shiny whatever? Since most people don't enter the Web with the idea of *writing* anything unless they are in a chat group, inducements must be offered to reach this stage. One of the major joys of the commercial Web sites are their virtually transparent technology with the payoff being a quiet hand of three-card monte.

Finally, the Web site-as-catalog blinks to life on the screen and Binkley's Screw & Bolt lays out, with a minimum of fuss, its catalog listing of each part, part number, order number, and per-unit cost. Usually this level of programming can be accomplished with a simple database application such as Adobe Acrobat™ plus a couple of "splash" pages showing a picture of Binkley world headquarters and a portrait of Hiram Isobard Binkley, the founder. With a bit more ingenuity, part numbers can be abstracted into a master order list and dispatched along with a customer order code via an e-mail or database link.

Of the three major site types listed here, the one that has the best chance of success is the last, the catalog site. The other sites cost much more to create and have superior visual pyrotechnics and bolder graphic concepts, but they stand the greatest chance to fall into the Web's most capacious trap — they could be huge commercials without content other than hype, blue smoke, and mirrors.

With Binkley's catalog Web site, the company's expectations are modest. They sent a mailing to their clients saying their catalog would now be on the Internet and would be updated quarterly instead of yearly. Three types of part search are available and an order can be made on the spot.

To make it on the Web, you need to provide content and services that are useful to people. If they are going to hang around, or revisit, it is because you offer something they value. In some cases, sites provide hot links to other locations that may have a sympathetic relationship to the company's specific product line and offer a line that complements those

products, creating a synergy in the customer's mind. In our neighborhood, a local plumber has a Web site that has links to a company that drains crawl spaces, another that cleans heating ducts, and a third that repairs furnaces. The plumber also supplies a monthly plumber joke that's worth the hit on the site even if you don't need your crawl space drained.

The Web became an almost instant success because of four factors:

1. By the time the Web came along, there was already a large group of people working the Internet.

2. The sudden ability to access graphics, video, and music added interest to the sites above and beyond the Internet's databases.

3. The base of computer-literate users was large and made up of people who were not intimidated by the Web's total lack of structure.

4. Mosaic, the first popular Web browser, worked across platforms and was a very user-friendly guide to the widely scattered sites and the information they held.

The explosive Web growth began in March 1989 with a proposal by physicist Tim Berners-Lee to the Electronics and Computing for Physics Division of the Conseil Europeen pour la Recherche Nucleair (CERN) that has progressed to today's appearance of virtual on-line software applications written in the Java language (Sun Microsystems, Mountain View, California) and using Microsoft's emerging Internet tools based around their OLE (object linking and embedding) system supported by current Microsoft desktop computer applications. Where it was once cool to have an Internet e-mail address on a business card, now, to be really with it, a Web address trumps an e-mail address.

In some instances this explosive popularity has caused many of the Web's biggest problems, especially as a multimedia alternative. There are four major considerations for the Web-as-multimedia:

1. Access

2. Speed

3. Security

4. Cost

ACCESS

Many Webheads get their first taste of surfing through one of the major on-line services such as America Online or CompuServe. Their Web browsers are improved and allow both rapid searching and the ability

to download a greater variety of site information. Heavy use rates in the form of flat monthly fees for unlimited use have also been inaugurated for the heavily addicted, with predicted log jam busy signals.

We'll discuss how a service provider can work with a company to offer extra services a bit later in this chapter. For now, suffice to say that they provide space on their hard drives for the client's Web site, offer downloading services, and bill by the amount of memory required for the site, for maintenance, for time on the modem, etcetera.

Accessing the Web depends on available lines for communication. Lines are not always available at certain times of the day due to sheer volume. The huge number of users, which is growing almost exponentially each day, strains the gateways into the Internet. Replacing hourly fees with flat monthly rates has caused heavy traffic tie-ups during peak hours (early AM and late PM). Until the phone line "pipes" and switching systems can increase their capacity, there will always be bottlenecks when the lines are all busy. This is one reason many Web site owners schedule e-mail links to download their data during the wee hours of the night so responses can be collected off the local hard drive in the morning.

Access also means locating specific sites. The URL address is a clumsy business with its http (HyperText Transfer Protocol) lead-in where one mistyped letter can cause frustration. Automating the call to a specific site can be programmed into an Internet-based multimedia project, but the line might be busy. Multimedia projects are often designed to operate either all day in a trade show or seminar venue, on demand at a small group meeting, at a one-on-one scheduled presentation, or in a classroom situation for training. With transportable media, the show is always ready to go on. But any network-based program that uses public phone lines has one final unpredictable hurdle before showtime.

For an all-day event such as a trade show, the call must be to a local provider number or an 800 number in order to keep the line open for a full day. Otherwise, if the call is long distance to the home office provider, the cost could be prohibitive. Some services provide an 800 number that shows local numbers that can be used within a given area code. The problem always remains that even if a local number is available, it might be under heavy use at the time required for the presentation. The other alternative is a special (and relatively expensive) T1 line or ISDN hookup that will be explained later.

As recommended in the opening section of this book, the Internet should be explored by any company seeking to establish a Web site. With typical multimedia, the potential client could visit trade shows, request direct mail disks, and conduct a systematic examination of what the competition is doing. This holds equally true for the Web. Sign up

with a provider or an on-line service such as America Online (AOL) and learn to use their browser and its search engine.

The browser is unleashed by typing a keyword or words such as "steam tractors" or "snark" or the home page address of the database search engine that should hold the information you are seeking. There are published print books available that catalog home page addresses such as *Yahoo! Unplugged*[4] by David Filo and Jerry Yang that indexes all the pages in their huge database by category (http//www.yahoo.com/).

After the mandatory display of graphics and visual hooha, the screen settles down to input boxes offering as many as three types of searches:

1. *Keyword:* This search requires the explorer to simply type in a word that embraces the information desired. For example, your author typed "Digital Video Disc" into AOL's "Webcrawler" and in about 30 seconds had a list of more than a hundred articles, papers, surveys, etcetera, dealing with the elusive DVD.

2. *Keyword plus Boolean operators:* Here, you use the keyword together with AND/OR to narrow the search further as in "Digital Video Disc and LaserDisc" to find articles that might compare the two.

3. *Concept:* The most complex of searches, this might take a bit of chugging about by your engine trying to find a match to "video on a disc."

The search engine then proceeds to scour that database location for your information. A list of titles is presented as hot buttons. Click on the title you wish to examine and, poof, there you are. Some browsers like the AOL Webcrawler offer favorite home sites on the Web and will also build a file of the sites the Web surfer has visited so the return trip is easier.

Browsers created by Netscape and Microsoft allow the surfer to download large amounts of information from sites since these engines recognize a large number of different file types that are used by Web developers. For example, video, audio, and interactive files used to create a site require visitation by a browser that can read them. Standard programming used to create the sites includes *helper plug-ins* that transfer to the browser along with the video or audio file so that the file can play on your computer. Other helper programs called CGIs (common gateway interfaces) are plugged into the site by programmers to allow interactivity such as answering questions, filling out forms, gathering database information, and so on. If your browser does not read these files, you get zip — or maybe a printed box reading "Exciting video happens in this space."

[4] David Filo and Jerry Yang, *Yahoo! Unplugged,* Online Press, IDG Book World Wide, Foster City, CA, 1995.

A few voyages into the Web will give the company point person responsible for this multimedia project a feel for the medium, its excitement, and its pitfalls.

SPEED

Transfer rate, as discussed at length in transportable media, raises its head again. The first modem your author connected up to a computer bulletin board had a speed of 300 baud (data bits per second). All that was transferred was plain text, but when the leap to 1200 baud became possible, everyone jumped at it. Then came 2400, then 9600, followed by 14,400. At this writing, the fastest commercially available rate is 56,000 baud, which is capable of downloading graphics, sound clips, video clips—everything available on the Web—if you have the time. As with most rapidly growing technology, the amount of material and its huge memory load of pixels grew faster than the modem's ability to suck it down the telephone pipeline. A video frame can take minutes to download over a 14.4-baud modem. High-resolution graphics are also time hogs. Motion video or animation can take an hour and a video program can take a full day.

A technology called *streaming* has emerged that relieves some of this problem. An audio or video file is played and the first part is buffered into the visiting computer's RAM. While that part is playing, the next segment is *streamed* into RAM. Using this technique, virtually unlimited video and audio can be played. Radio stations now have space on the Web broadcasting special events. These streamed events can also trigger page changes within a site, providing a synchronized sight and sound experience for the visitor.[5]

The site should be tested with a number of platforms, browsers, and computer monitors to see what happens to downloaded graphics. Graphic images kept to 72 dots per inch (dpi) are much easier to download than images of 600 dpi and up. Thumbnail photos or graphic images help reduce the modem squeeze. Special effects such as embossing often come out wrong depending on the translation to the home screen in use. Text for downloading should stand by itself rather than be incorporated with a graphic. Many "trimming" possibilities are open to developers who are creating corporate Web sites to make sure that items meant to be downloaded can be done so with a minimum waiting at the other end.

[5] John Leland, "The Web in Motion," *Multimedia Producer Magazine*, July 1996, p. 24.

SECURITY

CD-ROM and other transportable media maintain a degree of audience control. They go to the targeted audience and usually stop there. But, as with the producer who let the client keep a copy of the female singing group's tape in an earlier anecdote, one can never be sure where one's product will turn up. With the Internet, however, the moment that site opens for business, whatever in on there now becomes fair game for any use all over the planet if it can be downloaded.

Copyright infringement is difficult to enforce on the Web. For the most part, it depends on the honor system. Computer software and VHS movie tapes tried copy protection schemes, but they ultimately failed because they could be defeated by products sold to the public for that purpose. With software there was no way to make backup copies of the program and store the originals. These were the days before hard drives when a floppy disk with the application on it had to reside in a floppy disk drive slot when it was running. Early hard drives were for user data only, not applications. Copy boxes and cables for VHS copying were in every catalog. For the most part, the copy protection schemes were more trouble than they were worth so they were dropped. The world did not end.

Today, a philosophy on information sharing has become pervasive with various types of *shareware* appearing on the net. The very popular Netscape browser was offered free over the Internet when it was introduced. The HotJava browser and the Java language (discussed in Chapter 25) used to write Web site code have security built in to their content handling structure. For the most part, however, what is placed on line is open to all. The Web site owner must have the rights to use the elements that make up the site and there is no guarantee that anything downloaded from the site will not be used elsewhere.

And if sending thousands of dollars worth of media investment out into the chaos of the Internet isn't scary enough, the client must worry about what comes back! With multimedia, send out a disk and maybe get back formatted feedback from the targeted audience using a predetermined form. Send out an Internet program and a ghastly great virus can be sent back wrapped in an e-mail hyperlink return by some fiend that can tear right into a company's local-area network (LAN) and gut the data on individual computers connected to that LAN. Be sure that if you allow any connection between a server created to manage Web data and your company's LAN, there is also a powerful antivirus *firewall* built into that connection. Firewalls are designed to keep out whatever was not requested as elements of feedback. They also throw up a barrier against any deep, dark nasty hack into the vitals of the company LAN if the server is company operated.

Figure 23-2. A company created a LAN manned by an internal IBM System 36 computer. Every stage of the computer's content was password encrypted. The manager of the system was sent to computer security classes. A complex series of antihacking measures was introduced. The daily process of searching for data became a regular James Bond adventure. Eventually, the system became so security overloaded that it became unwieldy and useless. Interesting to note, at no time had the computer server ever been connected by modem to an outside telephone line.

COST

The creation of a site can cost as little as the time it takes to learn the HTML (HyperText Markup Language) or buy development software that automatically converts your page designs into HTML and the time it takes to put it to use. If the company programmer can program in C+, he or she can learn HTML. If, on the other hand, corporate programming skills are a bit ragged or are confined to non-Internet-compatible languages, then, as with other forms of multimedia discussed, the barbarians must be admitted into the palace. Even clinging to a language literate programmer doesn't put off that decision, because it is rare to find a programmer who also has the concept and design skills needed to create an effective Web site.

The selection process and management processes are the same as with conventional multimedia. The main difference being that when, for instance, a CD-ROM is stamped and shipped, that is usually the end of the process mediawise unless sporadic feedback maintenance is required or until the CD-ROM is updated down the road. Once a Web site is designed and laid on its home tracks on a whirling hard drive, the cost clock continues to run.

Providers have different schedules of charges but one set of rates gives an idea of ongoing cost. For mapping out the client's already designed site onto a server's hard drive there is a nominal up-front charge of $50. Then, for each service on that site such as setting up the Web address and adding a gopher search device, there is a cost of $50 for the first service and $20 for each successive service. These are not unreasonable one-time costs. It gets interesting when the monthly maintenance tab comes due. Memory space costs.

A bill for $75 per month pays for 10 MB of elbow room for a Web site. For each additional 10 MB, the cost is $25. One relatively high-resolution still photograph can take up 1 MB of space. Now, imagine the cost to a heavy equipment manufacturer who puts their entire 400-page illustrated catalog on line. Video and audio files eat up memory as do 3D graphics and animation. Another company with a multipage Web site selling alcoholic beverages entertains surfers with 30-second full-motion video commercials. Anyone for a nice stack of gigabyte hard drives?

Costs can be justified if there are methods to both quantify and qualify the resulting return on investment. Survey organizations are available for the Internet just as there are television ratings systems that help advertisers determine TV show demographics and viewer numbers. These

Internet survey companies provide a monitoring service for a Web site and determine the number of people who visit and spend time there. Instead of calling them *hits* in the common vernacular, these dalliances at deep pocket sites are called *impressions.* One company, Lycos, Inc., (http://www.lycos.com) uses a search engine created at the Carnegie Mellon Institute. They bill commercial sites that are called up on the Lycos site. These call-ups cost the commercial site owner between $20,000 and $50,000 per million impressions.[6]

Ultimately, the effect of a corporate Web site justifies itself on the bottom line by what portion of increase in the gross profit is attributable to the site's effectiveness. According to the Intentional Data Corporation,[7] of the Fortune 500 companies who have commercial web sites, 20 percent of them will have closed or "stabilized" them by the end of 1996. To stabilize a Web site means to let it sit without updating for a long period of time.[8] The only justification for this kind of neglect is a site that has been designed to be sent into the Internet ether like a Voyager space probe — beyond all human control.

By April 1996, on the other hand, 256,000 commercial "domains" or Web sites had been registered. This translates, according to Forrester Research in Cambridge, Massachusetts, to an estimated jump in corporate spending on the Internet from about $74 million this year to over $2.6 billion by the year 2000. Considering the constant mutation and upgrading of Internet services, it is interesting to speculate on the structure of the Internet by the millennium. The amount of $2.6 billion might be quite conservative.

[6] James Coates,"Clearing a Path in the Web's Clutter," *Chicago Tribune,* April 28, 1996, p. 2, Section 5.

[7] http://www.idcresearch.com/96pred.html, International Data Corporation, 1996.

[8] Alexandra Fisher, "Web As Theater," *Internet World Magazine,* Mecklermedia Corporation, June 1996, p. 36.

24

Managing the Web Spinning Process

If using the Web as a multimedia vehicle is in your future, there are steps that can be taken to aid in managing the construction process. While most of the multimedia vendor selection and management practices put forth elsewhere in this book also work for Web projects, certain safeguards and caveats are unique.

Producing a Web site is as much a team effort as any multimedia project. The skills involved are specialties and very few individuals are capable of getting their arms around all of them. As in the opening chapter on selecting developer–vendors, there are turnkey design houses who have all the necessary talent under one roof and there are individual specialists.

Picking individuals to create the sight is tricky, because the newness of the medium has attracted all sorts of talented people from other media who are gamely adapting themselves and their skills. But unfamiliarity with the Web leads to disaster. Many graphic designers who have made their livings off print have watched carefully developed techniques and standards of quality watered down by computer-based design and printing. They reach out to the Web as a new revenue generator with deep pockets. Equating good-sized budgets with high-quality images doesn't play on the Web. As described in the preceding chapter, a print-quality image of 3000 dots per inch takes up disk space like a Sumo wrestler in an elevator. Good graphic design on the Web requires the creativity of managing scale and download speed as well as playing on the visual senses.

This same requirement applies to the overall project designer, who is also the team leader. Comparing a site designer to a ship's architect offers a good perspective. Anyone who has gone on a cruise or sailed on a yacht has to marvel at the efficient use of space without sacrificing either efficiency or beauty of design. Not a millimeter of that compact marine world goes to waste. Even on a huge scale, imagine laying a 40-story luxury apartment complex on its side, adding a theater large enough for a Broadway show, dining rooms, swimming pools, and a propulsion system, delivering fast and constant gratification to all the passengers, and still being able to sail it and dock it at a tiny Caribbean port. That image describes a Web site. Every good site lives up to the cruise ship metaphor:

- The site is made up of a series of events.
- Each event is easily accessible by anyone who comes aboard.
- Passengers can travel easily throughout the site.
- Information and entertainment are quickly and simply downloaded as desired.
- The site allows movement to other locations where other events await.
- When the experience is over, you want to come back (unless you got seasick along the way—which is a whole new metaphor).

The comparison can go on and on (getting to the site can be a pain in the neck, but you can leave a Web site halfway explored without risk of drowning). A good designer understands how to wring the most out of a site and meet all expectations.

Selecting that designer requires a bit of attention. The only way to judge a portfolio of work is to compare it to the needs of the project as well as the requirements of the medium. If the designer sweeps in with a Pentium-based multimedia laptop and rolls through an impressive series of slick pages straight from the hard drive, or a CD-R, pause a moment. A better idea would be to offer the designer a phone hook-up so you can access some of his or her most recent sites. Until the designer's handiwork squeezes down that pipeline into a computer that is typical of the machines that will receive the project in question, a judgment call is tough to make.

Another team member is the programmer. In anticipation of what is happening in the evolution of Web site programming, programmers who only know the basic HTML language will be obsolete by 1997. Language interfaces such as Java, CGIs, and Microsoft's ActiveX are keys to creating truly exciting and interactive sites that invite revisits.

Java, for example, is a programming language that offers accessible content similar to that of a CD-ROM both in complexity of file types and functionality. This capability foreshadows the crossover of CD-ROM multimedia to the Internet, leaving only huge memory-intensive programs remaining in the transportable disk media. Programmers who already work in compiled languages such as C and C+ are learning Java and HTML in anticipation of this basic shift between transported and wired media.

To have to think in terms of skilled individuals' qualifications concerning your Web project and to form your own team is a tough row to hoe without a foundation of criteria from which to judge. A production house that has the talent under one roof relaxes that individual choice burden to narrow the selection process to the same, common sense judgment calls described earlier in this book's opening section.

Settling costs and responsibilities for design, production, and maintenance of a Web site should be part of the earliest negotiations. As stated before, a Web site is a medium in a constant state of flux, unlike a CD-ROM or other transportable media that is created and has a physical fixed lifetime before needing to be updated. In many cases with a Web site, maintenance and updating costs will be more than the original dollars needed to build the thing.

In some cases, the actual host, or provider, can also design and produce the Web pages used to create the site. If this is the case, then a sharp demarcation should be made between the production and host expenses. Designer–hosts have been known to offer discounts for maintaining the site if they do the design work. Have separate contracts drawn up covering each part of the job.

Another situation can occur when a designer refers a provider–host. As with the production house that bids a certain technology, because they must justify its original cost as well as the talent they hired to provide it to customers, a designer may have a "relationship" with a particular provider. A low up-front bid for producing the site may be tied to commissions paid to the designer for steering the client to the provider. Either way the client pays, but it's better to deal without entangling alliances.

As with multimedia, all ownership of the elements should be defined clearly, all fees paid and contracts signed. One difference lies with the ownership of the software, known as *scripts,* that runs the program. Some scripts have been developed by designers to serve specific markets. They use these predeveloped routines to prevent having to re-create the wheel for every new client. While most programming code for

multimedia has routines that are frequently "canned" (that is, used from other programs where the same need was required), their use is frequently a value-added element by the programmer to get the job. As the ante goes up in producing Internet Web sites, these scripts, especially those written for narrowly defined markets, have a value to the programmer as an intellectual creation licensed for a single use by the client. They constitute a competitive edge over other programmers. If the client wishes to go elsewhere with the Web site elements, those proprietary scripts don't tag along. They remain the property of the programmer. Other property housecleaning before shipping the site off to the provider involves being certain of ownership and release rights of all material: video, graphics, spoken word, music—anything that appears on that sight. CD-ROM technology has just been recognized by SAG (Screen Actors Guild) and AFTRA (American Federation of Television and Recording Artists), the media actors' unions, as a distinct medium with its own contract specifications and rules. Check with the local unions regarding rules that are being developed for the Internet.

25

Movin' On
Crossing Between CD-ROM and the Internet

The Internet part of this discussion of media is the most volatile and expanding growth area. Transportable media in all permutations of disks and tapes can't hold a candle to the power of the Internet, or its promise. It is almost impossible to write a book about specific aspects of the Internet that won't be obsolete before the book is printed. That's why there are so few hardcover computer books — they are cranked out on recycled paper between sheets of coated cardboard to keep up with the changes. This is one reason why your author has chosen to write about principles of vendor selection, project management, and media selection. Hardware and software change, but principles have a longer shelf life. Even though specific media are discussed, each type is treated as though it were a specimen, secure in its features, but vulnerable to the march of time. The histories included tell the tale of shining moments imprisoned in verbal amber to eventually be eclipsed by our own genius. Transportable media is just part of the sticky sap still oozing down the tree bark.

As with every losing confrontation, holding actions are fought. Last man, last bullet stands are made at the front, while developers squint anxiously into telescopes aimed at the future. The media confrontation is less a conflict in two dimensions, transportable media versus wired media, than it is a chess game in three dimensions as played by *Star Trek* characters. CD-ROM and the rest have the track record, the mature delivery systems, and experienced levels of creative talent on tap. The

assailing Internet force is involved in a huge double envelopment with cable and phone lines but with nervously unsecured flanks. The Internet is throwing in wave upon wave of users, but is changing its tactics every 10 minutes — and everything is happening with no sign of malice, only impatience.

Each successive medium through history has had to fight against the prevailing media for audience share and recognition. Movies waged a war with the legitimate stage and vaudeville. Radio elbowed its way into prominence during the depression at the expense of print advertising. Television shouldered aside movies. Tape and CDs were introduced at the expense of live performances. Finally, kids are walking away from the TV to log onto the Web. But after all that, we seem to have settled into an era of coexistence and truce. The primary reason for this seems to be the compression of the inventive cycle. Technology is changing at too fast a rate. What was once the overnight success that swept the field has meshed into today's tremendous breadth of communication options existing side by side, each drawing just enough market share to hold its own.

Even as CD-ROM continues to mutate into more efficient forms with greater capacity dictated by more sophisticated data compression techniques, a taste of its visual and audio dynamics is now appearing on the Internet. As the Internet becomes more like the CD-ROM, the net's ballooning multimedia capability is becoming too inflated for the transfer capacity of standard telephone modems to handle. The cable modem has emerged as the transfer rate champion with its fiber-optic "big pipes" as the telephone and video cable companies wrestle with each other and with legislation and for bandwidth allotments to see who becomes the ultimate communications carrier. Somewhere in this mix, the audience out there is trying to decide which way to jump.

The ability to transfer the capabilities of the CD-ROM to the Internet is being taken up by programming language interfaces such as Java, as discussed in the previous chapter. This object-oriented language developed by Sun Microsystems allows users to work with the Internet as though they were using a CD-ROM-based multimedia program. Image drawing delays, large file downloads to local disk drives, and other sluggish text functionality are remedied by this language and the browsers that read it. In place of simply reading pages made up of low-grade images, audio and video, the Java language allows users to download small helper programs called *applets* (small applications) onto their disk drives and interact with the material in real time.

A graphics example is explained by Elliotte R. Harold on the Java FAQ (frequently asked questions) Internet address (elharo@sunsite.unc.edu):

In practice, rather than using graphics primitives to create your desired web page, you'd use a graphics program to draw the page and then write a program that could read and display the file formats of that program. Java lets you write content-handlers that display any particular data format. This way you can download your data and your data display program rather than downloading a bitmapped snapshot of the display. People are already using this to add sound and animation to web pages. Rather than having to download a file and spawn an external viewer, the viewer is included with the data; and the data is displayed right on the page.[1]

To further enhance this process, Sun Microelectronics, a division of Sun Microsystems, is developing Java-optimized microprocessors to be built into the next generation of communications appliances designed to connect exclusively with the Web. These microprocessors would operate on the net at greater speeds than the processors used for general purposes in our computers, creating an almost transparent link with Java-written Web sites.[2]

Microsoft entered the Internet sweepstakes late, but when they saw the light, they entered with typical élan and innovation. Best of all, they arrived using tools most developers of Microsoft products already had and understood. The engineers extended the OLE (object linking and embedding) feature already available in Microsoft desktop applications to the needs of the Internet. OLE allows a user to embed or link objects such as spreadsheets, drawings, photos, audio clips, etcetera, into a word processing document. Object "packages" can also be called up from a document by clicking on an icon embedded in the text. From this object manipulation technology, it was not a far jump to extend the principles to the many objects flitting about the Internet, creating ActiveX.

As mentioned earlier, the Internet and World Wide Web are connected, but separate entities. The Internet provides the connectivity while the Web provides the most interesting and alluring content. While Java used a new language to create Internet applications that mimic the speed and interactivity of desktop software, Microsoft's Win32 application programming interface (API) took a different tack.

HTML (HyperText Markup Language) is the standard format used by almost all Web sites so that all browsers can find those sites. HTML provides the navigation tools that allow the user to leap from one HTML

[1] Copyright 1995, http://www.macfaq.com/personal.html, Elliotte Rusty Harold.
[2] Aldo Morri, "New Java Microprocessors to Stimulate Multimedia On-Line Production," *Internet World Magazine,* Mecklermedia Corporation, June 1996, p. 13.

site to the next. But HTML isn't the only format available. An entire alphabet soup of formats is available, but HTML has become the de facto standard now because it has been adopted by most sites.

Microsoft has chosen to create OLE document objects. This allows the developer to choose the best format for any given site and be assured the viewing code needed to visit the site will work with any browser. The tools used to create the links are part of any developer's toolbox who works in the ubiquitous Windows applications. By allowing any format to be used for publishing a Web page, this allows desktop application software to link seamlessly to the Internet by simply clicking on a toolbar icon or a "hot" button embedded in any multimedia program. To create an acceptable standard, Microsoft has created their system with an *open architecture*

> *. . . so that anyone can plug in their solutions regardless of the tool, language, data format, or protocol used. All of this is built on a standard, secure, open pipe that provides universal and ubiquitous connectivity. . . .*[3]

This integrated hardware and software brings us considerably closer to Bill Gates' hand-held communicator of the future described in his book *The Road Ahead.*[4]

Approaching the problem of sluggish interaction and the download logjam for large files from another angle, one company, Ahrens Interactive, Inc., in Chicago, Illinois, has developed a technology that incorporates the best characteristics of the CD-ROM with the connectivity of the Web. They call it WebROM. Also, as of this writing, Ahrens Interactive has produced an award-winning CD-ROM digital magazine call *DigiZINE,* which makes use of this disk-with-a-pipeline concept. In effect, *DigiZINE* provides regular updates and supplements to the stories contained on the disk through a unique link the CD-ROM provides to a variety of Web sites on the Internet.

This means readers of *DigiZINE* can access its Web site for additional information on topics they read about on the CD-ROM. From the *DigiZINE* site, links carry the reader to other Web sites for browsing through topics of their choice. If they want to comment or leave a message for another reader, an e-mail link is provided. According to Rich Dettmer, Ahrens Interactive's senior programmer, "The WebROM technology provides seamless integration from CD-ROM interactive technology into interactive Internet communication where broadband is almost as instantaneous as CD-ROM."

[3] *Creating Platforms for Innovative Internet Software,* http://www.microsoft.com/intdev, Microsoft bulletin, updated March 1996.
[4] Bill Gates, *The Road Ahead,* Viking Press, New York, 1995.

Figure 25-1. Ahrens Interactive Group DigiZINE disc allows connection to the Web from the CD-ROM for seamless interaction.

If the user doesn't have access to the Internet, *DigiZINE* provides a chance to sign up for America Online directly from the CD-ROM. WebROM is compatible with most major HTML browsers including Mosaic, Netscape Navigator, CompuServe, Prodigy, and Microsoft. It will also work on either Mac or PC platforms.

While the cable and telephone companies struggle to provide virtually transparent Internet service, interim technologies such as WebROM offer a wide range of corporate possibilities.*

If the idea of incorporating the CD-ROM's capacity for data with the Internet's ability to keep data updated is of interest on a developmental level, software is now appearing that allows the corporation to do-it-themselves. A venerable old application that premiered in the dawn of interactive LaserDiscs, Icon Author™, is in its 7.0 iteration. In its latest version, this very user-friendly programming tool allows direct, icon-click access to the Internet from within the interactive program.

Caribiner Productions in Rolling Meadows, Illinois, uses the Internet and CD-ROM combination in trade show applications. Because most major trade shows today include some sort of fast Internet link such as ISDN or T1 (1.544-Megabytes per second) lines in their communication

* In 1997, Ahrens Interactive became Taproot Productions.

structure, Lighthouse connects the trade show kiosk to this line through advance arrangements. The CD-ROM part of the trade show booth handles the muscle presentations: video, audio, and animated graphics, while interactive information entered by attendees goes up to the booth client's Web site or Internet e-mail address for direct access as the show progresses. Data that need updating at the kiosk can likewise be handled through the Internet link.

The biggest stumbling block to CD-ROM multimedia has always been the inability to update the mass-produced disk. Using direct connections to the Internet provides a good solution to the updating question while also dazzling clients and prospective clients with rapid-fire audio and visual pyrotechnics unavailable to the poor souls still stuck at the tiny end of the information pipeline.

26

The Cable Modem

As can be determined from previous chapters, there is a problem with the Internet as a multimedia resource: The ability to get at the information in an expeditious manner is not perfect yet. Logging in over a telephone modem is no major time waster, but extracting information, especially video, graphics, or audio files and pulling it back down the wires to a local hard drive for leisurely perusal is a huge bore. The problem is centered around using telephone technology, which was designed to accommodate voice communications, to squeeze millions of bits of data into a pair of wires. It is akin to attaching a soda straw to the end of a fire hose.

At research centers across the country, the Internet's shortcomings are under attack. That soda straw telephone line is being pushed to its limit by means of reconfiguring current tools to increase their efficiency. As of this writing, an example is occurring at the University of Chicago where team members Roy Campbell, Zhigang Chen, See-Mong Tan, and Dong Xie are releasing a new browser that is combined with a reconfigured server to allow almost instant full-frame, real-time video with a standard modem. Their browser system is called *Vosaic*.

Vosaic is based on the original browser, Mosaic, which created access to the Web for thousands of users. Mosaic, and most current browsers, is still based on file transfer protocols that do not permit speedy, or even tolerably fast, transfer of video, audio, or animation. Vosaic has its own transfer protocol called the Video Datagram Protocol (VDP). Combining VDP and the Vosaic browser with a server (the base unit used by Internet service providers to connect people to the Web) designed to

Figure 26-1. Zenith Electronics cable modem. (Courtesy of Zenith Electronics Corporation.)

use VDP, multimedia on the Web becomes accessible to the average computer user. Users can receive six frames per second of video on a 28.8-kbps modem and full-motion video on a T1 (1.544-Mbps) line.

Transferring video down telephone lines results in frame losses because the buffers that accept the data before transferring it can handle just so much high-density continuous data. On detecting data loss, a request is sent back up the line by the browser to resend all of the data until the missing frames are retrieved. The Vosaic browser detects the loss and decides *which* frames are to be retransmitted rather than requiring the entire video clip to be sent again. This saves time. With Vosaic, it is also possible to embed icons in the video data stream that can be clicked on to link to other pages on or off the Web site. VDP is an *adaptive* protocol that works with Internet congestion rather than just muscling through with repetition. The transmission of Internet-based video, audio, and animation arrives in a state that, though there are missing frames, is very acceptable to our visual perception. Since the video clips can also be addressed one frame at a time, segments of a video can be specified and viewed if desired.

What Vosaic proves is that real-time video and audio can be fully integrated into HTML (HyperText Markup Language) to create Web pages. A Vosaic server, however, is required at the provider's base. This

server can manage large video and audio files and also determines who can connect to a video file if it is in use so as not to degrade performance to connections being served.[1] More efficient technology is in the wings. In the very near future, hopefully, what is described here will be inching toward reality instead of held high as a bright promise.

Perusing the Web reveals a lot of static pages decorated like wedding cakes with still photos and two-dimensional graphics, patient and silent. Quite a bit of digging is required before uncovering video and audio nuggets. They glitter in the digital ether, but they are not gathered in. True multimedia does not exist on many Web sites, because, without more speedy transfer to the user's computer, these animated delights would be inaccessible to users. Great images and sounds cannot be speedily stuffed down the telephone line pipe at a wheezy 28.8 kbps. However, operating at test locations, sharp high-definition graphics, video clips, and CD-quality music are being transferred at the whistling rate of 10 Mbps. Everyone is waiting for the cable modem.

For years, the telephone companies have been touting their ISDN (Integrated Services Digital Network) lines that could pump data at speeds of 64,000 to 128,000 bits per second and found few takers, because the need for such speed was a hard sell and without wide acceptance systems were expensive to install and maintain. Now, with the Internet and exploding Web, 128 kbps is only moderately fast. New cable modems are pushing the 30-Mbps envelope, as shown here[2]:

Download	14.4-kbps Modem	ISDN	Cable Modem
Simple image	2.3 minutes	35.7 seconds	0.5 seconds
Complex image	18.5 minutes	4.8 minutes	4 seconds
Video clip	1.4 hours	21.5 minutes	18 seconds

Obviously, with this kind of transfer speed available, multimedia designers are having sweaty dreams about the possibilities to create real-time, all singing, all dancing extravaganzas on the Internet. Why aren't we doing it?

Coaxial cable — the kind that connects the cable box to the TV set — can pass huge amounts of data compared to the skinny twisted pair of copper wires that hook our telephones to the pole outside. Thousands of miles of fiber-optic cable have been laid and hung across

[1] http://www.uiuc.edu/ph/www/vosaic, University of Chicago, 1996.
[2] *Daily Herald*, Business Section (3). *Source:* Forrester Research, Inc., May 11, 1996, p. 1.

the country. These cables are the "big pipes" destined to carry all this neat multimedia. With these pipes connected to a computer, there is no need to even dial up the Web. Turn on the computer and the Web is there just like a cable TV channel. The problems with making these pipes flow according to hype are twofold on the technical level.

First, viewing the cable as a mighty river of data thundering between its banks helps us to understand what happens when that mighty current starts flowing off into thousands of tributaries and keeps flowing into them as the water is used up. Eventually, that torrent slows down until it's a trickle a cat could step across with dry paws. Simultaneous users slow down the flow, and a cost-efficient way to boost the flow in the same way amplifiers boost electricity to maintain a steady amperage is the subject of intense research.

Next, the river has to have a powerful push to get it started, but the very construction of the Internet is not the waterfall needed to get things going. There are literal bottlenecks in the Internet's plumbing that do not permit the efficient use of the high-bandwidth flow of data the cable modems require.

Speed is the game for cable modem manufacturers. Hewlett Packard has their Quickburst, which can squirt up to 40 Mbps worth of data into a home and receive as much as 15 Mbps. Zenith has been deploying units that send 4 MB of data in both directions.[3] Zenith's next generation of ultra-high-speed cable modems will operate in the 27 to 40 Mbps range.

Technical complications aside, even those folks with cable modems capable of downloading data 350 times faster than regular telephone modems are still looking at the same static Internet. According to Forrester Research, Inc., in Cambridge, Massachusetts, by the end of 1996, about 13.4 million users will dial up their conventional telephone modems to access the net. Including all experimental programs currently under way, roughly 90,000 users will switch on cable modems.[4] What incentive is there for content developers to produce multimedia sites for that small sampling until they see a pronounced upward movement in the numbers?

Finally, the cable boxes cost about $500 plus the monthly cost of the service. The level of service received can be seen in the Viacom system, owned by TCI, which is serving a trial group in Castro Valley, California. For $40 a month, plus the cost of the box, servers feed data

[3] Tony Seideman, "The Coaxial Connection," *Multimedia Producer Magazine,* Knowledge Industries Publications, May 1996, p. 26.
[4] Joan E. Rigdon, "Blurring the Line," *Wall Street Journal,* March 29, 1996, p. R20.

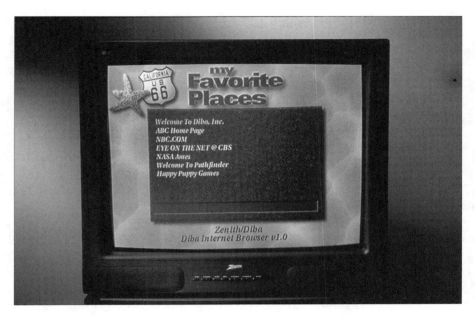

Figure 26-2. Zenith Electronics Television Internet system incorporated in a TV set using a Diba, Inc., browser and a 28.8-kbps telephone modem. (Courtesy of Zenith Electronics Corporation.)

to the subscribers at 1.5 Mbps. What arrives at the cable modem, because of the heavy net traffic, is data at about 400 kbps, or 14 times faster than a relatively fast 28.8-kbps telephone modem.[5] Sure it's quick, but is it worth the tariff?

With all these problems, is the potential there for corporate multimedia users? Most efforts at jump-starting this vision of the future are concentrating on tapping the largest revenue provider, the entertainment television market, and bringing it into the computer—or at least a digital "appliance" of some sort. They call it Web TV. There is a historical parallel here. Remember the venerable LaserDisc? It began as a source for high-fidelity movies and almost died until industry discovered its potential for delivering interactive training, large screen presentations, etcetera. Entertainment television content providers such as the Discovery Channel and Arts & Entertainment, with deeper pockets than most, could begin putting up high-class video imagery and other multimedia treats on the net to begin building interest.

[5] *Ibid.,* "Blurring the Line."

In February 1996, Motorola and Sun Microsystems announced plans to deliver a computer system that could accept data at cable modem speeds. In May of the same year, Zenith, in partnership with Diba, Inc., a Silicon Valley firm, announced a line of TV sets that would offer a low-cost bridge to future technology. The latest TV would have a 28.8-kbps telephone modem built in for standard-speed net surfing from the viewer's easy chair using an infrared controller. The "NetVision" sets that have been on the market since late 1996 also include an Ethernet port for connection to cable modems for high-speed applications. Magnavox-Philips launched a WEB-TV in time for Christmas, 1996. The web browsing capability and telephone modem connection add between $400 and $600 to the retail price of the set.

Also in development at Zenith is yet another partnership, this time with modem manufacturer, U.S. Robotics, to produce a hybrid cable–telephone system that can work with any cable television provider. According to research by the Yankee Group, 90 percent of cable providers offer only one-way data flow to the subscriber's television set. Combining Zenith Electronics Corporation and U.S. Robotics hardware, the hybrid system would use a telephone line to send data requests to the cable operator's head end studio and then switch to the "big pipe" cable to download the internet data at a high-speed rate.[6] The speed of development and introduction of these products will be predicated on advances in the data distribution arena as each mover and shaker keeps peeping over the fence to see what everyone else is doing.

One company partnership has committed a system to a path outside the Internet's bottleneck zone. Tele-Communications Inc. (TCI) and Kleiner Perkins Caufield & Byers, a venture capital firm, announced the creation of a ". . . high speed network that provides real-time multimedia news, information, entertainment, advertising, access to the Internet, E-mail and other services to consumers via cable systems and their computers." The system is called "@ Home."

When @ Home refers to a "high speed network," what they mean is a network backbone separate from and run parallel to the Internet. They are shooting for a target audience of 20 million subscribers and expect to take up to five years to wire the major urban areas of the country. Essentially, the network would be made up of lines leased from the long-distance telephone companies for connection to the Internet. But @ Home will originate from its own nodes, or *regional data centers* set up throughout the country and connected to the leased phone lines.

[6] Zenith Electronics Corporation/U.S. Robotics Joint Release. Also *The Cable Modem,* Zenith Electronics Corporation, May 1996.

The cable modem network is based on a model that involves ". . . caching and replication to minimize traffic on the system backbone and maintain high levels of speed." What this means is that PC servers are attached to the cable network head ends. The PC system will be able to host Web pages and provide information caches (storage areas) for, as an example, local newspapers. If a request for a story comes in from another part of the @ Home network to the head-end cache, the story is sent to the regional data center *replicator* nearest the request's geographic location where the story is temporarily cached for pickup by the requesting subscriber. Other information providers will be encouraged to connect to the replicator–server network in order to reach this new high-speed subscriber base.

The cache process will speed distribution of the most popular Web pages by storing the first subscriber that downloads the page in a cache. Subsequent requests for that page will go to the local cache, thereby speeding up the transmission time for other requests for that page in that same local loop and maintaining the network backbone's speed by eliminating the need to keep transmitting that same page over and over to the subscribers in that loop.

Using the flowing river analogy, @ Home takes the water from the river into the tributaries, but then dams up parts of the tributaries, storing the water for use and allowing the river to keep flowing at its original speed without having to continually replenish these little dammed up areas.

In Canada, two companies have already established cable modem networks. Gogeco is based in Quebec and has taken advantage of Canada's reliance on cable television due to its far-flung geography and long winters. More than 400 of their subscribers live in towns like Trois Rivieres near the slopes of Mount Tremblant and others named Shawinigan and Drummondville. They use Zenith Homeworks Universal cable modems hooked up to a very advanced fiber/cable infrastructure. When the traffic builds and the data are flying, the network does slow down, but the average maintained so far has been about 256 kbps—which is still whipping along compared to 28.8, 33.6, or even 56 kbps of current modems.

The other company, Rogers Cable, serves more than 2.4 million cable subscribers in Ontario and British Columbia. With half their system expected to be upgraded to fiber-optic cable by the end of 1996, what had been viewed as a race against the telephone companies has turned into an Internet profit hunt. Also using Zenith modems, tests that concluded in November 1995 proved the system was a revenue generator. More than 70 percent of the test users elected to keep the service

Figure 26-3. Zenith Electronics cable modem. (Courtesy of Zenith Electronics Corporation.)

at a cost of $39 per month for unlimited use.[7] As of this writing, Rogers has commercially rolled out its "Wave" service using Zenith hardware.

Finally, many companies are using the Internet concept and its structure to create what could only be called *Super LANs*. These local-area networks can span the corporation's regional offices and head-quarters both in the United States and offshore. They use the same kind of search engines employed when hunting for data on Web sites. These networks are called *intranets* and offer a whole new perspective on inter-corporation communications. In reality, they are growing at a greater rate than the Internet. By 1998, software sales supporting intranet services are expected to reach $8 billion. This would be four times larger than the Internet.

Already, the Huntsville Hospital in Huntsville, Alabama — a 900-bed teaching facility — connects more than 80 physicians at the doctors' offices and diagnostic laboratories around the city. The high-speed cable modem network using Zenith hardware provides two-way data transfer of patients' records, test results, and billing information.

[7] David Zgodzinski, "Cable Chase," *InternetWorld Magazine,* Mecklermedia Corporation, June 1996, p. 63.

In Evansville, Indiana, TCI and Zenith Electronics are linking an entire school district for high-speed data access using the local cable TV system. Thirty-seven schools and administrative facilities are linked for administrative data transfer, but the system expects to expand to include student PC-to-PC connections, classroom instruction, and home instruction capabilities.

Companies and institutions using this closed network emulation of the Internet don't have to cope with the slow transfer times, busy signals, or flat, two-dimensional presentations. Communications among the corporations can have a definite multimedia look. While internal training is a major focus, document sharing, group communications, and database access applications are happening. Some software is in preparation to allow the intranet to talk to the Internet.

With the use of fiber optics and high-bandwidth pipelines, the novelty of real-time teleconferencing has become as common as making a phone call. For a corporation considering the Internet for communications that also wants the presentation horsepower afforded by multimedia — all of it secure in a closed-circuit network — an intranet connection may prove to be an answer over both the long and the short term.

Boiling all the Internet availability together as a multimedia resource makes sense. As mentioned earlier, this is the way we are all heading. Transportable media will continue to be used for what they do best until even that huge database capability is transferred to the Internet — or something else resembling the Internet, but using broadcast nodes not unlike the cellular phone network. Cassette music tape sales have slumped, but audio books-on-tape sales have gone up. As long as there is a large installed base of tape players out there, the medium will stay alive. Will the digital video disc replace the analog LaserDisc? CD-ROM is the multimedia champ while the PCMCIA card struggles to expand its laptop and notebook computer niche. CD-i should have died aborning when the consumer box didn't sell, but industry saved it like industry saved the LaserDisc.

Now, industry, corporations, and educational institutions are turning toward the Internet and disembodied information flowing in bit streams through big and little pipes into and out of a cosmos of data repositories. They are taking the first steps away from media you can carry in a briefcase or a pocket and are embracing a place among a vast, linked community of communicators.

While this exploration is taking place, everyone — clients and vendors alike — is being bombarded with hype, blue smoke, and mirrors. Most of the tub-thumping comes from the direction of the broadband, hot-wired crowd. While it is certain we will become a "wired"

communications society in time, the corporations and start-up companies knee-deep in the pool of surging mergers suffer schizophrenic attacks of stirring the expectations pot while running up the "Any Year Now" yellow caution flag. Most client–consumers and a majority of vendors have settled into a "deer-caught-in-the-headlights" posture, numbed by the exponential jumps in technology that have already taken place over the short span of 20 years. Vendors realize they cannot keep waiting for the next update or the next media revolution. The vendors take a deep breath, push their chips into the center of the table, and draw their cards. Clients face the same dilemma, committing sizable budgets to technology that may or may not be around next year.

Today, the Internet is geared toward those who appreciate its elegance and tolerate its weaknesses. To grow, those weaknesses must go away. At a recent seminar entitled "Understanding the Communications Revolution," sponsored by Ameritech Corporation, a watchful perspective was offered. Avadis Trevanian, vice president for engineering at Next Software, Inc., was typical with his caution:

> Today, the Internet doesn't work. It works for technical people who will tolerate waiting a minute to get a page on the screen. But how do you explain to a non-technical person that it takes that much time? . . . It's as if everyone had rotary dial telephones and we were trying to use them for touch-tone applications. It will take five to ten years, maybe twenty to realize that potential.

The president of Neoglyphics Media Corporation, Alex Zoghlin, offered an interesting self-imposed discipline: "We have a 30 second rule. If your information can't be conveyed from the Web in less than 30 seconds, it's not worth doing."[8]

[8] Jon Van, "Be Wary of the Hype of Technology . . . ," *Chicago Tribune,* May 9, 1996, Sec. 3, p. 3.

27

It's a Wrap

Good hype increases stock prices as innovative start-ups go public or are bought out by the larger corporations in search of a market edge. Money means research and development. Good R&D means better products and those innovations propel supercompanies, the hardware manufacturers, and the media distribution folk deeper into the fray.

Updating your knowledge in the Great Digital Media Race requires a month by month refueling from trade magazines such as *Video & Multimedia Producer* (Knowledge Industry Publications, Inc.), or *Internet World* (Mecklermedia Corporation). For the client in search of a medium on which to hang your message, constantly updating your knowledge can either create a rolling epiphany of discovery or induce deep depression. The experience is not unlike approaching the tub full of floating rubber duckies in an amusement park midway. Which duck do I turn over to see if I've won a prize? At that point, it's time to allow the creative barbarians through your gates. It's their job to balance epiphany and paranoia to make a recommendation. Reread this book in five years and see how it all came out.

Throughout all the planning and market surveys and team task assigning and all the technology we can lay our hands on, let's not lose sight of the ultimate need waiting for our technological multimedia broadside. All the media that make up the *multi* in *multimedia* are focused toward one goal: communicating something of value. In the constant battle of flash over substance, there is no contest. Substance rules.

Henry Thoreau had a word or two on the subject back when multimedia was a bit thin on the ground.

Our inventions are wont to be pretty toys, which distract our attention from serious things. They are but improved means to unimproved ends.

Index